ACCENT

General Editor: TERENCE HAWKES

The Sound of Shakespeare

The *Sound of Shakespeare* reveals the surprising extent to which Shakespeare's art is informed by the various attitudes, beliefs, practices and discourses that pertained to sound and hearing in his culture.

In this engaging study, Wes Folkerth develops listening as a critical practice, attending to the ways in which Shakespeare's plays express their author's awareness of early modern associations between sound and particular forms of ethical and aesthetic experience. Through readings of the acoustic representation of deep subjectivity in *Richard III*, of the 'public ear' in *Antony and Cleopatra*, the receptive ear in *Coriolanus*, the grotesque ear in *A Midsummer Night's Dream*, the 'greedy ear' in *Othello*, and the 'willing ear' in *Measure for Measure*, Folkerth demonstrates that by listening to Shakespeare himself listening, we derive a fuller understanding of why his works continue to resonate so strongly with us today.

Wes Folkerth is an Assistant Professor of English at McGill University.

ACCENTS ON SHAKESPEARE
General Editor: TERENCE HAWKES

It is more than twenty years since the New Accents series helped to establish 'theory' as a fundamental and continuing feature of the study of literature at the undergraduate level. Since then, the need for short, powerful 'cutting edge' accounts of and comments on new developments has increased sharply. In the case of Shakespeare, books with this sort of focus have not been readily available. **Accents on Shakespeare** aims to supply them.

Accents on Shakespeare volumes will either 'apply' theory, or broaden and adapt it in order to connect with concrete teaching concerns. In the process, they will also reflect and engage with the major developments in Shakespeare studies of the last ten years.

The series will lead as well as follow. In pursuit of this goal it will be a two-tiered series. In addition to affordable, 'adoptable' titles aimed at modular undergraduate courses, it will include a number of research-based books. Spirited and committed, these second-tier volumes advocate radical change rather than stolidly reinforcing the status quo.

IN THE SAME SERIES

The Sound of Shakespeare

WES FOLKERTH

London and New York

First published 2002
by Routledge
11 New Fetter Lane,
London EC4P 4EE

Simultaneously published in
the USA and Canada
by Routledge
29 West 35th Street,
New York, NY 10001

Routledge is an imprint of the
Taylor & Francis Group

© 2002 Wes Folkerth

Typeset in Baskerville by
Bookcraft Ltd, Stroud
Printed and bound in Great Britain by
T J International Ltd, Padstow, Cornwall

British Library Cataloguing in
Publication Data

A catalogue record for this book is available
from the British Library

Library of Congress Cataloging in
Publication Data

A catalog record for this book has
been requested

ISBN 0–415–25376–4 (hbk)
ISBN 0–415–25377–2 (pbk)

For Susan Elmslie

Contents

General editor's preface

In our time, the field of literary studies has rarely been a settled, tranquil place. Indeed, for over two decades, the clash of opposed theories, prejudices and points of view has made it more of a battlefield. Echoing across its most beleaguered terrain, the student's weary complaint 'Why can't I just pick up Shakespeare's plays and read them?' seems to demand a sympathetic response.

Nevertheless, we know that modern spectacles will always impose their own particular characteristics on the vision of those who unthinkingly don them. This must mean, at the very least, that an apparently simple confrontation with, or pious contemplation of, the text of a 400-year-old play can scarcely supply the grounding for an adequate response to its complex demands. For this reason, a transfer of emphasis from 'text' towards 'context' has increasingly been the concern of critics and scholars since World War II: a tendency that has perhaps reached its climax in more recent movements such as new historicism or cultural materialism.

A consideration of the conditions – social, political, or economic – within which the play came to exist, from which it derives, and to which it speaks will certainly make legitimate demands on the attention of any well-prepared student nowadays. Of course, the serious pursuit of those interests will also inevitably start to undermine ancient and inherited prejudices, such as the supposed distinction between 'foreground' and 'background' in literary studies. And even the slightest awareness of the pressures of gender or of race, or the most cursory glance at the role played by that strange creature 'Shakespeare' in our cultural politics, will reinforce a similar turn towards questions that sometimes appear scandalously 'non-literary'. It seems clear that very different and unsettling notions of the ways in which literature might be addressed can hardly be avoided. The worrying truth is that nobody can just pick up Shakespeare's plays and read them. Perhaps – even more worrying – they never could.

The aim of *Accents on Shakespeare* is to encourage students and teachers to explore the implications of this situation by means of an engagement with the major developments in Shakespeare studies over recent years. It will offer a continuing and challenging reflection on those ideas through a series of multi- and single-author books which will also supply the basis for adapting or augmenting them in the light of changing concerns.

Accents on Shakespeare also intends to lead as well as follow. In pursuit of this goal, the series will operate on more than one level. In addition to titles aimed at modular undergraduate courses, it will include a number of books embodying polemical, strongly argued cases aimed at expanding the horizons of a specific aspect of the subject and at challenging the preconceptions on which it is based. These volumes will not be learned 'monographs' in any traditional sense. They will, it is hoped, offer a platform for the work of the liveliest younger scholars and teachers at their most outspoken and provocative. Committed and contentious, they will be reporting from the forefront of current critical activity and will have something new to say. The fact that each book in the series promises a Shakespeare inflected in terms of a specific urgency should ensure that, in the present as in the recent past, the accent will be on change.

Terence Hawkes

Acknowledgements

Over the life of this project I have benefited from the involvement, support and encouragement of numerous people and institutions, and it gives me great pleasure to acknowledge them here. First, I say 'Say hey!' to Mike Bristol, who wears the number twenty-four in my book. I thank him for all of his advice, as well for his insistence, at an early stage, upon hearing my voice in this work. The Shakespeare in Performance Research Team at McGill and Concordia universities has provided a wonderfully vibrant intellectual environment in which to conduct this research. In addition to Mike, I wish to thank fellow teammates Leanore Lieblein, Patrick Neilson, John Ripley, Kate Shaw, Ed Pechter, Eve Sanders, Kevin Pask, Catherine Graham, Denis Salter, Sarah Werner, and Chris Holmes. My other colleagues in the McGill English Department have contributed to the present work in many ways; in particular I wish to acknowledge my indebtedness to Ken Borris, Dorothy Bray, Peter Gibian, David Hensley, Maggie Kilgour, Paisley Livingston, Trevor Ponech, Brian Trehearne, and David Williams, as well as fellow students Colene Bentley, Matt Bergbusch, Sally Chivers, Brad Clissold, Mike Epp, Chris Frey, Michael Morgan Holmes, Torsten Kehler, Jen Lokash, Dean Irvine, Kristin Lucas, John McIntyre, Jackie Pitcher, Jessica Slights, and Masarah Van Eyck.

This book was completed with very generous assistance in the form of a postdoctoral fellowship from the Québec Fonds pour la Formation de Chercheurs et l'Aide à la Recherche. A year of research leave from the McGill English Department brings me to Vancouver, where there are a number of people who also deserve acknowledgement, and my sincere gratitude. Foremost among these is Paul Yachnin, whose careful and challenging reading, timely encouragement, good cheer and boundless hospitality have all been more important to me than he knows. I would also like to thank Patsy Badir, Tony Dawson, Sherrill

Grace, and Seán Lawrence, each of whom has made me feel very welcome at UBC in the short time I have been here. Rachel Rose and Isabelle Fieschi offered safe harbour and wonderful company upon our arrival in Vancouver. Further afield, I wish to express my gratitude to Bruce Smith for organizing the 'Knowing Bodies' seminar at the SAA in 1999, for writing such an inspiring book, and for being a beacon in this profession. At Routledge, series editor Terry Hawkes lent his keen critical ear to my proposal, and suggested numerous changes to the typescript which have made this a much better book; I am very grateful for his involvement. Liz Thompson helped me wrestle with how best to make the Irving recording available to readers. I'm also grateful to Joan Pong Linton for her shrewd and perceptive comments on an earlier version of this material. Thanks also to David Howes and Jim Drobnick for organizing and hosting the 'Uncommon Senses' conference at Concordia in the spring of 2000, which gave me the opportunity to present some of the Henry Irving material that appears here. Richard Green of the National Library of Canada, the staff at the Recorded Sound Reference Center at the Library of Congress, and Brien Chitty of The Irving Society all assisted me with the Henry Irving recording. I would also like to thank, for their generous assistance and astonishing expertise, McGill librarians Kendall Wallis and Lonnie Weatherby, Georgianna Ziegler and Betsy Walsh of the Folger Library, and the staff of the Koerner Library at UBC. Roger Kaye, Karen Hatch and Gil Prince from CSU Chico would be surprised to discover their names here, as would Cott Hobart of Santa Rosa JC, but each of them played a crucial role in making this book possible.

I also owe a great intellectual debt to longtime musical comrades Geoffrey Folkerth, Tim Alexander, Kevin McCaughey, Marc Spooner, Jim Callahan, Brian Caselden, Ned Jackson, and the late Dale Strachan, who all helped me to discover much of what went into the present work, while we spent literally tens of thousands of hours learning how to listen to each other. Finally, I am grateful for the encouragement and support of my family: my wonderful son Alex, as well as Ted and Lenora, Marvin and Jean, Beth and John, Geoffrey and Ania, and Bill and Janet. I would also like to thank God, for hints, ideas, and for ears. My greatest thanks are reserved for Sue Elmslie, who supported me in all ways through the writing of this, and who piloted me through the difficult passages, on the page and off. Love on you, Sue.

Introduction

Let us inspect the Lyre, and weigh the stress
Of every chord, and see what may be gain'd
By ear industrious, and attention meet …
 John Keats, 'On the Sonnet'

This book is about the role of sound in Shakespeare's art, about how he heard the world around him, as well as what it means for us to listen to him – for us to listen, centuries later, to him listening. Our exploration of the Shakespearean soundscape naturally begins in London, though you should not imagine the reigning queen as Elizabeth, but rather, Victoria. It is the end of August, 1888. An American veteran of the Civil War named George E. Gouraud pays a visit to his friend, the legendary actor Henry Irving. Their meeting on this day is significant in the history of the Shakespearean soundscape, because it results in the production of the earliest known sound recording of Shakespeare's words. Gouraud, who is Thomas Edison's representative in London, is acquainted with Irving through having recently advised him on the use of electrical effects in his triumphant, exceedingly lucrative production of *Faust*. To the present meeting he brings with him Edison's latest invention, the phonograph, with which he plans to make a recording of Irving's voice.[1] The machine captures Irving's distinctive voice delivering the opening lines of *Richard III*, as well as passages from *Henry VIII* and other roles he was famous for playing, such as Mathias in *The Bells*. Several months after this event, at a public lecture, Gouraud would describe the scene of Irving's initial reaction to the sound recording machine:

I was never so amazed as to see Mr Irving attack the phonograph. He walked up to it with that air of confidence which characterises Mr Irving when he walks. When he stopped walking, he found himself in front of the phonograph and began to talk into it, but it was not Irving in the least. Some of his old friends there said 'Why, my dear Irving, it was not you who spoke' and it was not Mr Irving himself: absolutely he was frightened out of his own voice. I had actually to put him through his paces to train him for it, to make him walk backwards and forwards a bit, and when he had got into the swing, he finally came up and said something which was truly delightful, both when it went into the phonograph and when it came out of it.

(Gouraud, quoted in Bebb 1977: 729)

What I find most compelling about Colonel Gouraud's narrative of the incident is the way he repeatedly refers to the phonograph's effect on Irving's sense of his own identity. Irving approaches the machine confidently, but his customary assurance is deflated once he begins to interact with it, especially when he hears its rendition of him. The talking machine immediately alienates him from his own voice, a personal attribute and artistic tool very closely tied to his sense of professional identity.[2] As Gouraud remembers, the initial run-through 'was not Irving in the least', an opinion shared by the assembled friends who assure the actor, 'it was not you who spoke'. Irving, who comes to the exercise with his usual self-assurance, surrounded as he is by old friends, is nevertheless described as having been 'frightened out of his own voice'. He has to be coached how to speak into the machine, and upon hearing the result of the recording is said to have responded by exclaiming, as so many of us do, 'Is that my voice? My God!' (Gouraud, quoted in Bebb 1977: 727). In time Irving's reaction to the phonograph would modulate from a minor to a major key, from horrified fascination to wonder and admiration. He would later write to Ellen Terry, who eventually came into possession of the cylinder, conveying his impression of the unnerving, unprecedented mimetic fidelity of the new device: 'You speak into it,' he wrote, 'and everything is recorded, voice, tone, intonation, everything. You turn a little wheel, and forth it comes, and can be repeated tens of thousands of times' (Irving, quoted in Bebb 1977: 727).

Something of the ripe old sounds

Irving is a pivotal figure in the history of the Shakespearean soundscape not solely because he made the earliest sound recording of the playwright's words, but perhaps more importantly because he altered the

way Shakespeare's verse was spoken in the theatre. In doing this, he changed the way we hear the plays today. Just as the phonograph was a modern invention, Irving was a thoroughly modern actor, one who took fresh approaches to the production of Shakespeare's works, who presented contemporary audiences with what were at the time exciting new alternatives to time-worn theatrical traditions. He initiated, and has thereby come to represent, a significant development in the way Shakespeare's works were acted, in the way his words were sounded out in the theatre. His 'naturalistic' style of speaking the verse would be adopted in the following century by Laurence Olivier, whose own style has commonly been juxtaposed to that of John Gielgud, the latter considered to embody a more traditionally classical, melodic approach to Shakespeare's language.

Henry Irving was well-known, and in some circles infamous, for his slightly nasal vocal delivery. Critics often commented that he would lapse inadvertently into his native Cornish accent during onstage scenes of great emotion or physical exertion. The actor's early self-consciousness about his accent is supported by the story that, as a young clerk named John Brodribb in London, he had organized a system of penalties with fellow clerks, who would fine him for instances of faulty pronunciation and grammar (Bingham 1978: 25). Richard Bebb, an expert on early voice recordings, suggests that Irving later came to regard his idiosyncratic vocal mannerisms as an asset, and that his choice of fellow actors at the Lyceum Theatre came to be motivated at least in part by the desire to set his own voice off acoustically from those of the others in the cast:

> by surrounding himself with actors of the older traditional style, he was bound to highlight his own distinctive originality. The thought is, perhaps, unworthy, but I do believe that in any case Irving real-ised that, lacking a conventional beauty of voice, it was his own way of minimising the lack, and turning a weakness into a strength.
>
> (Bebb 1977: 730)

Probably the most familiar treatment of Irving's voice is found in Edward Gordon Craig's memoir of the actor. Craig devotes half of an entire chapter to the actor's voice in his book *Henry Irving* (Craig 1930: 62–9). What was most notable about Irving's voice, he finds (as did others), was his pronunciation. It has often been noted that Irving would pronounce the word *God* as *Gud*, the word *rich* as *ritz*, *sight* as *seyt*, *hand* as *hend*, and so forth. Craig fondly remembers that Irving's 'ten-dency was to enrich the sounds of words – to make them expressive

rather than refined' (62–3). In the spirit of homage that engenders his book, Craig chooses to situate Irving's peculiar pronunciation in an authoritative, romantic past, rather than call attention to the influence of his provincial upbringing. He recalls reading an old sixteenth-century ballad of Robin Hood aloud to himself during a trip through Italy, and discovering that he sounded remarkably like Irving as he tried to pronounce the archaic words. Revisiting the ballad as he writes the book at hand, he finds himself transported from its original setting to Irving's theatre in London:

> On reading the whole ballad again, this time indoors, I am no longer in Nottinghamshire, I am at the Lyceum Theatre, and I become very aware of Irving, and I hear again as it were the old voice; and as I listen to this pure old English strain I think how strange it is that it is always for preserving the best that men lay themselves open to the attacks of their fellows.
>
> For this is the old English speech, and Irving brought back to us something of the ripe old sounds, and damme if we didn't object.
>
> (65)

Craig recollects the sound of Irving's voice, in which 'all kinds of contortions were employed to bring out the full horror of the nobility of each vowel and the sweetness of each consonant', as a present event in which the sounds of the past were still embedded (66). Irving 'came to speak English as I believe it should be spoken,' he claims, 'and as this same good rich English was always spoken in the days of Robin Hood, and long before and after.' Henry Irving's voice embodies the vibrant history of the national language. His voice is itself a kind of recording, in which the sounds of the past are preserved to re-sound in the present.

As fortune would have it, Henry Irving's recording of the opening soliloquy of *Richard III* is not only the earliest known sound recording of Shakespeare, it is also the earliest *surviving* sound recording of Shakespeare, and I invite you to listen to it at this point (see note).[3] Because the recording is extremely difficult to understand in places, I here provide the lines Irving speaks:

> Now is the winter of our discontent
> Made glorious summer by this son of York;
> And all the clouds that low'r'd upon our house
> In the deep bosom of the ocean buried.
> Now are our brows bound with victorious wreaths,
> Our bruised arms hung up for monuments,

Our stern alarums chang'd to merry meetings,
Our dreadful marches to delightful measures,
Grim-visag'd War hath smooth'd his wrinkled front;
And now, in stead of mounting barbed steeds
To fright the souls of fearful adversaries,
He capers nimbly in a lady's chamber
To the lascivious pleasing of a lute.
But I, that am not shap'd for sportive tricks,
Nor made to court an amorous looking-glass;
I, that am rudely stamp'd, and want love's majesty
To strut before a wanton ambling nymph;
I, that am curtail'd of this fair proportion,
Cheated of feature by dissembling nature,
Deform'd, unfinish'd, sent before my time
Into this breathing world, scarce half made up,
And that so lamely and unfashionable
That dogs bark at me as I halt by them –
Why, I, in this weak piping time of peace ...

(1.1.1–24)[4]

The cylinder runs out at this point, and the moment it records disappears back into the August air of 1888. Although you have read about this event for several pages now, I want to emphasize how, through actually listening to Irving speak, you get a heightened sense of the *reality* of that otherness, a sense of how the acoustic experience of the event insists on, and testifies to, the fact that *this actually happened*. Listening to this recording, we actually get the chance to hear what Craig means when he refers to 'something of the ripe old sounds'. We get to hear Irving's idiosyncratic vowel sounds, in all their horrible nobility. It becomes easy to imagine the scene of the actor, fifty years old and at the height of his artistic and commercial success, weaving back and forth in front of the phonograph, surrounded by friends in a comfortable Victorian parlour, speaking words by Shakespeare that he had, single-handedly, reintroduced to the English stage. This is because Irving presented the play, not in the Colley Cibber version which had traditionally been presented since the beginning of the previous century, but in Shakespeare's version. For the first time in over thirty years, since Samuel Phelps had tried unsuccessfully to present the Shakespearean version in 1845, London audiences heard *Richard III* open with the title character's soliloquy, with the words 'Now is the winter of our dis-con-tent ...' (Hughes 1981: 151).

But that is not exactly correct. To be more precise, Irving's

production of *Richard III* did not begin with these words, but with a different sound altogether. As William Winter recounts, the actor 'entered through an archway, and paused, and glanced around, and listened to the merry bells before he began to speak ...' (Winter, quoted in Hankey 1981: 88). The bells continued ringing through the first several lines of the opening speech, until the point where the tone shifts dramatically at line fourteen, at which point they ceased, leaving Richard to descant on his own deformity in acoustic isolation (Hankey 1981: 89). To contemporary audiences, the sound of the bells at the start of the play would have instantly, without a doubt instantly, called to mind Irving's signature role: that of Mathias in Leopold Lewis's melodrama *The Bells*. This was the part which in 1871 had launched Irving to prominence on the London stage, and it was one he would continue to play throughout his long career, right up until the very night before his death (Mayer 1980: xiv). In the play, Mathias is an Alsatian burgomaster guilty of the murder of a Polish Jew. During each of the play's three acts he is haunted by the sound of sleigh-bells associated with that event, until he is finally so overcome with guilt that it kills him in the play's final moments. In the first act no one in the theatre hears the bells but Mathias. In the second act, however, the audience begins to hear the bells as well, drawing it deeper into the murderer's consciousness, into that part of himself which he needs most to conceal. It is evident that Irving must have learned a great deal from this hugely popular play, especially from the way it affected audiences with its exceptionally effective use of sound. For him to resort to bells again in the opening moments of *Richard III* would have been a quick, economical way of lending some of Mathias's psychological realism to a Shakespearean part that can tend to veer dangerously towards caricature.

The recording of the opening speech of *Richard III* that you have just listened to is a deceptively complex historical artefact. While listening to Irving speak, you are not only listening *to* a particular historical event, you are listening *through* history as well. What sounds like obtrusive background noise is actually layer upon audible layer of acoustic technology, a sonic palimpsest of different temporalities. From the loud whirr of the original wax cylinder that recorded the original event, to the hiss of the audiotape it was later transferred onto, to the faint graininess of resolution that was introduced when the audiotape was transferred to the digital audio file we now listen to (whether as streaming media or on compact disc), one's sense of the presence of Irving's voice is accompanied by the concomitant presences of a century of technological evolution. We naturally listen through these technological layers when we try to imagine what Henry Irving actually sounded like

at that moment in 1888. We quite reasonably intuit that the world, even London, couldn't have sounded so deafeningly scratchy back then. After all, we would have heard about it somehow. And yet at the same time the fidelity was such that Henry Irving would eventually fall under the spell of the talking machine. 'You speak into it and everything is recorded, voice, tone, intonation, everything.'

Edison called his invention the *phonograph*, the 'sound-writer'. The phonograph literally wrote sound, which was inscribed onto the wax cylinder. The name takes a page from the earlier communications technology upon which it was modelled, writing, which was likewise the most sophisticated technology available for recording sound events in Shakespeare's England. Many early modern authors, especially those who wrote professionally as Shakespeare did, quickly learned to push that representational technology to its mimetic limits. The main point I wish to suggest here is that, just as the wax cylinder of Henry Irving's voice speaking the opening lines of *Richard III* vividly records the presence of the past (whether that be the present of August 1888, or the ripe old sounds of Robin Hood's England), so too do Shakespeare's playtexts record past acoustic events, vivifying the past presences of different voices, tones, and intonations in the early modern theatre. The sounds embedded in these playtexts ask us to assent to the fullness and reality of their temporal and cultural otherness. At the same time, they also express, at various registers of theatrical and linguistic representation, their author's understanding of sound. They do so at least partially because the spoken word is the communicative medium the playtexts were employed to notate in the first place. The primary goals of this book are to find new ways of hearing the sounds that are embedded in these playtexts, and to identify the various ethical and aesthetic dispositions Shakespeare associates specifically with sound.

The Shakespearean soundscape

Shakespeare created worlds with sound, worlds that in turn contain whole soundscapes within them. To illustrate this we need look no further than the very speech we have just listened to Henry Irving recite. To begin the play that bears his name, Richard of Gloucester makes his way downstage to establish the scene by describing the sociopolitical changes that have recently transpired in his England. He repeatedly refers to those changes in terms of sound, describing 'stern alarums chang'd to merry meetings', and 'dreadful marches' exchanged for 'delightful measures'. His personification of War now 'capers nimbly in a lady's chamber / To the lascivious pleasing of a lute'.

England has entered into a 'weak piping time of peace', in which Richard has no place, other than to stand by and 'descant' upon, to improvise a counter-melody with, his own physical/moral 'deformity'. What Richard does in this speech, and he seems to do it without even thinking about it, is describe a *soundscape*. He not only catalogues the various sounds that make up the shifting acoustic environment of his country, but also expresses his attitude towards that environment, which has become a kind of desert to him. It is an environment, he wants us to believe, in which he lacks the physical qualifications for any sort of meaningful social interaction. We learn about that environment, and him, through his responses to the sounds he hears in it. The vital relevance of the concept of the soundscape to literary studies is only just beginning to be recognized. This book is the first to apply it specifically to Shakespeare, his works, and to his continuing cultural impact.

In his recent, pioneering book on *The Acoustic World of Early Modern England*, Bruce Smith has powerfully and comprehensively reconstructed the many and varied elements of the acoustic environment of early modern England (Smith 1999). Some of the sounds he includes in his analysis are (to name but a few): civic 'soundmarks' such as bells and street criers; rural 'keynote' sounds such as streams, birds, dogs, horses, and rustic musical instruments; festive practices such as the beating of the bounds at Rogation-tide; the sounds and speech protocols associated with aristocratic entertainments; and contemporary examples of regional and class-based linguistic variation. Smith's work on sound in early modern England proceeds from the assumption that,

> Since knowledge and intentions are shaped by culture, we need to attend also to cultural differences in the construction of aural experience. The multiple cultures of early modern England may have shared with us the biological materiality of hearing, but their protocols of listening could be remarkably different from ours. We need a *cultural poetics* of listening. We must take into account, finally, the subjective experience of sound. We need a *phenomenology* of listening, which we can expect to be an amalgam of biological constants and cultural variables.
>
> (Smith 1999: 8)

The chapters that follow are my own response to Smith's call for a 'cultural poetics of listening', or at least for a more nuanced, experientially-based understanding of the role of sound in Shakespeare's works. I plan to pursue this type of understanding not by cataloguing the sounds that occur in the various acoustic

environments of the plays, but by trying to identify what these sounds would have meant, and how their meanings would have been received by the people who heard and understood them in specific contexts, with early modern ears.

My guiding intuition in this book is that Shakespeare and his contemporaries had a relationship to sound radically different from our own. By listening carefully to the language they use when they talk of sound and hearing, I aim to show that this perceptual domain held many related associations for the early modern imagination, among which are notions of vulnerability, community, the idea of 'cognitive nourishment', access to the deeply subjective or pre-articulated self, grotesque forms of continuity and transformation, radical provisionality, free-flowing expenditure, and related ethical dispositions such as obedience, receptivity, assent, and belief. References to sound and hearing appear throughout Shakespeare's plays, and wherever they do they consistently indicate how strongly these acoustic values and dispositions resonate at what we might call the 'lower frequencies' of his work – frequencies which, because of their longer wavelengths, have proved to be remarkably enduring, and far less susceptible to the disturbances that commonly occur at the surface of our cultural and intellectual lives. It is also worth noting that, collectively, such values run counter to the values of mastery, dominance, and invulnerability that our predominantly visual culture has come to privilege since the era of the Enlightenment. I hope to demonstrate that by listening closely to Shakespeare himself listening to the world around him, we gain a much better understanding of why his works continue to reverberate so strongly amongst us today.

In the first chapter, I introduce 'Shakespearience', which is my name for this broader historical–phenomenological approach to the study of Shakespeare, an approach which proceeds from the assumption that his plays were the products of an embodied consciousness that was itself informed by cultural attitudes and practices. Then, after explaining the term 'soundscape' and presenting a brief overview of its early modern theatrical provenance, I delve into the phenomenological mechanics of Renaissance textuality, especially playtextuality. Reading Shakespeare's plays, which were written for performance in the theatre, requires that we listen to them with the awareness that they are less a species of writing in which a single objectifiable meaning or argument is advanced, than something more akin to a variety of musical notation from which a protensive experience (one extending in time) is meant to be reproduced. It is therefore important for modern scholars to pay attention to the tonalities embedded in these texts, to attempt to hear them, 'in time' as it were, with early modern ears. The first chapter ends with a brief

listening to the soundscapes of 'The Rape of Lucrece' and *Richard III*, where we hear Shakespeare's close association of sound with the deeply subjective self, and note his awareness of sound's special capacity to access that form of experience which scholars have recently begun to describe in terms of 'interiority'.

In order better to understand how Shakespeare and his early modern audiences would have understood sound and hearing, the second chapter addresses the cultural contexts of the Shakespearean soundscape: that is, the kinds of associations sound and hearing would have preconsciously generated in the minds of Shakespeare and the average playgoer. Discourse directly concentrated on hearing is found in three main disciplinary contexts in the period: the religious, the philosophical, and the anatomical. The religious discourse is represented in a number of sermons published during Shakespeare's career, which invariably make reference to the Biblical story of the parable of the sower, in which different types of hearers are categorized and morally evaluated. Other writers take a more philosophical approach to the subject, and depend heavily upon received knowledge from Classical authors such as Galen and Aristotle. The anatomical discourse of Shakespeare's day introduces some of the latest anatomical research from Italy, but also continues to rely heavily on Classical medical knowledge. All of these accounts suggest that early modern people strongly associated hearing and sound with notions of obedience, duty, receptivity, penetrability, transformation, and reproduction. They also associate hearing with the idea of community, with what Shakespeare was to describe in *Measure for Measure* and *Antony and Cleopatra* as 'the public ear' (MM 4.2.99; Ant. 3.4.5). Furthermore, it is notable that many of these more 'acoustic' values were culturally coded as feminine in Shakespeare's day.

In the third chapter I examine Shakespeare's treatment of the ethical implications which proceed from the early modern understanding of the ear as a feminized perceptual organ. Hearing is characterized as an opening up of the self, as a kind of receptivity and radical vulnerability. The play that speaks most directly to these ethical implications is Shakespeare's final tragedy, *Coriolanus*, in which the title character's refusal to hear the plebeians, and then even his own family and friends, results in his ostracism and eventually, by extension, in his death. Chapter 4 concentrates on Shakespeare's consistent voicings of the interrelations between sound, transformation, and the grotesque. The character who most fully embodies these joined concepts is Nick Bottom, the weaver from *A Midsummer Night's Dream*, whose fluid experience of conceptual categories is also exemplified in his radical physical transformation, figured in his ass's ears. Shakespeare's characterization

of Bottom suggests that the grotesque, which Bakhtin located in what he famously called the 'lower bodily stratum', was also associated with the perceptual organs, and especially with the ears. The fifth chapter explores the notion of Shakespearean 'acoustemologies', a useful portmanteau word coined by anthropologist Steven Feld (1996) to denote the specific relations between acoustic experience and epistemology in the establishment of personal and cultural identity. First, I focus on the idea of the 'greedy ear' in *Othello*, on how that phrase describes the ear as a vortex of desire which destabilizes characters, causing them to become lost in the space between what they actually hear and what they more strongly desire to hear. The chapter continues with a reading of *Measure for Measure* in terms of its final scene, in which Shakespeare phrases the crux of whether or not Isabella will marry the Duke in terms of her disposition to incline 'a willing ear' to his proposal. I close by calling attention to the prevalence of the willing ear in contemporary literary criticism, especially in Shakespeare criticism, where we find Harold Bloom having more in common with John Wayne than you might think.

1
Shakespearience

Are you Shakespearienced?

Trip Shakespeare

My God, I wish I'd met him, talked to him – but
above all, heard and listened.

Laurence Olivier

The name 'Pavlov' wouldn't have meant anything to Thomas Dekker
or any of the audience members assembled to hear his play *The Shoemaker's
Holiday* at what was probably the Rose theatre around 1597–1600.[1] In
the second scene of the fifth act, however, the apprentice Firke is in the
midst of inviting various characters to his master's feast when a sound
effect causes what can only be described as a Pavlovian reaction among
the characters onstage. Firke notes the sound first, because his 'O
brave, hearke, hearke' occurs just before the stage direction, '*Bell ringes*',
in the text (5.2.184).[2] The order of these two elements in the playtext
seems to indicate that the actor's words were aural signals to whoever
was in charge of actually ringing the bell during the performance.
There is a general excitement onstage once the sound is recognized:
'ALL. The Pancake bell rings, the pancake bel, tri-lill my hearts'
(5.2.185). For the apprentice characters onstage, the sound suggests at
least two types of association. The first, as Firke tells us, is that it signals
the start of a feast that has been promised by his master Simon Eyre,
the new Lord Mayor. Indeed, the food is so central to Firke's experi-
ence of the holiday that he describes it ambulating up and down the city
streets under its own power:

> O musical bel stil! O Hodge, O my brethren! theres cheere for the
> heavens, venson pasties walke up and down piping hote, like

sergeants, beefe and brewesse comes marching in drie fattes, fritters and pancakes comes trowling in in wheele barrowes, hennes and orenges hopping in porters baskets, colloppes and egges in scuttles, and tartes and custardes comes quavering in in mault shovels.

(5.2.197–203)

Notwithstanding its centrality to this apprentice's experience of the holiday, the pancake bell signifies more than a surfeit of food.

It also signals the start of a period of festivity (the 'Shoemaker's Holiday' of the play's title) that temporarily releases the workers from their routine obligations and responsibilities. The new Lord Mayor had promised as much in the previous scene: '… upon every Shrovetuesday, at the sound of the pancake bell: my fine dapper Assyrian lads, shall clap up their shop windows, and away … . Boyes, that day are you free, let masters care, And prentises shall pray for Simon Eyre' (5.1.48–53). Firke again makes this clear for the audience, and for posterity: 'Nay more my hearts, every Shrovetuesday is our yeere of Jubile: and when the pancake bel rings, we are as free as my lord Maior, we may shut up our shops, and make holiday: Ile have it calld, Saint Hughes Holiday' (5.2.211–4). St Hugh, the patron saint of shoemakers, had already been apportioned a holiday in the English calendar, 17 November – though by the time of Dekker's play it had become overshadowed by Elizabeth's 'crownation', which had fallen on the same day, when it was customary for all the bells in the kingdom to be rung in dynastic celebration (Cressy 1989: 30; 50–1; 136). St Hugh's holiday had been appropriated by the Elizabethan government. Firke, whether wittingly or no, repossesses it for the fellows of his trade by repositioning the date of St Hugh's Day to Shrove Tuesday, in speech licensed by the festive occasion, marked by the pancake bell.[3]

Whereas Dekker portrays the jubilant reactions of the apprentice-characters, the sound of the pancake bell would have resonated quite differently with many members of the play's initial audiences, who may have associated the sound of the bell in the streets of London on Shrove Tuesdays with anarchy and mob rule. This third response to the effect of the pancake bell is left to us by John Taylor in 1617, who writes of that particular holiday that

all the whole Kingdome is in quiet, but by that time the clocke strikes eleuen, which (by the helpe of a knavish Sexton) is commonly before nine, then there is a bell rung, cald *The Pancake Bell*, the sound whereof makes thousands of people distracted, and forgetfull either of manner or humanitie.[4]

Dekker's benign characterization of the holiday masks Shrove Tuesday's reputation as a day when the London apprentices frequently ran riot, at times tearing down reputed brothels, carting prostitutes through the streets, freeing prisoners, and assaulting the theatres.[5] It is important to note that the apprentices who enter the scene I've been describing do so armed, according to a stage direction, '*all with cudgels, or such weapons*'.

The points I want to emphasize in this short reading are that (1) a temporary disruption of the normal patterns of social order is announced simultaneously to the entire community by means of a very simple acoustic signal, (2) that the responses prompted by that signal would have been extremely variegated across the social spectrum, and (3) that these responses would include not only conventional semantic meanings such as 'the festival has started', but physiological and emotional components that will never be fully recoverable. This last point is, I believe, the most important. The pancake bell would have imparted a variety of extralinguistic meanings to the general public in attendance at a performance of *The Shoemaker's Holiday*. In addition to announcing the commencement of that day's festivities, it would also evoke a wide range of visceral emotional responses – from excitement and exhilaration to aggravation, revulsion and outright fear, depending upon whether one was an apprentice, a Thames boatman such as John Taylor, a tavern keeper, a theatre owner, or a worker in the South Bank's sex industry. Hearing the pancake bell represented in a theatrical performance would undoubtedly evoke or carry over trace elements of these kinds of reactions in individual playgoers, and these reactions would then become part of that audience member's experience of the play.[6] While I have asserted that these types of responses will never be fully recoverable, I do believe that recent innovations in our understanding of the ways in which sound and culture interrelate provide us with the archaeological tools to chip away at these responses, and throw them into sharper relief.

Culture and sound | soundscape

Penelope Gouk, a pre-eminent researcher of the history of early modern acoustics, has observed that sound was not investigated as a discrete subject of study in its own right 400 years ago. Instead, the phenomenon was addressed from a number of different vantage points, including anatomy, religion, natural philosophy, magic, and cosmology, as well as musical, political and educational theory. Gouk accounts for this broad dispersion by reminding her reader that 'seventeenth-century categories of thought are quite independent of present-day ones, and we must not

expect to find the kind of systematic treatment that would be adopted by a modern writer' (Gouk 1991: 95). It is notable, however, that little has actually changed in the intervening centuries. Today, there are many modern systematic approaches to sound, as Barry Truax has noted, and these approaches often work in effective isolation from one another in the physics, psychology, linguistics, audiology, medicine and engineering departments of academic institutions, where 'each discipline concerns itself with only a particular aspect of the entire subject, and often no attempt is made to bridge the arbitrary gaps between them' (Truax 1984: 2).

In response to the need for a more unified understanding of sound's role in the lived experience of human cognition, communication and culture, the term *soundscape* was developed by communications theorists at Simon Fraser University in the late 1970s to denote the function of sound in human perceptual ecology.[7] The word is closely related to, and of course derives from, the more familiar *landscape*, although there is also a significant difference between the two terms, which derives from the distinctive experiential properties of visual and acoustic perception. While we generally experience and therefore regard landscapes as objective entities, as existing 'out there', the soundscape is more specifically situated at the interface between the 'out there' and the perceiving subject's involvement in its constitution. As Truax defines it in *Acoustic Communication*, the term 'soundscape' is not altogether synonymous with the 'acoustic environment', but instead denotes 'how the individual and society as a whole *understand* the acoustic environment through listening' (Truax 1984: xii; emphasis in original). What Truax means by *listening* is not simply acoustic sensation, but the process through which acoustic information is processed and rendered meaningful to us, by us. To listen is to winnow meaning from the acoustic environment.

The way early modern individuals record their listening experiences can tell us a great deal about the soundscape and their relationship to it, such as whether a sound is commonplace, sporadic, or rare, whether it has positive or negative connotations for that particular listener, whether it is tied to specific seasonal or calendrical festivities or rituals, and whether it contains symbolic significance for specific individuals or for the community as a whole. The degree to which a given listener is acquainted with the source of a particular sound, or to individual elements of the soundscape more generally, is often an index of that person's position in, or relation to, the larger community. Richard of Gloucester's opening soliloquy attests to Shakespeare's own keen awareness of this. When considering the role of sound in early modern

England, it is equally important to bear in mind that a number of cultures are entailed under that umbrella term. As Bruce R. Smith has comprehensively demonstrated, each of these subcultures has its own soundscape and acoustic complexion, from the rural hamlet and seaside village, to the royal court and the metropolitan centre of London with its markets and guild/plebeian components (Smith 1999: 49–95). Each makes localized contributions to the total acoustic environment, and, as the preceding discussion of the final scene of *The Shoemaker's Holiday* suggests, each may experience and interpret the same acoustic event in very different ways. Truax calls these types of cultural formations *acoustic communities*, which he defines as

> any soundscape in which acoustic information plays a pervasive role in the lives of the inhabitants (no matter how the commonality of such people is understood). Therefore, the boundary of the community is arbitrary and may be as small as a room of people, a home or building, or as large as an urban community, a broadcast area, or any other system of electroacoustic communication.
>
> (Truax 1984: 58)

In addition to the soundscapes associated with specific localities in early modern England, other more mobile acoustic communities would have been formed of shepherds, soldiers, merchant sailors, players, healers, soldiers, tinkers, and other itinerant tradespeople, as well as vagabonds, thieves, robbers, and rogues, who were known to speak in their own obscure jargon called 'cant'.[8] Truax notes that in such acoustic communities sound plays a significant role in 'defining the community spatially, temporally in terms of daily and seasonal cycles, as well as socially and culturally in terms of shared activities, rituals and dominant institutions' (Truax 1984: 58). As we have seen, many of these roles would have come into play during the ringing of the pancake bell, though as John Taylor notes, the exact hour of the bell could vary from year to year, depending on the amount of 'knavish' impatience or enthusiasm possessed by the sexton charged with ringing it. In this ritual the civic tradespeople operate as an acoustic community, engaging sound to notify those in the immediate vicinity that time is about to be radically redescribed. Sound becomes the medium through which this community momentarily takes charge of, and redefines, social time. Contemporary listeners who heard an 'early' pancake bell would undoubtedly have experienced – and perhaps even recognized, if only for a fleeting moment – temporality itself as a contingent social phenomenon, rather than an objective parameter of social and ritual organization.

Another early modern acoustic community is quite clearly the public theatre itself, the sounds of which regularly carried from the loose acoustical confines of the theatre out to the wider culture. Even in the most populous city in Europe it would have been difficult to ignore the noise and clamour produced by close to 3,000 people gathered in an open-air building, erupting with laughter at the improvisations of a clown, spontaneously raining down hisses on a villain, or reacting to some sport or altercation taking place within the ranks of the audience itself. The noise that tended to emanate from the city playhouses was included as one of the complaints levelled in a petition to the Privy Council by citizens of the Blackfriars district in 1596, in which the citizens protest the presence of a playing house in their midst. Included in their list of objections is the complaint that 'the same playhouse is so neere the Church that the noyse of the drummes and trumpetts will greatly disturbe and hinder both the ministers and parishioners in tyme of devine service and sermons' (Thomson 1992: 178). The main argument advanced by the plaintiffs, who declare they are concerned that the noise will hinder the work of the local clergy, is probably also a roundabout way of legitimating the understandable fears they have for their own peace and quiet.

Of course, not all of the noise issuing from the theatres would have been produced by audience members. In London during the indoor playing season, for example, the theatre troupes would often announce performances and call potential customers with drums and trumpets. The practice is referred to in a letter from Lord Hunsdon to the Lord Mayor of London in September 1594, in which Hunsdon requests that his players be allowed to play at the Cross Keys that season, with the proviso that they 'will nott use anie drumes or trumpettes att all for the callinge of peopell together' (quoted in Thomson 1994: 114). It is not certain whether audiences were also called with these instruments from the top of the theatres' tiring-houses over on the South Bank, or whether younger members of the troupes or technical assistants would parade noisily through the streets with such instruments to inform the populace about upcoming performances. It is probable that the same instruments were used to 'drum up' business when the troupes went on tour. Five years after Hunsdon's request, Philip Henslowe records in his diary that he has lent some money to a member of his company 'for to buy a drum when to go into the country'. Peter Thomson suspects that 'two trumpets bought the following day by the actor Robert Shaw were for the same purpose' (Thomson 1992: 20). Drums and trumpets were also sounded during performances to create effects such as thunder and military fanfares. Returning to the city, the bell atop the

tiring-house could also have been used to notify audiences, its sound wafting over the river with much greater amplitude and clarity than that of a drum, or even of trumpets.

At this stage perhaps it will be helpful to preview, by way of a brief example, what I mean when I speak of sound having ethical valences. When we speak of listening as a form of 'winnowing', when we talk about the decisions we make, and don't make, about what we hear, how we hear, and who we hear, we are talking about hearing as an ethical act involved in assigning value and recognition to particular elements and events in the acoustic environment. Hearing resonates throughout early modern culture as a sense characterized by passivity, community, obedience, and tradition. This is in contrast to vision, which the early modern understanding aligns with notions of activity, individualism, aggression, and technical innovation. Without denying the emerging ascendancy of the visual in early modern England, it bears remembering that the sense of hearing continues to occupy a significant place in that persistently oral culture as well; that light in the King James version of the Bible is brought into existence by a prior vocalization, that the first words to the gospel of John are 'In the beginning was the word'. Further examples of the importance of sound are encountered in the well-known cosmological metaphors elaborated in various early modern accounts of the *musica mundana* (Gouk 1999: 81; 95–111). Aural imagery used in conceptualizing the physical universe was commonly applied in references to human social existence as well. There is a preoccupation in Shakespeare's day, one which permeates his history plays, with social harmony and concord, two terms that indicate the obligation individuals have to accept their social roles and stations. The defence of social stratification, of one's necessary obedience to the greater harmony or concord of one's society, is expressed most famously in the acoustic metaphor Ulysses employs in his speech on degree in *Troilus and Cressida*. Of degree, he says, 'untune that string, / And, hark, what discord follows' (1.3.109–10).

Contemporary links between the concepts of aurality and obedience can be traced in the historical record, where they are manifest in specific ideological legitimizing practices of the late Elizabethan/early Jacobean period, as well as in records of the contemporary judicial system. The Tudor monarchs, who ruled without the benefit of a standing army or police force, discovered that an effective preventative measure against civil disobedience was the dissemination of propaganda directly into their subjects' ears on a weekly basis. Attendance at Sunday service was mandatory for all subjects of the realm. Throughout the year at these

services, the assembled audience would hear a variety of state-sponsored sermons, which were collected and distributed in 1559 as *The Book of Common Prayer* (Church of England 1844). Several of these sermons – 'An exhortation to obedience', 'Against strife and contention', 'An homily against disobedience and wilfull rebellion' – emphasize the idea that obedience to one's social superiors is a natural and holy state, an echo of the perfect harmony produced in the music of the spheres.

There were of course instances when disobedient subjects failed to 'hear' the messages the government was transmitting, and in such cases the judicial system could respond with a brutally blunt reciprocity. Several notices in the collected manuscripts of the Earl of Egmont from the 1570s to the early 1600s vividly illustrate the contemporary connections between ears, assent, and obedience. The records recount numerous punishments meted out in Ireland for the crime of jury perjury in cases involving the prosecution of treasonous individuals or groups. The entry for 17 November 1609 concerns a treason trial in which the poet John Davies had acted as prosecuting attorney. Four of the jurors were back in court on this day to face charges of jury perjury. The record reads that the guilty jurors were to

> pay fines of 100*l*. apiece, to be pilloried at Dublin and the next assize town in co. Coleraine, and each of them to lose one of his ears, for acquitting the said traitors contrary to the clear evidence that they had been in open rebellion.
>
> (Historical Manuscripts Commission 1905: 35)

This is by no means an isolated instance; other entries in the manuscripts relate similar cases of jury perjury, with the like punishment. Reading through them one inevitably develops the sense that to hear 'correctly' in this culture is a sign of assent and obedience. Not to do so is to risk losing one's ears. Other punishments similarly focused on the ear had long been imposed for lesser crimes. John Bellamy, in *Crime and Public Order in England in the Later Middle Ages*, cites two laws from the late fourteenth century which prescribed related punishments aimed at the ears of offenders:

> A law of Dover stated that any cut-purse captured with the *mainour* was to be led before the mayor and bailiff, and if he could not offer a reasonable excuse be set in the pillory 'and all the peple that will come ther may do hym vylonye; and after that they may cut off hys one ere'. A law of Portsmouth was of a similar brutality. A person convicted of taking goods worth less than a shilling was to

have an ear nailed to the pillory, 'he to chese whether he woll kytt [i.e. cut] or tere it of'.

(Bellamy 1973: 185)

Years later, Robert Greene likewise tells of a group of cony-catchers likely to have their ears burned when accused of stealing a horse in *The Second Part of Cony Catching* (Greene 1972: 209).

In addition to their expression in disciplinary practices, the ways in which early modern attitudes concerning sound and hearing are represented in texts can tell us a great deal about the culture and what it was like to live in it – not only because theirs was still very much a residually oral culture, but because sound and culture are always involved in a form of coarticulation. As Truax notes, 'the inseparability of every sound from its context makes it a valuable source of useable information about the current state of the environment. ... in terms of community, sounds not only reflect its complete social and geographical context, but also reinforce community identity and cohesion' (Truax 1984: 10). Just as sounds are articulated and heard within cultures, so are cultures within sounds. With that in mind, how might we go about listening to the soundscapes embedded in Shakespeare's plays today?

Reading the soundscape: early modern playtextuality

In recent years it has become possible to conceive of a phenomenological Shakespeare criticism which neither presupposes the fractured duality of the Cartesian subject, nor yokes itself to assuming the complete permeation of consciousness by language that has characterized much poststructuralist literary theory. Until recently, phenomenological studies of theatrical experience, concerned with the perceptual and cognitive experience of the theatre, have typically explored how the theatre focuses the attention of the playgoer in different ways, how it manipulates its own reception (Garner 1989; States 1985). Such studies have tended to focus solely on the experience of the individual playgoer, who is often an idealized construct, to the neglect of the cultural context's contribution to the formation of that experience – although in his later book, *Bodied Spaces: Phenomenology and Performance in Contemporary Drama*, Stanton Garner gestures in this direction when he declares his intention to monitor 'those moments when phenomenological perception encounters the culturally, historically, analytically constituted' (Garner 1994: 15). By adapting a similar phenomenological approach to Shakespeare studies, we discover that such encounters in Shakespeare's playtexts communicate a great deal of information about the early modern culture that

collaboratively participated in their material, and even their imaginative, production.

One strategy that can help us to hear the soundscapes in Shakespeare's plays is to approach the texts less as a species of writing in which a strictly conventional semantic meaning or narrative is advanced, than as something closer to a type of musical notation which describes, or eventuates in, a protensive experience – that is, one which necessarily occurs in time. Alfred Schutz, who wrote extensively on the phenomenological structures of communication and other forms of social interaction, has argued that music, along with other similar types of social intercourse such as dancing, wrestling, playing chess, and presumably theatrical performance as well, is a mode of communication of a very different order because it does not rely as completely as natural language upon the transfer of idealizable and objectifiable semantic content (Schutz 1962).[9] The key distinction Schutz makes between these modes of communication is that language conveys *monothetic* meaning; music and other related forms, *polythetic* meaning.[10] To elaborate, monothetic meaning is a function of the semantic component of sign systems such as natural language. It is ideational, and can be characterized as time-transcendent, sign-oriented, and conceptual. Polythetic meaning, on the other hand, is a 'time-immanent' mode of experiential meaning, meaning that is perceived in the fullness of our material, embodied experience in time, as in the experience of a theatrical performance. It pertains to the embodied consciousness in the sense that it is generated out of symbol systems motivated by various forms of prelinguistic engagement with the material world. Polythetic meaning allows us to conceive of meaning as a *process* that takes place within the experience of embodied consciousness, and not simply as an *object* of consciousness. An awareness of this type of extralinguistic, experiential meaning can greatly assist us in listening for the soundscapes embedded in early modern playtexts, especially once we also take into account the characteristically expansive early modern attitudes toward textual mimesis, as we will in a moment.

Whereas semiotic approaches still typically look to 'read' theatrical performance as an aggregate of signs, Shakespearience keeps an ear cocked for suggestions of polythetic experience encoded within the Shakespearean playtext. These are texts that ask to be heard more than read, produced in an era when the representational frontiers of writing and print technology were still very much uncharted.[11] We should not assume that early modern expectations and implementations of this technology were as determinate and convention-bound as our own have since become. Just as we sometimes call our age 'the digital age',

or 'the information age', Thomas Dekker could refer to his own as 'This Printing age of ours' in his dedication of *Lanthorne and Candle-light* (Dekker 1963: 177). Because the transition from oral culture to print culture was by no means complete during this period, early modern writers and their reading audiences seem to have had very different expectations from our own as to what a printed text could do and be. Nowhere are these different expectations about the potentialities of textual representation more readily apparent than in the various titles given to publications, wherein books are metaphorically endowed with properties we no longer so freely attribute to them. Contemporary books are frequently called 'schooles' (Gosson 1587), 'mirrours' (Munday 1579; Rankins 1587), 'looking glasses' (Lodge and Greene 1594), 'jewels' (Dawson 1596; Fioravanti *et al*. 1579; Gesner *et al*. 1576), and even a 'perfume against the noysome pestilence' (Fenton 1603). What is more, these are texts that *do* things; they are 'blaste[s] of retrait' (Munday and Salvian 1580), and 'divine ecchoes' (Swift 1612). We should recognize that titles such as these are not merely descriptive; they are also casual metonymic invocations of the sort of power the printed text was considered to possess as an increasingly accessible repository of knowledge and recorded experience. It is probable that most people's introduction to print technology in the period was with two such textual repositories: the Bible, and the almanac.

Contemporary evidence suggests that playtexts were similarly regarded, and that they were typically sold as documentary representations of prior theatrical performances. Michael Bristol has noted that playtexts of the period were commonly marketed by printers and booksellers as records of particular performances or productions. He remarks that 'the title pages, blurbs, and other promotional materials that accompany the early printed editions suggest how the appeal of texts is referred back to and thus depends on the spectacles of which they are not so much a literary source as a mechanically produced record' (Bristol 1996: 47). Title pages from numerous plays printed in the period, for example, advertise that the particular book on offer presents the play 'as it was performed at' such-and-such a theatre. That is, the playtexts were produced and marketed as monothetic transcriptions of anterior polythetic events. In this sense, they are the early modern equivalent of tape recordings.

While we have no substantial indication that Shakespeare participated in, let alone supervised, the textual publication of any of his plays, prefaces to the printed editions of other contemporary plays inform us how other playwrights viewed the medium of print as a substitute for encountering their work in the theatre. John Marston, for

instance, was very clear on this subject, voicing his disdain for print in his preface to the printed edition of *The Malcontent*:

> I would fain leave the paper; only one thing afflicts me, to think that scenes invented merely to be spoken should be enforcively published to be read, and that the least hurt I can receive is to do myself the wrong. ... but I shall entreat ... that the unhandsome shape which this trifle in reading presents be pardoned for the pleasure it once afforded you when it was presented with the soul of lively action.
>
> (Marston 1967: 5–6)

In the preface to *The Fawn* he makes a similar assertion, adding that the genre of comedy seems to suffer an especially unfortunate transition from the stage to the page: 'If any shall wonder why I print a comedy, whose life rests much in the actor's voice, let such know that it cannot avoid publishing Comedies are writ to be spoken, not read. Remember the life of these things consists in action ...' (Marston 1965: 3–5). Print is clearly not the medium through which Marston prefers his audience to receive his work. If they want the real thing they should venture to the theatre, where he intended his plays to be experienced. One can detect a subtle hint of trade protectionism in Marston's caveats as well, pointing indirectly to the fact that the printed play was a potential market competitor with the theatres, one from which playing companies were not legally entitled to benefit (Bristol 1996: 43–4).[12] By publishing their works, playwrights risked alienating the very customers to whom their plays were sold in the first place: the players.

Surviving letters from the players themselves indicate that they instinctively thought of the playtext not as something to be read, but as something to be heard. On 8 November 1599, Robert Shaw of the Admirals' Men composed a letter to Phillip Henslowe about a new play the company was in the process of acquiring. In the letter he writes, 'Mr Henshlowe, we haue heard their booke and lyke yt.' Samuel Rowley of the same company wrote to Henslowe on 4 April 1601 concerning a similar transaction: 'Mr. Hinchloe, I haue harde fyue shetes of a playe of the Conqueste of the Indes & I dow not doute but it wyll be a verye good playe ...' (quoted in Chambers 1923: vol. 3, 161). These are the words of prospective buyers listening to the text with the ears of their audiences, imagining how the words on the page will play in the polythetic environment of the theatre. Speaking of audiences, Andrew Gurr has noted that at this time there was no established term for referring to the group of people assembled to take in a play. 'The concept of huge and regular

urban gatherings of people was new enough,' he observes, 'to produce a sensitive and discriminating range of terms which only slowly narrowed down to the current usage' (Gurr 1984: 32). The two main terms that survive to this day – *audience* and *spectators* – refer to specific modes of perceptual experience, the auditory and the visual. Furthermore, each makes implicit assumptions with respect to that experience: *spectators* is of course a plural word, and connotes an assembly of separate individuals with different perspectives on an event, while an *audience* describes a single community sharing a common experience.

Through the centuries, editing practices have necessarily kept pace with our evolving relations to the printed word, causing us to lose touch in the process with the aural nature of early modern playtexts. Over time, the strong and increasing visual bias of our culture has influenced not only how we receive Shakespeare, but which Shakespeare we receive. Just as there are many layers of sound reproduction technology discernible in the Henry Irving recording of *Richard III*, there have been many layers of 'silent' emendations introduced to the texts of Shakespeare's plays by generations of editors.[13] Marshall McLuhan remarks, for example, on the significance of the changes Shakespeare's nineteenth-century editors made to the texts. He observes that these editors

> tidied up his text by providing him with grammatical punctuation. They thought to bring out, or hold down, his meaning by introducing a kind of punctuation that came into use more and more after printing. This was an ordering of commas and periods to set off clauses for the eye. But in Shakespeare's time, punctuation was mainly rhetorical and auditory rather than grammatical.
>
> (McLuhan 1960: 126)

Such editorial re-*visions* are of course still with us, and they have quietly grown to immense proportions over the centuries in our efforts to make Shakespeare not necessarily more audible, but more *readable*. Patrick Tucker, founder of London's Original Shakespeare Company, discovered after comparing a First Folio edition of *Antony and Cleopatra* with the Arden edition, that in the play's 3,014 lines the Arden editors had made 1,466 changes in punctuation – including the addition of 217 exclamation points, and the subtraction of one (Moston 1995: xiii). This is of course in addition to the numerous modernized spellings that are standard substitutions in most editions. My purpose is certainly not to argue that these later editions are not 'Shakespeare'. What these improvements do underscore, however, is the extent to which our culture's relation to the printed word has altered over the centuries, in

some ways becoming more sophisticated and precise, in other ways perhaps less flexible and expressive, less directly connected to, or implicated in, our embodied experience of language. While our printed Shakespeare needs to keep pace with changes in the way we relate to the printed word, I think it nonetheless important in the present context, where we are trying to hear the sounds that were embedded in these texts, to call attention to the fact that the works were written at a time when the playtext was quite a different animal from what it is today, and it was an animal with pronounced ears.

Sounding out deep subjectivity

When Shakespeare uses the word *sound*, it is almost always as a verb or an adjective, only rarely as a noun. As a verb, *to sound* means not only to produce sound, but also to measure the depth of something, to establish its boundaries, to define it spatially. The early modern practice of 'beating the bounds' at Rogation-tide is representative of the way sound was used to *sound*, to establish space and define the boundaries of rural communities in early modern England (Smith 1999: 31–2). Shakespeare is clearly intrigued by this resonance of the word, which his characters consistently invoke in their references to the depth and knowability, not of physical spaces, but of their own intentions, feelings, thoughts, and motivations, as well as those of others. The following exchange between Rosalind and Celia in *As You Like It* expresses Shakespeare's awareness of the close links between sound, space, and our affective life, that part of our subjective world which we often experience as profound, and beneath the surface:

Rosalind: O coz, coz, coz, my pretty little coz, that thou
 didst know how many fathom deep I am in love! But it
 cannot be sounded; my affection hath an unknown
 bottom, like the bay of Portugal.
Celia: Or rather, bottomless – that as fast as you pour
 affection in, it runs out.

 (4.3.205–10)

Rosalind professes that she is 'deep' in love, a phrase she uses to describe her emotional capacity. Her love is of such a depth that it 'cannot be sounded', since it has no discernible bottom or limit. At the same time she also suggests a recognition, one expressed throughout Shakespeare's works, that we naturally access this register of deeply subjective experience primarily through sound, through the practice of

sounding out ourselves and others. Rosalind's love also 'cannot be sounded' because she has adopted the persona of Ganymede while in Arden, through which she is unable to express her true identity to Orlando. Prompted by Rosalind's metaphor, I wish to employ the term 'deep subjectivity' to denote this unarticulated, or prearticulated self, a particular mode of subjectivity which begins to effloresce into language and other forms of representation at the dawn of the modern era, and which has recently been artfully theorized as 'inwardness' and 'interiority' by critics such as Katharine Eisaman Maus and Michael Schoenfeldt (Maus 1995; Schoenfeldt 1999). Schoenfeldt in particular reiterates Rosalind's association of this inwardness with the idea of depth. Variations of the term occur three times in as many sentences in the opening paragraphs of his book: artistic works of the Renaissance, which frequently 'demand a deep attention to the body', are meaningful to us because this corporeal attention encourages 'a kind of psychological inwardness that we value deeply' in a Classical and Judeo-Christian tradition which cultivates 'this deeply physical sense of self' (Schoenfeldt 1999: 1–2). How might we attempt to fathom, how understand, this deeply subjective, prearticulated self? More often than not, as Shakespeare asserts in the voices of Rosalind and many of his other characters, we have to sound it out, coax it into language.

Rosalind's suggestion that the register of deep subjectivity is most readily described in terms of sound and sounding finds an echo near the end of *The Rape of Lucrece*, wherein Brutus refers to himself as an 'unsounded self' (line 1819). Hitherto strategically hidden beneath a veil of folly and political inconsequence, the 'unsounded' Brutus materializes at this crucial moment in the narrative, entering into the soundscape of public discourse in order to provide direction to Collatine and Lucrece's father, each of whom is so consumed with grief that neither can begin to shoulder the necessary burden of avenging her. Until this moment, Brutus's public persona has been similar to that of Hamlet, based on a calculated 'show' of folly which Brutus himself describes, yet again in terms of relative depth, as a 'shallow habit' (1814). Like Hamlet, Brutus also retains 'that within which passes show', a deeper subjectivity possessed of experiences, knowledge, and motivations which must be carefully shielded from the jealous supervision of those in power (Ham. 1.2.85).[14] Katharine Eisaman Maus suggests that, for Hamlet, this interior self 'surpasses the visible – its validity is unimpeachable. The exterior, by contrast, is partial, misleading, falsifiable, unsubstantial' (Maus 1995: 4). In the language Brutus and Hamlet use to describe their circumstances, in its implication that visual modes of understanding others are deficient and liable to

error, we can hear hints of the early modern subject's developing resistance to what Martin Jay has called, after Christian Metz, the 'scopic regimes of modernity' (Jay 1988).

Brutus's talk of depth and knowability engages with earlier, related utterances in the poem which touch on language's limited ability to communicate deeply subjective forms of polythetic experience. After venting her sweeping curse of Tarquin, Lucrece bitterly concludes that her words are wasted and worthless: 'Out, idle words, servants to shallow fools, / Unprofitable sounds, weak arbitrators!' (1016–17). As a means of expressing the depth and complexity of her reaction to the rape, words are little more than 'unprofitable sounds', better fit for the service of 'shallow fools' such as Brutus is considered to be, such as she makes of herself when she too relies too heavily upon their weak arbitration. She makes a similar assessment of written language later in the poem, during a remarkable excursus into the rational processes which inform the letter she writes to her husband Collatine. She decides to request his return home so that she may break the news to him in person, since their copresence will allow her to convey more completely the enormity of what has happened to her:

> To see sad sights moves more than hear them told,
> For then the eye interprets the ear
> The heavy motion that it doth behold,
> When every part a part of woe doth bear.
> 'Tis but a part of sorrow that we hear;
> Deep sounds make lesser noise than shallow fords,
> And sorrow ebbs, being blown with wind of words.
>
> (1324–30)

The sounds referred to in this passage are of course the words Collatine will hear in the letter Lucrece writes. The messenger charged with delivering the letter will doubtless be expected to read the contents aloud to him. As in our discussion of the contemporary playtext, we find written language casually referred to here as something intended primarily to be heard, not construed in silence on the page. Written language, even that spoken into sound through an intermediary voice, is still a weak arbitrator, however, when set over and against the fullness of a polythetic, multisensory presence, in which 'every part a part of woe doth bear'. Words can communicate only a portion of the grief Lucrece feels, since ''tis but a part of sorrow that we hear'. In her reasoning we also detect the early modern association of the ear with the faculty of understanding, for 'the eye interprets [for] the ear' the

'part of woe' that the eye experiences. That is, the ear is here imagined as the perceptual avenue through which we most deeply comprehend the experience of others. The perceptions of the other senses are funneled through it, mediated by it. A related comparison of sound and sight is made earlier in the poem, when Lucrece desperately attempts to dissuade Tarquin from raping her: 'But will is deaf, and hears no heedful friends / Only he hath an eye to gaze on beauty' (495–6). Sight is here related to objectification and the projection of the will, sound to the capacity for a sympathy which forms the basis of intersubjective understanding. Sound's direct influence on the affect is double-edged, however; to Tarquin's 'thievish ears' earlier in the poem, this powerful sympathy also foments the mimetic desire which sparks his initial interest in Lucrece, 'for by our ears our hearts oft tainted be' (35; 38).[15]

Shakespeare's characters frequently ask for others to be 'sounded' with respect to their feelings, opinions, affiliations, and 'deeply' held convictions. In their efforts to explore the interiority of those around them, they almost always figure sound as the most reliable way of penetrating through the opacity of the other.[16] I find it noteworthy that in so many early modern plays this type of intelligence gathering is represented as an acoustic enterprise, since in our own time we have come to conceptualize this activity in visual terms, as 'surveillance'. Richard of Gloucester's ascent to the throne is accompanied by many such soundings. His confederate Buckingham is particularly adept at auscultating the body politic, and is shown on more than one occasion conducting targeted, impromptu opinion polls (for which the French word is *sondage*). The council scene in the play's third act, and the stratagems that lead up to it, provide numerous examples of this practice. Immediately after the princes have been sent off to the Tower, Buckingham proceeds to sound Catesby for information about the political climate, posing a series of questions concerning the extent to which Hastings and Stanley are disposed to accept the coronation of Richard in lieu of the princes. When Catesby obliges these delicate questions with answers, Buckingham then presses him to obtain a more concrete reaction from Hastings concerning the prospect of Richard on the throne: 'sound thou Lord Hastings / How he doth stand affected to our purpose' (3.1.160–71). Three scenes later, in an effort to ascertain what people know during the council scene, Buckingham sounds out the entire room with a question: 'Who is most inward with the noble Duke?' The question is directed primarily toward Hastings, who responds that, with respect to the date and planning of the coronation, 'I have not sounded him [Richard], nor he deliver'd / His gracious pleasure any way therein' (3.4.8, 16–17). A few lines later Richard returns,

informing Buckingham in private conference that 'Catesby hath sounded Hastings in our business' (36). Once the two have withdrawn again for further conference, Shakespeare exploits the opportunity to comment upon the differing strengths of auditory and visual means of knowing the other. Hastings looks encouragingly around the table, then, in a classic example of dramatic irony, delivers the scene's punch line: 'For by his face straight shall you know his heart' (53). The entire episode is mainly composed of a series of attempts to sound out the interior thoughts and intentions, the deep subjectivity, of others.

After Richard has assumed the throne, Buckingham reaches the limit of his moral tether with the proposed murder of the princes. He attempts to extricate himself and square accounts, launching the diffi- cult conversation with reference to the fact that the sounder has now become the sounded: 'My lord, I have consider'd in my mind / The late request you did sound me in' (4.2.84–5). But his request for the earldom promised him falls on deaf ears. Richard merely counters with irritation, animadverting that Buckingham only makes bootless noises, that 'like a Jack thou keep'st the stroke / Betwixt thy begging and my meditation' (114–15). Richard much prefers to hear that which he wishes to hear, as when just previous to Buckingham's entrance he tells Tyrell, who offers to murder the princes for him, that in so doing he 'sing'st sweet music' (78).

Richard, as we have already noted, is especially attuned to the soundscape. In his first speech he describes England in terms of mili- tary noises that have since turned to merriment, dance music, and the private serenadings of lutes. In spite of these changes, he characterizes his own acoustic experience in largely hostile terms. While others enjoy the pleasant sounds that now surround them, he must still endure the violent, threatening sounds of the dogs that bark at him as he halts by. Richard's sensitivity to sound, his awareness of its affective power, is made conspicuously evident throughout the play, and he uses this power throughout as a tool to manipulate others. He prefers to control the soundscape, to harness the acoustic disturbances created by others, incorporate them into his own designs, produce and manage the sound waves that control and define the space around him. Storming in on the queen mother and her two sons, he complains that the king has been unduly influenced: 'By holy Paul, they love his Grace but lightly / That fill his ears with such dissentious rumors' (1.3.45–6). The loud accusa- tion not only creates an unsettling acoustic disturbance in the hitherto subdued scene, it also suggestively proclaims Richard's mindfulness of others' vulnerability to acoustic impressions. This awareness is also evident when he advises Clarence's murderers to remain 'obdurate, do

not hear him plead', for he 'may move your hearts to pity if you mark him' (1.3.346–8). Despite this warning, the Second Murderer does open his ears to his victim, only to find that 'the urging of that word "judgment" hath bred a kind of remorse in me' (1.4.107–8). Richard's acoustic manipulation of others also extends into the realm of imaginary sound events, such as when he explains the execution of Hastings to the Lord Mayor. 'I would have had you heard / The traitor speak,' he tells him, 'and timorously confess / The manner and the purpose of his treasons' (3.5.56–8).

While we have noted how attentive Richard is to sound and its effects on those around him, we should not forget that his account of the soundscape of his country remains only a partial one. Anne, for example, hears something very different in the soundscape, for Richard's repeated violence to her family has filled it with 'cursing cries and deep exclaims' (1.2.52). The agonized cries and wailings of those Richard has harmed resound throughout the play. Taken together, these sounds form his most salient contribution to the soundscape of England, though his own ability to hear them is only activated once his conscience is awakened, and then he immediately finds himself surrounded by his own sins, which accuse him: 'All several sins, all us'd in each degree, / Throng to the bar, crying all, "Guilty! guilty!"' (5.3.198–9). This capacity to imagine hearing something, and to imagine that one is heard, that one can be judged as a result of being heard (as in a judicial 'hearing'), becomes a kind of moral anchor in a play without many others.

To imagine that one is heard. 'Can curses pierce the clouds and enter heaven?' asks Margaret (1.3.194). She answers her own question several minutes later, as Buckingham tries unsuccessfully to stifle her curses. 'I will not think,' she shoots back, 'but they ascend the sky, / And there awake God's gentle-sleeping peace' (1.3.286–7). They certainly have a visceral effect on Richard and Buckingham, who, once she has departed, confess that their hair stands on end to hear them (1.3.303–4). Links between sound, hearing, and the supernatural are reiterated throughout the play, from Margaret's question about the ultimate destination of her curses, to Richard explaining to Clarence that the king apparently 'hearkens after prophecies and dreams', to Anne asking that the funeral procession of her father-in-law be suspended momentarily so that his ghost might hear her lamentations, to Clarence imagining the soundscape of hell, the 'very noise' of which awakes him from his dream – and we are still only in the first act. Late in the play, we find Shakespeare weaving these acoustic motifs together, combining this association of sound and the supernatural with Richard's continuing reliance on it as a tool for the manipulation

of others, as he desperately tries to stave off the inevitable reckoning that awaits him. In the fourth act, as Elizabeth and Margaret commiserate in their grief, vying over who has been more wronged by him, Richard enters: speak of the devil. They demand of him an accounting for their losses, and he responds by drowning them out with the noise of the instruments in his royal train: 'A flourish, trumpets! strike alarum, drums! / Let not the heavens hear these tell-tale women / Rail on the Lord's anointed. Strike, I say!' (4.4.149–51). As king, Richard will attempt to reign with absolute control over the soundscape up until his death, up until his famous final words, shouted out at the top of his lungs, sounding out the battlefield for a horse, sounding out the deeply subjective contradiction at the heart of his story, which through the sheer, monstrous power of his will he can almost prevent from ending.

As it is in the England of Richard of Gloucester, sound is considered crucial in Denmark's world of intrigue, especially by those who would try to diagnose the cause of Hamlet's recent, apparently unsound, behaviour. Guildenstern and Rosencrantz report back to Polonius and Claudius after finding the prince not 'forward to be sounded' (3.1.7). In the next scene, Hamlet confides to Horatio that he counts blessed those who 'are not a pipe for Fortune's finger / To sound what stop she pleases' (3.2.70–1). Later in the same scene he accuses Rosencrantz and Guildenstern of spying on him, employing the same metaphor:

> You would play upon me, you would seem to know my stops, you would pluck out the heart of my mystery, you would sound me from the lowest note to the top of my compass; and there is much music, excellent voice, in this little organ, yet cannot you make it speak. 'Sblood, do you think I am easier to be play'd on than a pipe?
> (3.2.364–70)

Hamlet not only resists their attempt to 'play' him, to sound out his deepest sense of self, he mocks the attempt by taunting them, as well as generations of audiences and readers, with sly references to the 'heart' of his mystery, to the fact that 'there is much music, excellent voice, in this little organ' which they will never hear. Reading primarily in terms of early modern specularity leads Francis Barker to interpret this moment as an expression of Hamlet's empty interiority. Barker asserts that for Hamlet, there is no deep subjectivity. Whether he knows it or not, he 'is truly this hollow reed which will "discourse most eloquent music" but is none the less vacuous for that. At the centre of Hamlet, in the interior of his mystery, there is, in short, nothing' (Barker 1984: 37). I think it worth emphasizing, however, that while Hamlet refers to

himself here as a potential instrument (and not just a pipe either, since they are not 'plucked' as are stringed instruments), it is clearly in the context of refusing to become one, in the way that his two friends apparently have in the hands of Claudius.

While sounding is mentioned routinely in Shakespeare's plays as a way of obtaining reliable information about the deeper convictions and motives of others, his characters also commonly refer to the practice in more benign circumstances, as a way of establishing and maintaining emotional proximity with each other. Something similar occurs today when we hear people speak of being 'on the same wavelength' with someone else. Like many the father of a teenager, Montague feels he lacks emotional access to his son, Romeo, who is 'to himself so secret and so close, / So far from sounding and discovery' (1.1.149–50). If an absence of sound characterizes Montague's lack of access to his son, Juliet's intimacy with him is typified by its presence, and in her immediate recognition of his voice: 'My ears have yet not drunk a hundred words / Of thy tongue's uttering, yet I know the sound' (2.2.58–9). In *Love's Labor's Lost*, Berowne maintains that 'A lover's ear will hear the lowest sound' (4.3.332). When Hal bursts into the Boar's Head Tavern, proclaiming to Poins, 'I have sounded the very base-string of humility', he means that he has achieved a kind of sympathy with the tapsters, the lowest rung on the social ladder at the tavern (2.4.5–6). In *As You Like It*, Orlando bursts into the banished Duke's encampment ready to steal food from them, and is quickly taken aback by their generosity. The fact that they speak so 'gently' positions them for Orlando at a different, somehow more comfortable, social register (2.7.106). In *Lear*, the blinded Gloucester is represented as quickly having developed a keener sense of hearing, with which he correctly suspects Edgar of some kind of fraud as they make their way to the 'cliff': 'Methinks thy voice is alter'd, and thou speak'st / In better phrase and matter than thou did'st' (4.6.7–8).[17] Edgar has temporarily fallen out of character, forgetting that his visual disguise as Tom O'Bedlam is of no use in the present situation. The relation between hearing and emotional proximity is even more pronounced at the beginning of that play, where Lear's main desire, which drives the ensuing events, is to hear how much he is loved. Kent tries to get Lear to listen to reason about Cordelia, to educate his sense of hearing: 'Thy youngest daughter does not love thee least, / Nor are those empty-hearted whose low sounds / Reverb no hollowness' (1.1.152–4). Cordelia, like Brutus and Hamlet before her, is an unsounded self.

Although I have focused here on Shakespeare's use of *sound* as a verb, the word is of course also an adjective, denoting good health and general fitness. Orlando protests to Rosalind that his love is 'sound,

sans crack or flaw' (5.2.415). *Measure for Measure*, too, provides several clear examples of sound as an index to one's internal state. The First Gentleman and Lucio trade senses of the word, the former complaining that 'Thou art always figuring diseases in me; but thou art full of error, I am sound' – to which Lucio replies, 'Nay, not (as one would say) healthy; but so sound as things that are hollow. Thy bones are hollow; impiety has made a feast of thee' (1.2.53–7). In a later scene, the Duke uses the word to describe Juliet's spiritual state: 'I'll teach you how you shall arraign your conscience, / And try your penitence, if it be sound, / Or hollowly put on' (2.3.21–3). In *Much Ado About Nothing*, Don Pedro describes Benedick's candour as the true index of his inner self, of his deeper subjectivity: 'He hath a heart as sound as a bell, and his tongue is the clapper, for what his heart thinks, his tongue speaks' (3.2.12–14). As all of these examples suggest, Shakespeare seldom misses an opportunity to quibble with *sound*'s polysemy.

In early modern culture, sound is considered a privileged mode of access to the deeply subjective thoughts, emotions, and intentions of others. We find this association between sound and the deeply subjective self articulated throughout Shakespeare's works. In them, the practice of 'sounding out' others is frequently represented not only as an important method of surveillance, but also as a way of representing characters' emotional proximity to each other. Thus far in our exploration of the Shakespearean soundscape, we have dealt with sound and its close relation to private experience, to the interior life. In the next chapter, we will listen more extensively to some of the many discourses concerning sound and hearing in the early modern era, and begin to explore sound not only as a form of communal experience, but as a function of that experience, paying closer attention to what Shakespeare calls 'the public ear'.

2
The public ear

Do you hear, masters? Do you hear?
Antony and Cleopatra (4.3.20)

Hearing is the organ of vnderstanding; by it we
conceiue
Richard Brathwaite

As noted in the preceding chapter, the soundscape is not entirely an objective phenomenon, but rather the intersection between the sounds we hear and how we react to and derive meaning from them. This includes whether we listen to certain sounds at all, or allow them to inform us. One of the guiding assumptions behind this book is that, in addition to the individual dispositions that affect what we hear, or how much we hear, there are cultural dispositions that influence our listening practices as well. The acoustic environment is always experienced within specific cultural contexts. Our ears are tuned by culture. In the present chapter, I would like to identify some of the cultural dispositions that are related to sound and hearing in the early modern period, to explore some of the ways in which early modern ears were tuned to the world around them. In order to do this, we will have to listen carefully ourselves, to what various contemporary writers have to say on the subject, to the ways in which they describe, and in some cases seek to regulate, acoustic experience. Before we listen to those discourses, however, we can begin to gauge Shakespeare's own awareness of the cultural dimensions of sound by unpacking a phrase, 'the public ear', which he first sets in the mouth of the Provost in *Measure for Measure* (4.2.99), and which is later echoed by Antony in *Antony and Cleopatra* (3.4.5).

The public ear in *Antony and Cleopatra*

A telling indication that we live in a predominantly visual culture is the way we casually refer to famous people such as actors, politicians and sports figures as being in 'the public eye'. We never speak of these people as being in 'the public ear', though they actually are in the public ear whenever we do speak of them. While Shakespeare uses both phrases in the third act of *Antony and Cleopatra*, at present I wish to dwell briefly on the latter, for us less familiar, expression. Scene four begins with Antony ranting to his new wife Octavia about the recent actions of her brother, his rival, Octavius Caesar:

> Nay, nay, Octavia, not only that –
> That were excusable, that, and thousands more
> Of semblable import – but he hath wag'd
> New wars 'gainst Pompey; made his will, and read it
> To public ear;
> Spoke scantly of me; when perforce he could not
> But pay me terms of honor, cold and sickly
> He vented them, most narrow measure lent me ...
>
> (3.4.1–8)

What appears to vex Antony most acutely is the news that Caesar has staged a public reading of his will in Rome.[1] Antony knowingly interprets this reading of his will 'to public ear', accompanied by Caesar's 'most narrow' allusions to his honour, as a form of accusation, intended to expose him as anti-Roman, to further arouse the people's mistrust of his interests in Egypt. His intense anger at this gesture, partially triggered by his growing sensitivity about his reputation, suggests just how important and influential the public ear is in this play. As the residence of reputation, the primary sensory and political organ through which public opinion is received and shaped, the public ear is of immense significance to almost every character of the play. Although mentioned explicitly only once, it emerges as one of the play's central characters.

The public ear makes its entrance in the play's very opening moments, where Antony is first introduced, not as a personated character on stage, but as the subject of discussion and rumour. We overhear Philo acquaint Demetrius with the transformation he has noted in him, from 'triple pillar of the world' to 'strumpet's fool' (1.1.12–13). After Antony and Cleopatra appear and leave, Demetrius informs us that Antony's recent behaviour has been in the public ear previous to this; he also voices his regret that what he has just witnessed 'approves the common

liar, who / Thus speaks of him at Rome' (1.1.60–1). A few scenes later, the talk of Antony in Rome is revisited when we learn that news of his transformation has reached Caesar's ear as well. Like Philo, Caesar can compare these late reports of Antony's indulgence with a time when he was noted for his ability to withstand severe privation during military campaigns, in stories that record him drinking horse urine, eating tree bark, and scavenging in the alps, there even resorting to 'strange flesh / Which some did die to look on' (1.4.61–8). Antony shows himself to be keenly aware of his presence in the public ear at various moments in the play, such as when he asks of his new wife Octavia, 'Read not my blemishes in the world's report', or when, after the disastrous sea-battle with Caesar, he laments to Cleopatra, 'I have offended reputation, / A most unnoble swerving' (2.3.5; 3.11.49–50). After winning the day against Caesar in Alexandria, he commands his trumpeters to sound out his victory to 'the city's ear', a phrase that echoes his earlier reference to the public ear, and hints at his desire to compensate for his reputation's ill-treatment in Rome (4.8.36).

Attending to the public ear in *Antony and Cleopatra* makes audible one of the play's larger concerns: the extent to which individual identities become entangled in, and even partly a function of, the social discourses of others. An example of this occurs in the brief episode featuring Ventidius, one of many shorter scenes frequently cut from productions of the play (Madelaine 1998: 213). Here, even though Antony is unaware of Ventidius's successes in Parthia, his reputation is affected when Ventidius elects to stop fighting, and then strategically confers the greater honour of his victory upon his superior. 'Better to leave undone,' he confides to Silius, 'than by our deed / Acquire too high a fame when him we serve's away' (3.1.14–15). To find himself drawn into the vortex of the public ear, like Antony, would mean becoming a potential rival to him. Instead, he plans to 'humbly signify what in his name, / That magical word of war, we have effected' (3.1.30–1). Ventidius comprehends the potential danger of being in the public ear, which sways with prevailing opinion and report. It belongs to the 'common body' which, as Caesar earlier complains to Lepidus, 'Like to a vagabond flag upon the stream, / Goes to and back, lackeying the varying tide, / To rot itself with motion' (1.4.44–7). The tidal vicissitudes of the public ear are neatly illustrated in the juxtaposition between the scene with Ventidius and the one immediately following, which begins with a very different example of the workings of social discourse and report, where Agrippa and Enobarbus air out their disparaging opinions of Lepidus by mocking the way he fawns over the two other triumvirs. Much of the play is given over to this kind of discourse, as Janet Adelman has noted. This 'insistence upon

report and discussion,' she writes, 'makes us suspect that the actions are unimportant except insofar as they are interpreted; in fact, the dramatic design of *Antony and Cleopatra* forces us to acknowledge the process of judgment at every turn' (Adelman 1973: 30–31). The public ear in this play is the court in which different versions of reputation, different perspectives on experience, are sounded out and adjudicated. The entire play takes place in the public ear, is set in the public ear, and this is where we the audience give it its true hearing.

I would now like to shift the frame of this discussion slightly, in order to pay closer attention to the way the phrase 'public ear' also describes the ear itself as a 'public' sense organ. This valence of the phrase calls greater attention to the way that hearing, as a perceptual domain, is constituted, developed, and performed in culture. With this inflection in mind, the public ear's most striking appearance in *Antony and Cleopatra* occurs in a scene rarely performed in the theatre since Shakespeare's day. It is quite brief, and contains none of the major characters. However, the scene does interesting tonal work that is more difficult for us to hear today, and this is why I find it worth attending to more closely. Toward the end of the play at act four, scene three, several soldiers are on sentinel duty. As one bids another good night, they attempt to exchange whatever information they can about the next day's battle. 'Heard you nothing strange about the streets?' asks the Second Soldier, to which the first replies that he has heard nothing. The Second Soldier then adds, 'Belike 'tis but a rumor.' The moment passes as our attention is directed to other soldiers arriving. They take up positions at the corners of the stage and begin to talk, assessing their chances for the next day. Interrupting them, a strange sound begins to emanate from under the stage:

	Music of the hoboys is under the stage.
2 Sold:	Peace, what noise?
1 Sold:	List, list!
2 Sold:	Hark!
1 Sold:	Music i' th' air.
3 Sold:	'Under the earth.
4 Sold:	It signs well, does it not?
3 Sold:	No.
1 Sold:	Peace, say I.
	What should this mean?
2 Sold:	'Tis the god Hercules, whom Antony lov'd,
	Now leaves him.
1 Sold:	Walk; let's see if other watchmen
	Do hear what we do.

2 Sold:		How now, masters?
Omnes:	*(speak together.)*	How now?
	How now? Do you hear this?	
1 Sold:		Ay, is't not strange?
3 Sold:	Do you hear, masters? Do you hear?	
1 Sold:	Follow the noise so far as we have quarter;	
	Let's see how it will give off.	

(4.3.12–22)

To date, John Shaw has offered the only detailed critical commentary on this moment, which he considers 'one of the most unusual scenes in Shakespeare' (Shaw 1974: 227). Shaw focuses on the way the visual elements of the scene contribute to the dramatic effect it creates, specifically in the placement of the soldiers at the corners of the stage, where he recognizes the expansive, cosmological representational conventions of the medieval stage. He also observes that this staging draws on other visual antecedents in iconographic traditions associated with the book of Revelation. Whereas Shaw's reading of the scene has a clear visual emphasis, I would argue that the acoustic elements of the scene are more immediate, more crucial to its dramatic effect, and therefore worth further attention in and of themselves.

Music of the hoboys is under the stage. Here, as elsewhere, Shakespeare seems to prefer the French-derived 'hoboy' (hautboy) to the instrument's more common contemporary name, the 'shawm'. A medieval double-reed instrument that evolved into the oboe we recognize today, the shawm was produced in a greater variety of registers than its modern successor, and included soprano, alto, and bass varieties. The shawm's timbre, its acoustic signature, is sharper, more open and reedy than the mellow and round tones of the oboe. In the lower registers played by the bass version, shawms make a noticeable buzzing, which shifts into a honking sound as they climb more squarely into the alto range. Compared to the smooth, meditative tone of today's oboe, they can sound as if someone has decided to try to make music with a duck-call. The bass register in particular gives off a distorted sound that would have allowed medieval waits to perform a surprisingly faithful, if absurdly proleptic, rendition of the Rolling Stones' '(I Can't Get No) Satisfaction'. Such modern assessments do not appear to be wholly off-base either; in 1602, Michael Praetorius supposed that the Latin name for the treble shawm, *gingrina*, referred to the fact that it sounded like a goose (Sadie and Tyrrell 2001: 'shawm'). In *Othello* we encounter a similar passing reference to the distinctive sound of the shawm, when the musicians that Cassio hires to play for his general are interrupted

by a clown who needles them with, 'Why, masters, have your instruments been in Naples, that they speak i' th' nose thus?' (3.1.3–4). Notwithstanding its timbral coarseness, one of the more important strengths of the shawm was its volume, which made it a popular open-air instrument, capable of holding its own next to trumpets and contemporary drums such as the tabor and nakers.

The sound of shawms would have had many associations for Shakespeare's early modern audience, but none more so than the fact that shawms were the primary instrument of town waits throughout the country.[2] The contemporary identification of the instrument with these musicians was such that, in addition to being called shawms and hautboys, they were also known as 'wait-pipes'. The civic institution of waits originated during the reign of Edward IV, when minstrels were hired to keep the watch and sound the hours throughout the night. Over time, the position eventually developed a more exclusive emphasis on musical performance. By Shakespeare's day, however, waits were still expected in many towns to sound curfew along a specified route, and to play the people awake in the early morning. Their other official duties as municipal employees typically involved providing music for various civic ceremonies, welcoming visiting dignitaries, and, in London at least, playing outdoor concerts on certain days of the week. All of this suggests that the sound of the shawm was an important part of the early modern urban soundscape. 'Of all the musical sounds that from day to day smote the ears of a sixteenth-century town resident,' proposes Anthony Baines, 'the deafening skirl of the shawm band in palace courtyard or market square must have been the most familiar' (Baines 1957: 268). John Coldewey similarly notes that the waits were 'an integral part of a thousand moments of pomp and benediction in the daily, weekly, and seasonal life of the town' (Coldewey 1982: 42). Inevitably, some of these moments found their way into contemporary literature. The waits of London, for example, make a brief appearance in the festive finale to Thomas Deloney's *The Gentle Craft*, where they have been called upon 'to beguile the time, and to put off all discontent' at the inaugural shoemakers' holiday (Deloney 1912: 132–3).

In addition to these official duties, waits typically supplemented their scant incomes by touring to other towns. Like the travelling theatrical troupes of the period, they would be careful to wear their official livery while on the road so as not to subject themselves to arrest and punishment as 'masterless' men. They were also frequently hired to provide music for private parties, weddings, and funerals back at home, where they typically enjoyed monopoly rights for these types of engagements: Robert Armin depicts the waits of London playing at a wedding in the

first scene of his *Two Maids of More-Clacke* (Armin 1609). Waits could also earn extra money working at the theatres, where the money was apparently good enough that they might risk the displeasure of their employers. In 1613, the London city aldermen complained that their waits were unavailable to play for them because they were 'then employed at play houses' (quoted in Woodfill 1953: 30). Their availability to perform at the play houses is also suggested in the induction to Francis Beaumont's *The Knight of the Burning Pestle*, in which a Citizen gives the Prologue two shillings for the waits of Southwark to be brought across the river to Blackfriars, where they will provide 'stately music' for his apprentice's impromptu personation of the play's hero (Beaumont 1969: Ind. 96–106). The moment provides a sense of the easy familiarity that people had with the waits, and perhaps even satirizes those particular Southwark musicians in a topical way that we have yet to understand.

Shakespeare specifically calls for the sound of hautboys in a number of plays. Early in the 1590s, they announce the beginning of *2 Henry 6*, accompanying the entrance of the king and queen from opposite sides of the stage. Here Shakespeare employs the sound in a way that undoubtedly would have been familiar to his audience. Shawms were customarily played by the waits to announce the presence of important and powerful civic and national authorities, and to focus public attention on them. During these presentations, they would have provided a kind of acoustic halo for the exalted. Civic dignitaries, and often even the queen herself, were introduced in public to the music of town waits. In this context, hautboys were popularly associated in the audience's everyday, extra-theatrical experience with the kind of awe typically reserved for important persons and dignitaries.[3]

Not content to rest with his audience's most obvious associations, however, early in his career Shakespeare already begins to imagine more complex mimetic possibilities and dramatic uses for the sound of shawms. He begins to bring his audience's everyday associations with the instrument into interplay with its dramatic expectations in ways that become increasingly metatheatrical, and mimetically complex. For example, early on he discovers in their sound a useful acoustic tool for setting a tone of uneasiness, such as that established in the Folio edition of *Titus Andronicus*, where hautboys are called for as Titus, dressed as a cook, enters to feed Tamora's two sons to her in a pie. In this scene, a trumpet flourish has just heralded the arrival of Saturninus, Tamora, and the various tribunes and senators who accompany them. The sound of the hautboys as Titus enters grotesquely heightens the festive atmosphere. Their music provides a charged counterpoint to the

enormity the audience senses is about to take place, the harmony of their consort contrasting with the radical breakdown of social order depicted in the scene.

Shakespeare next calls for shawms in the Folio text of *Hamlet*, where they are used, as in *2 Henry 6*, to accompany the entrance of a king and queen. However, this time it is not the play's actual king and queen that they introduce, Claudius and Gertrude, but the player king and queen in the dumbshow at act three, scene two. We can assume that a specific effect was intended, given that shawms are never used for the same purpose in the play proper: trumpet flourishes are the norm elsewhere in Elsinore. The sound of shawms preceding the dumb show must have been intended to lend a heightened sense of verisimilitude to the play-within, in much the same way that some of the play's other, more famous, metatheatrical moments, such as Hamlet's advice to the players, do in the play proper.

A few years beyond *Hamlet*, Shakespeare revisits the hautboy, continuing to exploit the sound's dramatic possibilities. His work at this time provides the basis for Maurice Charney's claim that 'there is a general Renaissance association of oboes with the supernatural and the portentous, as in *Antony and Cleopatra* (4.3) and *Macbeth* (4.1)' (Charney 1969: 183). Bearing in mind that these two plays are commonly believed to have been written within a year of each other, the sound may well have been a particular device that Shakespeare was experimenting with, or had access to, for a limited period of time. Clarence O. Johnson, who has briefly traced the history of the hautboy in the drama of the period, finds the instrument first used as an indicator of ill omen in the fourth act of *Gorboduc* (1562), a play whose 'influence on the development of English drama, and its popularity, especially at court, would have made the convention established by its dumb shows and their music a model to be emulated' (Johnson 1979: 34). While Charney and Johnson merely call attention to the association between hautboys and the ominous, I'd actually like to venture an explanation for it, one that draws upon the instrument's customary use and social role. Owing to the particular duties of the waits, shawms traditionally would have been heard in the dead of night and in the early morning hours. The sound, coming from outside on the street while one was inside, and often in bed, would have consistently, over generations, accompanied people's transitions from sleep to waking, from unconsciousness to consciousness. The shawm would have been one of the signature sounds of this liminal state of consciousness, and therefore enormously effective at evoking that atmosphere in the theatre. In *Macbeth*, we first hear the shawms as Duncan arrives at Macbeth's castle, at act one,

scene six. They are accompanied by torches as well, indicating we are to understand that the king's arrival occurs at night. Here, as in *Titus Andronicus*, the ceremony of the event is accompanied by the audience's prior knowledge of malevolent deeds in the works, in this case, that the Macbeths have been plotting against the king's life, and actually plan to murder him during the present visit. This knowledge plays sinister counterpoint to a sound the audience would have naturally associated with nocturnal vigilance and community safety. Later in the play, at act four, scene one, hautboys are again used, to announce the passing of the eight spectral Scottish kings during Macbeth's second encounter with the weird sisters, a moment that fuses the ceremonial and supernatural associations of the sound.

With these associations in mind, we can now return to *Antony and Cleopatra*: 'Heard you nothing strange about the streets?'. The scene begins with the suggestion that a strange rumour has been circulating in the public ear. As the sound of the hautboys starts to emanate from underneath the stage, the soldiers on guard attempt to make sense of what this 'noise' means. One suggests that it might bode well: 'It signs well, does it not?' Another disagrees. Yet another asks, again, 'What should this mean?'. Though they identify it as music, their reactions suggest that the sound is foreign to them. It is both in the air, and under the ground. The Second Soldier, the one who had inquired earlier about the rumour on the streets, is first to arrive at the definitive interpretation of what this must indicate: ''Tis the god Hercules, whom Antony lov'd, / Now leaves him.' For the sound he now hears is like the rumour he has heard; both are 'strange'. The music is twice described as 'strange' in this short scene, once by the First Soldier, and then by all on stage as the scene's final, echoing word. The strange sound confirms the strange rumour which portends a shift in Antony's relation to the god who has watched over him, who now, on the eve of battle, chooses to desert him.

How is the sound of the hautboys made strange in the theatre? An important thing to note about the scene is that, for the first time, Shakespeare specifically calls for the hautboys to be positioned 'under the stage'. This staging would have muffled the sound, attenuated its volume, softened its harder edges and distanced it, thereby giving it a more ethereal quality. The intended theatrical effect would, of course, be to approximate music heard from the underworld. The actual sound itself, however, of shawms coming from another place, would also have been very close to what people could have heard from sleeping quarters in towns all over the country, when the noise of waits playing outside awakened them from sleep in the early morning hours.

I wanted to call attention to this scene from *Antony and Cleopatra*

because it so deftly fuses the two senses of the 'public ear' that operate in the play. In addition to its representation of the public ear in the play itself, we also notice Shakespeare engaging the public ear of his contemporary audience, showing his interest in the expressive potentialities of the various extralinguistic sounds present in the soundscape around him. As the soldiers make clear in the scene itself, the sound of the shawms underneath the stage has an ascertainable semantic meaning: Hercules has left Antony. However, just as importantly, the sound contributes tonally to the scene, invoking a dramatic sense of the uncanny by activating the early modern audience's extratheatrical experiences with the music of shawms, both ceremonial and nocturnal. In today's performances of *Antony and Cleopatra*, we have no similar set of associations to draw upon with respect to the sound that Shakespeare calls for so specifically in this scene. In modern film and television soundtracks, for example, oboes are more familiar as an accompaniment to scenes of mischief or comic relief. Today, they give a decidedly whimsical tone to representations of the supernatural. Our acoustic experience is not the same, our world is alive with different sounds, our ears are tuned to different things, and this is what makes it difficult for us to hear act four, scene three of *Antony and Cleopatra* with the ears of its earliest audiences.

As the preceding account suggests, our access to the early modern soundscape is radically problematized by sound's transience. Sounds, and our relations to them, are both subject to time. They evanesce, and fade from cultural memory over the *longue durée*. As Robert Hapgood notes in his critical account of listening to twentieth-century recorded versions of *Antony and Cleopatra*, 'our own ears change':

> For communicative sound is not only something spoken; it is something understandingly heard. And as the necessary rapport between speaker and listener fades, it becomes increasingly difficult for this communication to take place.
>
> (Hapgood 1971: 3)

The larger point I would emphasize here is that even the most comprehensive reconstruction of the sounds of Shakespeare's theatre, however well-researched and performed, wouldn't amount to a recreation of the Shakespearean soundscape, since those acoustic events would fail to resonate with twentieth-century listeners in the same way they did with audiences in their originating context. This is perhaps why there have been so few studies of sound in Shakespeare. Where is the object of

study? With that in mind, I prefer not to spend the remainder of the present book attempting to conjure up complete reconstructions of the various sound events that occurred on the stage of the Globe theatre, at Blackfriars, or at Court during specific performances of specific plays. Instead, I wish to pursue my intuition that Shakespeare and his contemporaries had at base (allowing for individual variation, of course) a relationship to sound radically different from our own. To that end, this investigation of the Shakespearean soundscape continues with a short tour through early modern attitudes towards, and beliefs concerning, the practice of hearing.

In order to arrive at a better understanding of what early moderns were capable of thinking about the sense of hearing and the subject of sound more generally, the remainder of this chapter is divided into three parts, each one detailing a broad disciplinary avenue through which these topics were routinely approached by writers of the period. I begin with those who pursue the subject from a religious background and its traditions of writing on the subject, follow with more philosophical writers, and finish with an exposition of the most recent anatomical information available from the Continent, specifically, in the case of hearing, from Italy. I have chosen this sequence because it traces in descending order the degrees of familiarity we can reasonably expect Shakespeare and his earliest audiences to have had with the various approaches to understanding sound and hearing that were currently available. It is reasonable to assume that very few people at the time would have had access to the latest anatomical information, that more by virtue of an elementary education would be conversant in the references to the subject in Aristotle and other philosophers of the Classical and medieval periods, and that many more would have derived most of their associations with the subject via religious discourse both in printed form and, more probably, through oral transmission in sermons. Contemporaries of Shakespeare who addressed the subjects of sound and hearing from one or a number of these disciplinary positions include Francis Bacon, Richard Brathwaite, the physician Helkiah Crooke, ministers Stephen Egerton and William Harrison, poet Sir John Davies, minister Robert Wilkinson, and Jesuit priest/philosopher of the passions Thomas Wright. While this list is certainly not comprehensive, it is nevertheless amply representative of the main streams of thought on the subject.

The doctrine is sound

The most salient discourse on hearing and the role of sound in early modern English culture was conducted in the religious sphere, and

concerned the proper use of the Christian ears. Within a span of thirty years, from early in Shakespeare's professional lifetime until the publication of the First Folio, no fewer than three extended sermons were published on the role of hearing and the use of the Christian organs in church. These sermons appear roughly every decade: Robert Wilkinson's *A Iewell for the Eare* was first published in 1593, and was republished six times in the following thirty-two years; William Harrison's *The Difference of Hearers* was published twice in 1614, then once again in 1625; and Stephen Egerton's *The Boring of the Eare* was brought into press posthumously in 1623 by Richard Crooke, who apparently gave the work its title. Little is known about any of these men apart from what can be gleaned from their works. Robert Wilkinson conducted a ministry at Horton in Kent for a time in the early 1590s. William Harrison preached at Hyton in Lancashire (he should not be confused with the famous Elizabethan topographer and historian of the same name; nor, judging from the anti-Catholic invective that permeates his contribution, should he be confused with the William Harrison who acted as England's final archpriest from 1615 to 1621). Stephen Egerton is credited on the title-page of his work with having preached at Blackfriars, probably during years when Shakespeare and the King's Men were performing at their private theatre in the same district.

The sermons by these figures were written out of the desire to promote a more active and obedient attention on the part of regular sermon audiences. The fact that they appeared in print form suggests that the topic they address resonated far afield from the individual parishes for which they were written. Because attendance at Sunday and holiday services had been legally compulsory for all subjects of the realm since the 1559 Act of Uniformity, the audience for sermons such as these would ostensibly have comprised the entire population (Prall 1993: 73–6, 83). The Act of Uniformity, combined with the newly-revised *Book of Common Prayer*, guaranteed the government broadcast access to the entire realm for regular ideological and spiritual prophylaxis of the body politic. Actual compliance with the statute probably varied, however, according to geographical factors that would have affected enforcement, combined with the measure of contemporary political interest in its implementation. The penalty for failing to attend services was not physical punishment or incarceration, but a simple fine per episode that those who were more well-off could easily rationalize as a tax on religious freedom. The statute and its increasingly expensive penalty are typical of a management style Elizabeth was to employ throughout her long reign; while avoiding direct confrontation and provocation, an issue is ingeniously framed so that she wins either

way, in this particular case receiving either obedience or financial tribute. If she couldn't have the ears of her subjects, she would graciously accept their money in substitution thereof. The trade-off indicates that the Elizabethan political establishment was very quick to pick up on the association between hearing and obedience, and placed a great deal of practical value upon that association. At other times, if Elizabeth couldn't metaphorically have the ears of her subjects, she would, as pointed out above, accept their literal ears in lieu thereof: as Richard Crooke notes in his introduction to Egerton's dialogue, 'the next punishment vnto death by our Nationall law, is losing the eares'.

I wouldn't like to give the impression that Wilkinson, Harrison and Egerton were primarily interested in enforcing political obedience in their sermons, however. What they were really after was a voluntary spiritual obedience from their audience, and this for them began with the ear. A single Biblical passage runs as a common thread throughout their sermons. This is the parable of the sower, in which Christ describes four types of hearers. The parable occurs with slight varia-tions in each of the three synoptic gospels (Matthew 13:4–23, Mark 4:1–29, and Luke 8:4–21), and is basically as follows: a sower goes out to sow his seed. On the way to the field some of the seed falls on the road, some falls onto rocky ground, some among thistles, and finally some makes it into good earth. The seed that falls onto the road is eaten by birds; that which falls onto the rocky ground never develops adequate roots and is blasted by the sun; that which grows among the thistles is in turn choked by them; and the last, which falls into good soil, yields many fold in return. In each version of the parable even the apostles, those closest to Jesus, fail to grasp the meaning of his story, and are forced to request an explanation (this is the first time in each of the gospel accounts that Jesus uses parables in his teaching). After allowing that they are sufficiently disposed to hear the meaning of the parable, Jesus obliges them with the following interpretation: the seed is the word of God, which falls into four different types of ears. There are those who hear the word without understanding it, so that it can never take root within them; those who allow it to take root but do not allow those roots to grow strong enough; those who hear the word but allow it to become choked off within them by greater attention to earthly consid-erations; and finally those who hear the word and welcome it, and hold it fast in their hearts. These latter individuals benefit from their persever-ance, and reap a bountiful harvest. In other words, the perceptual interest of hearers, their attention, is repaid with spiritual interest.

Each of the early modern authors we're concerned with draws upon the parable's central agricultural and physio-economic metaphor, that

the ear makes possible a kind of spiritual fertilization. Believers will accrue benefits in accordance with their ability and willingness to receive the divine word into their hearts, where it will germinate and transform the hearer. The metaphor through which this parable is communicated exemplifies the very process described in its content: that is, if you can understand the extended metaphor that the parable describes, then you have indeed heard it with the right kind of ears. This is of course why it is reported to be Christ's first parable in each of the synoptic accounts: because it is the hermeneutic key that enables one to understand the following parables as well. One of the assumptions necessary for the central metaphor of the parable of the sower to obtain cogency is that the ear must be considered a privileged point of entry to the heart, and by extension to the soul. This was an assumption shared by many writers in early modern England.

We should note that in the parable's matrix of agricultural, reproductive and cognitive associations, the ear becomes 'feminized'. When word is conceived of as seed, the ear is either the vaginal gateway through which the seed must travel on its way to the earth/heart/womb, or it is the womb itself. This notion of the feminized ear was undoubtedly current in Shakespeare's day because it is found to exist outside the strictly religious sphere as well, finding its way, among other places, into contemporary political iconography. Joel Fineman notes in passing during his reading of Elizabeth's 'Rainbow Portrait' that 'the painting places an exceptionally pornographic ear over [her] genitals', and that this ear has a 'vulvalike quality' (1994a: 121). Another scriptural link between ears, obedience and penetration occurs in the phrase 'the boring of the ear' employed by Richard Crooke as the title for Egerton's work (Egerton 1623). The phrase comes from Exodus (21.6), in which God announces to Moses that the piercing or penetration of the servant's ear will be the sign of a life-long voluntary servitude and obedience. The notion of the feminized ear is also implicit in the contemporary observance of Lady Day (25 March, the first day of the English calendar until 1752), which celebrates the story of the Annunciation, wherein the Virgin Mary is said to have conceived her son through the ear.

From the Protestant viewpoint, the struggle for doctrinal legitimacy with respect to Catholicism centred upon positioning the movement in such a way that its members could regard and advertise themselves as the more obedient of God's children, or, in another metaphor then current, the more deserving brides-to-be of Christ. The condition of possibility for spiritual fertilization – that the hearer be appropriately disposed or prepared to receive the word/seed into the ear (the reason

why Christ chooses to interpret the parable for his apostles) – falls perfectly in line with the notions of spiritual election that formed such a defining and yet obscure part of contemporary Protestant doctrine. Martin Luther had written in his commentary on *Hebrews* that 'the ears alone are the organs of a Christian man', thereby laying the Protestant claim to one entire domain of the human perceptual apparatus (Luther 1955: 224). Luther's claim to the Christian soundscape was not quick to fade away in England, where Catholicism remained metaphorically on the horizon, if not literally, as it had in the summer of 1588.

Writing in Lancashire, William Harrison picks up on Luther's idea and intensifies it with reference to the parable of the sower, claiming that not only does the ear allow for spiritual fertilization to occur, but that salvation is made possible only through the ear. In the Epistle Dedicatorie to his *The Difference of Hearers*, he echoes Luther's Protestant claim to Christian ears, writing 'it is well knowne that the papists make small account of hearing Gods word preached they hope to be saved, rather by sight then by hearing. … it is not the sight of their abhominable idoll, but the reuerend hearing of Gods sacred word, that must make them fruitfull in all good workes' (Harrison 1614). A few pages further on Harrison continues with the same criticism, again reiterating the Protestant claim to the Christian soundscape: 'yet the Romish prelates haue made it a precept of their Church, that euery one shall see a masse on each Sabboth, but will not make it a precept, to heare a sermon each Sabboth. As if the often sight of a masse were more necessarie and more profitable, then the hearing of a sermon.'

Harrison further represents Catholics as misunderstanding the role of sound in religious observance by drawing attention to and ridiculing their superstitious practice of ringing church bells in an attempt to drive the devil away from their churches (Harrison 1614: 35). It has yet to be sufficiently noted that the Reformation had an enormous impact on the acoustic environment of early modern England, simply through its effects on bellringing in the realm. Catholic bellringing practices were extremely curtailed, while the dissolution of the monasteries contributed to the selling off of many church bells. Some went to civic organizations; others were scrapped to make cannon, which was a popular use for decommissioned bells. Bells that had for centuries provided entire populations with information about religious celebrations and events were now used for more secular purposes, or were simply bells no more.

The importance of the ears as specifically Christian organs had been remarked upon eleven years earlier than Harrison's work, in greater detail and less overtly sectarian terms, by Robert Wilkinson in his *A Iewell for the Eare*:

God neuer commeth so neere a mans soule as when he entreth in by the doore of the eare, therefore the eare is a moste precious member if men knewe how to use it: and better were it to loose a better member then to want it, if a man loose an eie, an arme, or a legge, he iudgeth of himselfe as of a cripple, unworthy to liue among men, and fit for no place but for a spittle: and yet these are but maimes in the boddy: but if God take away the use of hearing, it is a signe he is angry indeede, and threatneth a famine to the soule, for the soule feedeth at the eare, as the body by the mouth: therefore better loose all then loose it.

(Wilkinson 1610)

Implicit in Wilkinson's assertion that 'the eare is a moste precious member, if men knewe how to use it', is that there is a right way to hear, and a wrong way. The right way to hear is to 'lay up the word in our harts'. Wilkinson also uses the term 'hearken', by which he means that one should hear but also assume a welcoming and receptive mental disposition toward what is heard (think of Firke's enthusiastic 'hearke!' at the sound of the pancake bell in *The Shoemaker's Holiday*). Otherwise, Wilkinson tells his congregation, they are just as well to bring their oxen to church, for beasts can hear the word of God as well as man. Those who come to church to hear the word, but do not bring with them the correct attitude towards what they are about to hear, are likened to beasts in church.

Like Wilkinson, Harrison attempts to teach his audience and readers how to become better hearers, more obedient to the word of God and His will revealed therein: 'the doctrine is sound, and the manner of teaching profitable, but the people heare amisse, and so for want of good hearing, loose the fruite of many good sermons; because the profit of hearing, dependeth on the maner of hearing'. To that end, Harrison states that the manner in which one hears for most profit involves a total interiorization of the word of God; not just into the ears, but into the heart (Wilkinson had referred to the ears as 'the doore of the hart'). According to Harrison, there are six ways in which churchgoers can become better hearers: (1) they must prepare themselves before coming to church (here he employs the metaphor of plowing the ground before planting it); (2) they must pray beforehand, as a way of focusing their attention for the sermon; (3) they must exercise themselves by daily reading of the scriptures; (4) they must listen attentively to the sermon; (5) they should ask questions if they don't understand; (6) and finally they should put into practice what they have heard (here he notes that obedience is the key to knowledge).

Each of these authors uses the parable of the sower to address a chronic problem that probably resulted from the state's position on mandatory attendance: their parishioners' ears seemed naturally to tend towards other things. Put in terms of the parable itself, the earth these preachers were expected to sow was oftentimes less than hospitable to their holy seed. Their complaints provide us with valuable information concerning the ways people preferred to use their ears during their leisure time, so let's listen outside the church door where we can hear William Harrison protest against the practice of piping and dancing on the Sabbath. He laments that 'for one person which we haue in the Church, to heare diuine service, sermons and catechisme, euery pyper (there being many in one parish) should at the same instant, haue many hundreds on the greenes'. Over in Kent, Robert Wilkinson seeks to encourage those who see the Sabbath as 'a day of holy rest, not of unholye ryot', and reproaches those who come to church 'not to haue their liues reformed, but to haue theyr eares tickled euen as at a play'. This is almost certainly an allusion to the contemporary debate over the rhetorically sophisticated, 'metaphysical' preaching style that was then coming into prominence (Crockett 1993). Echoing Wilkinson, Egerton asks why it is that people find it difficult to sit quietly and attentively through a sermon, but seem to have no trouble paying attention to an entire play: 'let hearers consider how easily without irkesomnesse they can be present at a play, or at some other prophane and idle exercise and discourse of greater length then those Sermons which they doe so much distaste in respect of the tediousnesse (as they esteeme it) of them ...' (54). Egerton's objection strikes particularly close to home when one considers that we are probably hearing him preach at Blackfriars during the years when Shakespeare and his company were performing at their private theatre in the same district.

In this Protestant discourse there are, in addition to the many wrong sounds to listen to, many wrong ways to hear as well. Wilkinson concludes his sermon by identifying the five enemies to the attention that are to be found in church. They are 'a straying thought', 'a wandring eie', 'a needelesse shiftinge, and stirringe of the bodie', 'an unreuerent talking and unciuill laughinge in the Churche', and 'a secure and senceles sleeping'. In a fit of inspiration he then throws in a sixth enemy to the attention, which 'of al the rest is most scandolous and offensiue, and that is a shameful departing out of the church, and violent breaking from the congregation, wherein a man doeth as it were openlye protest, that he is exceeding weary ...'. Egerton enlists yet another agrarian metaphor in his similar comment, that one's duty after having heard the sermon is not to bolt from church afterwards,

but to 'sift' the information with one's heart for a while after. Richard Crooke does Jesus two better in his introductory section to Egerton's work, identifying not three, but 'five sorts of eares that are not hearing eares': they are (1) a dull eare, 'when a man is either drousie, or carelesse, or ignorant'; (2) a stopped eare, characterized by recusants and such like persons; (3) a prejudiciall eare, which characterizes the man who 'comes as the Pharisee to Christ, to tempt the Minister, to catch him in his talke, turning all his speech to the worst'; (4) the itching eare, one that must always have novelty; and (5) the adulterous eare, 'that will heare any but the voice of their owne Shepherds'.

The sermons of these three authors are quite explicit in asserting that for the early modern Protestant, the ear is the primary corporeal agent of spiritual transformation. The Protestant discourse pertaining to sound and hearing associates this entire perceptual domain with obedience, duty, receptivity and penetrability – all concepts which were gendered feminine in the period, and were officially codified as such with the state's sanction in the *Book of Common Prayer*. Wilkinson clearly associates the visual sense with mastery over the material world, the ears with the spiritual:

> for by the eie we come to the naturall mans diuinity in
> suruaying the creatures ... then our eie is our schoolemaister
> to bring us to the knowledge of the Creator: but that knowl-
> edge is unperfect as the glimmering of a lighte, but by our ears
> more specially and expresselye we attaine to the knowledge of
> Gods reuealed will ...

The ear, Wilkinson reminds his audience, is where 'the soule feedeth'. For all the great changes that were beginning to take place in 'the naturall mans' relationship to the material world at this time, changes that were largely the result of innovations in the understanding of visual perception reflected in exciting new modes of visuality such as print, perspective, cartography and marine navigation, sound remained, especially for the Protestant but by no means exclusively, the most important sensory repository and refuge of the metaphysical mysteries one might contemplate in Shakespeare's England.

One of the subtilest pieces of nature

The probable reason that sound functioned as a repository for these mysteries is that of the two major perceptual domains, it was the lesser understood. Francis Bacon suggests as much in the second century of

his *Sylva Sylvarum* when he writes 'perspective hath been with some dili-
gence inquired; and so hath the nature of sounds, in some sort, as far as
concerneth music; but the nature of sounds in general hath been super-
ficially observed. It is one of the subtilest pieces of nature' (Bacon 1824:
114).[4] In what follows I will consider Bacon, Richard Brathwaite and
Thomas Wright as interlocutors in a contemporary discourse which
occupied a broad intellectual bandwidth between the religious dis-
course surveyed in the previous section and the anatomical discourse,
which occurred primarily on the Continent. This philosophically-inflected
approach is an important source of information about the contemporary
soundscape because it reacts to and builds upon Greek and medieval tradi-
tions of understanding sensory perception that had become very heavily
sedimented into early modern intellectual life by centuries of continuous
transmission. I have chosen these three writers because they help us to
understand contemporary attitudes towards and developments in this
received tradition as it pertains to sound and hearing.

Francis Bacon is such an original and independent thinker that it might
seem decidedly unsound to portray his ideas as representative of what
early moderns thought about anything, let alone sound and hearing.
Although admittedly an anomalous figure, in many ways remarkably
ahead of his time, it is worth remembering that he was scientifically-
speaking only a gifted amateur, 'out of touch with the scientific discov-
eries of his own day' (Vickers 1978: 18). The work of Kepler, Coper-
nicus, Galileo, Harvey, the anatomical discoveries concerning the ear
taking place in Italy by Eustachius and Fallopius, all were unknown to
him. As a legal professional and government official, he simply couldn't
afford the time to keep up with these kinds of developments. Profes-
sional responsibilities, coupled with the extraordinary range of his inter-
ests, certainly prevented him from tracking developments specific to
anatomy. His most notable writings on sound and hearing occur in one
of his later works: in *Sylva Sylvarum*, better known as the *Natural History*.

The second and third centuries of *Sylva Sylvarum* provide the fullest
description we have of Bacon's understanding of sound, but the
account is not arranged as logically or argued as explicitly as one could
wish.[5] This is because the *Sylva* was not organized to explain broad
concepts in a linear fashion; rather, it is a compendium of observations
of phenomena accompanied by explanations, or by suggestions for
experiments that might provide explanations for those observations.
As a thinker Bacon was more interested in confronting longstanding
orthodoxies in intellectual systems, and instantiating programmes for
research and discovery, than he was in keeping up with contemporary

developments taking place outside what he considered the current dispensation (developments such as the above-mentioned which, ironically, were really quite revolutionary and radically thought-altering in themselves). Frederick Hunt barely touches on Bacon in his book *Origins in Acoustics* because he finds the work in this area so derivative: 'His acoustical facts hardly went beyond those of Aristotle, from whom, indeed, he took most of them' (Hunt 1978: 77). Although Bacon's lack of innovation may deny him a place in the history of acoustic theory, it does make him a useful informant about contemporary popular belief, and more generally about the entire received tradition pertaining to sound and hearing that is brought into play whenever he discusses the subject.

That tradition had at its source a small group of Greek and early medieval authorities, most notably Pythagoras, Aristotle, Galen and Boethius. Like other elements of Classical culture, it went through a period of Islamic custodianship during the medieval era, making its way with elaboration and refinement back into Europe during the Renaissance (Hunt 1978). Although the tradition is hardly uniform, it can be summarized as follows: sound is produced when a body's motion is transferred to the surrounding air, creating an 'audible species' which then travels to the ear. The assumption is that the corresponding organs of these senses are not acted upon directly by external objects, as are those of touch and taste (Crombie 1962: 94). Therefore, the objects which affect these three senses must do so through a medium. They do this by emitting or propagating what were called 'species', 'forms', or 'images'. In the case of the audible species, these forms or images are perhaps best described as representations of the motion of the sounding body. When the audible species reaches the ear it causes the ear drum (the *tympanus*) to vibrate, which in turn causes the internal air of the ear (sometimes called the auditory spirit) to vibrate and register the sound in the *sensus communis* which resides, depending on which theory you subscribe to, in the brain, the heart (Aristotle), or the liver (Plato).

The greatest obstacle to understanding early modern explanations of sound and hearing lies in the terminology in which they are inevitably couched. For a similar example of this elusive terminology I reach back to *The House of Fame*, where Chaucer rehearses an acoustical theory that would survive into Bacon's day and beyond: 'Soun ys noght but eyr ybroken; / And every speche that ys spoken, / Lowd or pryvee, foul or fair, / In his substaunce ys but air; / For as flaumbe ys but lyghted smoke, / Ryght soo soun ys air ybroke' (lines 765–70). Just what does it mean to 'break' air? Without any contextualization, the

modern reader can easily be left with the impression that these people were quaintly misguided when it came to the physics of sound, and had no real idea of what they were talking about. This is not the case, however. The word 'break' has many associations with the religious discourse of the period. When specifically applied to sound, it means simply 'to penetrate' (OED 21), or 'to come out or emerge by breaking barriers; to burst forth, rush out with sudden violence; (a) of words, laughter, sounds, etc. (def. 37a). The notion of obedience also occurs in another definition of the word: 'to reduce to obedience or discipline, tame, train (horses or other animals, also human beings)' (def. 14). According to the OED each of these definitions was current in Bacon's day; moreover, the first and last are illustrated by quotations from Shakespeare.

Bacon was wary of lexical innovations masquerading as intellectual improvements in the field. Writing some 250 years after Chaucer, he criticizes those who propose that 'the cause given of sound ... should be an elision of the air, whereby, if they mean anything, they mean a cutting or dividing, or else an attenuating of the air'. A 'cutting' or 'dividing' of the air is much closer to a 'breaking' of the air than is an 'elision'. Bacon blames the newfangled notion on intellectual fashion, for 'it is common with men, that if they have gotten a pretty expression by a word of art, that expression goeth current; though it be empty of matter' (124). He then proves the explanation false by noting that numerous sounds, such as the ringing of a bell or the sound of a plucked string, 'continueth melting some time after the percussion; but ceaseth straitways if the bell, or string, be touched and stayed'. He also adduces the phenomenon of echo, in which 'there is no new elision, but a repercussion only'. Finally, his most effective argument to the contrary is that 'sounds are generated where there is no air at all'.

His point is that air is only the medium or 'vehiculum casuae' for sound, 'and in that it resembleth the species visible', for after a sound has been made, 'we cannot discern any perceptible motion at all in the air along as the sound goeth; but only at first' (125). That is, air is broken by 'some local motion' only at the beginning of the production of sound. Since sounds continue to carry through the air and reverberate after this initial local motion, they cannot be defined *as* that local motion. Though he admits some sounds seem to radiate actual physical force, such as when 'upon the noise of thunder, and great ordnance, glass windows will shake', he contends that 'these effects are from the local motion of the air, which is a concomitant of the sound, as hath been said, and not from the sound' (126). He cites a related folk belief concerning the force of loud sounds. 'It hath been reported, and is still received, that extreme applauses and shouting of people assembled in

great multitudes, have so rarified and broken the air, that birds flying over have fallen down, the air being not able to support them', and that 'it is believed by some, that great ringing of bells in populous cities hath chased away thunder; and also dissipated pestilent air' (127). Bacon does not completely denounce the veracity of these accounts, though he attributes them not to the sound, but to the 'concussion of the air'. On the other hand, he notes that loud sounds near to the perceiver may cause deafness by the 'breaking of a skin or parchment in their ear', giving as an example his own experience of someone shouting into his ear. He was left with a ringing in his ear 'so as I feared some deafness', but 'after some half quarter of an hour it vanished' (128). From this example he decides that 'this effect may be truly referred unto the sound: for, as is commonly received, an over-potent object doth destroy the sense; and spiritual species, both visible and audible, will work upon the sensories, though they move not any other body'. He notes that sounds seem to move better downwards than upwards, saying this is why pulpits are placed above the people, and why generals speak to their troops from the tops of hills: 'it may be that spiritual species, both of things visible and sounds, do move better downwards than upwards' (205).

For Bacon, as for the Protestant ministers discussed in the preceding section, sound affords a privileged mode of access to the spiritual essence within human beings. From the early modern physiological perspective, hearing is the sense with the greatest and most immediate access to the body's internal spirits. Because of this, of all the sensory domains sound was also reputed to have the most immediate and visceral effect on the perceiver. As proof of this Bacon notes that our reactions to 'harsh sounds, as of a saw when it is sharpened; grinding of one stone against another; squeaking or shrieking noise; make a shivering or horror in the body, and set the teeth on edge' (700). Anyone who has experienced the sound of fingernails on a blackboard can corroborate this. His explanation for why 'the objects of the ear do affect the spirits, immediately, most with pleasure and offence', is that 'sight, taste, and feeling, have their organs not of so present and immediate access to the spirits, as the hearing hath' (114). Sound mingles with the internal spirits of the body in a way that makes it a more emotionally immediate sense. He alludes to the 'anciently held and observed' notion that music can make men 'warlike', 'soft and effeminate', 'grave', 'light', 'gentle and inclined to pity', etc. At the same time, he is careful to note the importance of taking into account individual and cultural predispositions when contemplating these effects: 'generally music feedeth that disposition of the spirits, which it findeth. We

see also, that several airs and tunes do please several nations and persons, according to the sympathy they have with their spirits.'

Bacon believes that not only human beings but all physical objects have some sort of spirit in them that can serve to propagate sound, much as air does: 'the pneumatical part which is in all tangible bodies, and hath some affinity with the air, performeth, in some degree, the parts of the air; as when you knock upon an empty barrel, the sound is in part created by the air on the outside; and in part by the air in the inside'. For not only does the amount of air inside the barrel help to produce sound, but 'the sound participateth also with the spirit in the wood through which it passeth' (136). Later Bacon uses the example of a rod struck near the ear to reiterate his point that 'sounds do not only slide upon the surface of a smooth body, but do also communicate with the spirits, that are in the pores of the body' (150).

Because sound was thought to communicate and commingle with the spiritual essences of people and objects, it is easy to understand why it was so closely linked to ideas about identity and the representation of identity in the period. I have already cited Bacon's example concerning the effects of music on different individual and cultural dispositions. In that case, music is held to reinforce identity by encouraging 'that disposition of the spirits, which it findeth'. Conversely, one of the qualities of sound Bacon recognizes is that it 'admitteth much variety; as we see in the voices of several men, for we are capable to discern several men by their voices' (295). He also mentions the capacity some actors and people have of imitating the voices of other people: 'there be certain pantomimi, that will represent the voices of players of interludes so to life, as if you see them not you would think they were those players themselves; and so the voices of other men that they hear' (337). It is evident that some contemporary actors were known by their voices, or for their ability to incorporate different kinds of voices in their work. In his next paragraph Bacon mentions the knack some people have for throwing their voices, but decides such talent is not of much use, except 'for imposture, in counterfeiting ghosts or spirits' (337); that is, for assuming alternate identities.

Richard Brathwaite was born a barrister's son in Kendal, probably in 1588. Sent to Oxford in his sixteenth year, he later attended Cambridge to study law. His real calling appears to have been writing, however, for he published widely and in a variety of genres during his long lifetime (he died in 1673, in his mid-80s). Although he is best known as a poet, his *Essaies upon the five Senses* were published in 1620. The collection's dominant theme is that one should direct one's attention away

from worldly matters, and use the sense organs instead to catch glimpses of the spiritual realm's eternal verities. As is common in discussions of the five senses, sight is given first place, though Brathwaite's comments on it are for the most part critical and admonitory: e.g. 'as the eye of all other Sences is most needfull, so of all others it is most hurtfull' (3).[6] Furthermore, the essay on sight seems perfunctory when compared to that of hearing; it is allotted less than a third of the space devoted to the latter.

Brathwaite introduces the sense of hearing with words that have by this point become familiar. In fact, the essay's first five sentences quickly and compactly refer to many of the associations we have found in the previous discourses:

> Hearing is the organ of vnderstanding; by it we conceiue, by the memorie we conserue, and by our iudgment wee revolue; as maine riuers haue their confluence, by small streames, so knowledg her essence by the accent of the *eare*. As our *eare* can best iudge of sound, so hath it a distinct power to sound into the centre of the heart. It is open to receiue, ministring matter sufficient for the minde to digest; some things it relisheth pleasantly, apprehending them with a kinde of enforced delight: some things it distastes, and those it either egesteth, as friuolous, or as a subiect of merriment meerly ridiculous. In affaires conferring delight, the voluptuous man hath an excellent *eare*; in matters of profit, the worldly-minded man is attentiue; and in state-deportments the Politician is retentiue. The *eare* is best delighted, when any thing is treated on, which the minde fancieth: and it is soone cloyed, when the minde is not satisfied with the *subiect* whereof it treateth.
>
> (6–7)

We have heard many of these ideas before. Hearing provides the most immediate access to the internal spirits with its 'distinct power to sound into the centre of the heart'. Like Bacon, Brathwaite observes that people are attuned to various components of the soundscape according to personal disposition. The ear is described as 'open' and penetrable. The transformative power of this feminized ear is announced in the first two phrases of the essay: '[h]earing is the organ of vnderstanding; by it we conceiue ...'. 'Conceive' is a word with physiological as well as cognitive valences. As noted above, a conflation of these valences is entirely possible, as in the story of the Annunciation, in which physiological conception occurs via the principal avenue of cognitive conception. Like Robert Wilkinson, Brathwaite also conceives of sound as a

kind of cognitive nourishment. The ear receives 'ministring matter sufficient for the minde to digest', some of which it 'relisheth', some of which it 'distastes'. For Brathwaite, 'the *eare* is an edifying sence, conveying the fruit of either morall or diuine discourse to the imagination, and conferring with iudgment, whether that which it hath heard, seem to deserue approbation' (8).

While sight presents only the veneer of the world, sound's affinity with the internal spirits provides access to interior truths and essences unavailable through other sensory avenues. Brathwaite is critical of 'the common sort' who 'haue their *eares* in their *eyes*: whatsoeuer they heare spoken, if they approue not of the *person*, it skils not; such a neere affinitie haue the *eare* and the *eye* in the vulgar' (9). A little over a decade earlier, Shakespeare had prompted Volumnia to counsel her son Coriolanus along very similar lines. She advises him to make a show of kneeling in supplication before the tribunes, 'for in such business / Action is eloquence, and the eyes of th' ignorant / More learned than the ears' (3.2.75–7). We know that Brathwaite tried his hand at writing plays when he came to London, though none of these works is extant. It does seem that the example he provides on this point has its origin in the theatre. Further on he complains that 'if *Herod* speake, hauing a garment glittering like the sunne, the light-headed multitude will reuerence *Herod*, and make him a deitie, not so much for his *speech*, for that is common, as for his apparell, to them an especiall motiue of admiration' (8–9). This complaint resonates powerfully with Hamlet, who twenty years previously had advised his players not to speak their lines too loudly lest they 'spleet the ears of the groundlings, who for the most part are capable of nothing but inexplicable dumbshows and noise' (3.2.10–12). Sheer volume will not force speeches into the ears of these audience members, who are there merely to watch the proceedings. Besides, says Hamlet, 'it out-Herods Herod, pray you avoid it' (3.2.13–14).

In the remainder of his essay Brathwaite reflects on how the ear should best be employed. He suggests listening to music, but rejects it on the grounds that that provides only a temporary pleasure. He then considers listening to histories, with the Sidneian rationale that they inspire admiration and imitation. But he again finds himself left unsatisfied in the aftermath: '[w]here be those eminent and memorable Heroes, whose acts I haue heard recounted? where those victorious Princes, whose names yet remaine to posteritie recorded? and *hearing* no other answer, saue that they once *were*, and now are not, I wayned my *eare* from such a subiect' (13). From thence he devotes himself to the 'discourse of the Lawes', but comes to the conclusion that the ear

desires a way to eternity, not to the things of the world. Hearing, which he notably personifies with the feminine pronoun, is described as his 'directing sense', directing him away from all these worldly sounds and discourses: 'she is not for earth; her Musicke is mixt with too many discords. The worlds harmonie to a good Christian *eare*, may be compared to that of *Archabius* the trumpeter, who had more giuen him to cease than to sound: so harsh is the sound of this world in the eare of a diuinely affected soule' (16).

The last work we will concern ourselves with in this section was also the first to be published, by almost twenty years. Although Thomas Wright and Francis Bacon were exact contemporaries (both were born in 1561, and each lived into the mid-1620s), the first edition of Wright's *The Passions of the Minde* was published in 1601, twenty-six years before Bacon's *Sylva*, and almost twenty before Brathwaite's *Essais* saw print. Born into a vigorously Catholic family in York, Wright was educated on the Continent. He attended the seminary at Douai for a few years before moving onward, from Rheims to Rome, where he and another English pupil were given special permission to join the Society of Jesuits.[7] After completing his novitiate in Rome he embarked on a peripatetic academic career with stops in Milan, Rome, Louvain, Genoa, and finally Valladolid in Spain. In the mid-1590s he came to believe Spain's interests in England had more to do with political imperialism than with religious liberation. He made these views public and soon after left the Jesuits, returning to England in 1595 under the political protection of the ill-fated Earl of Essex. He was given special permission to return to his native city of York in the summer of that year, and by the fall he was under house arrest at the Dean of Westminster's for publicly arguing with members of the clergy in York. He must have enjoyed considerable enlargement there in comparison to the sentences he would later serve at various prisons for the duration of Elizabeth's reign. As a Catholic, especially an ex-Jesuit, and friend of Essex, Wright was frequently interrogated about his suspected participation in a number of subversive disturbances.

William Webster Newbold suggests that Wright probably began and completed *The Passions of the Mind* during the two years of his house arrest with the Dean of Westminster (Wright 1986: 11). The work as a whole, divided into six books, is one of the earliest attempts to present a detailed anatomy of what the passions are, and how they influence us. Wright also suggests what may be done to control these influences, as well as how we may in turn influence others by taking note of their own passionate dispositions. The work is of relevance because it shows that many of the ideas

we have encountered so far in this chapter were current at the time Shake-speare was writing; furthermore, it shows that some of these ideas crossed religious borderlines. Most of the material specific to sound and hearing doesn't find its way into Wright's book until the second edition of 1604, in new sections which form that edition's fifth book.

By engaging in informal fieldwork, Wright finds that sound provides the best means of ascertaining the passionate dispositions of others. He begins the first chapter of his fourth book, 'wherein is explained how Passions may be discovered', by noting the importance people place on conversation when assessing the characters of others in everyday situa-tions. 'Sometimes,' he writes, 'I have enquired of sundry persons what they thought of certain men's inclinations, and I found that almost whatsoever they had noted in others commonly to proceed from one sort of speech or other' (166). Noting that most people don't 'blaze their imperfections to the eyes of the world', he decides to 'sound out a little further, and wade something deeper into a secret survey of men's speeches to see if we may discover some more hidden passions; and this either in the manner or matter of speech'. It is worth calling special attention to the rhetoric of this passage, in which the initial visual meta-phor is employed in reference to obvious significations, while more subtle forms of knowledge become available to those attuned to sound. Wright devotes the remainder of the chapter to the various ways people communicate their inclinations in conversation. They do so first by the *manner* of their conversation – by talking too much, too little, very slowly, or rashly, or with affectation. They may tend to denigrate others too much. After discussing the manner of talk, he takes up what may be learned from the 'matter' of talk. Here we are presented with another set of types, including those who tend to hold forth on things they know nothing about, those who have 'quarreling and contentious spirits' in conversation, those who gravitate towards specific subjects of conversation, those who are too secretive and those who are too open, those who pretend confidence in order to gain access, and those who do so in order to cause dissension.

Like Bacon and Brathwaite after him, Wright voices the contempo-rary belief that sound provides a privileged mode of access to the spiri-tual essences of things. The second chapter of the fifth book, 'How Passions are moved with music and instruments', addresses and tries to explain this phenomenon, specifically with respect to the effects of music on the passions. Admitting the question is 'as difficult as any whatsoever in all natural or moral philosophy', he rejects the temptation to offer an explanation out of 'some learned discourse', preferring to 'set down those forms or manners of motion which occur to my mind

and seem likeliest' (208). To that effect, Wright proposes four possible theories as to why music so affects the passions. The first of these theories is simply that there is 'a certain sympathy, correspondence, or proportion betwixt our souls and music'. This argument is supported with reference to other physical mysteries the explanations for which were based on similar associative logic, such as 'who can give any other reason why the loadstone draweth iron but a sympathy of nature?' Wright's second theory is that music doesn't affect the soul directly, but acts on the material body in such a way that it allows God to stir the spirit. Wright finds an analogy here in the presence of the soul in the body, 'for men being able to produce that body but unable to create the soul; man prepareth the matter and God createth the form. So in music men sound and hear, God striketh upon and stirreth the heart' (209). The third theory, which Wright describes as 'more sensible and palpable', deserves to be quoted at length:

> the very sound itself, which according to the best philosophy is nothing else but a certain artificial shaking, crispling, or tickling of the air (like as we see in the water crispled, when it is calm and a sweet gale of wind ruffleth it a little; or when we cast a stone into a calm water we may perceive divers warbling natural circles) which passeth through the ears, and by them into the heart, and there beateth and tickleth it in such sort as it is moved with semblable passions. For as the heart is most delicate and sensitive, so it perceiveth the least motions and impressions that may be; and it seemeth that music in those cells playeth with the vital and animate spirits, the only instruments and spurs of passions.
>
> (209)

In juxtaposition to the pleasant sensations provided by music, Wright also refers to the unpleasant sensations that can follow when one hears other sounds. Here again we find the filing of iron and the scraping of trenchers referred to, with both reportedly having a viscerally unpleasant effect on the auditor. These are sounds that people 'abhor to hear, not only because they are ungrateful to the ear but also for that the air so carved punisheth and fretteth the heart' (209). The fourth and final explanation advanced by Wright is that just as other senses 'have an admirable multiplicity of sounds which delight them,' so does the ear. Music has the power to 'stir up in the heart divers sorts of sadness or pain, the which, as men are affected, may be diversely applied'. Wright clearly thinks of sounds as disturbances of the heart:

Let a good and Godly man hear music and he will lift up his heart to heaven; let a bad man hear the same and he will convert it to lust. Let a soldier hear a trumpet or a drum and his blood will boil and bend to battle; let a clown hear the same and he will fall a dancing; let the common people hear the like and they will fall a gazing or laughing, and many never regard them, especially if they be accustomed to hear them ... the natural disposition of a man, his custom or exercise, his virtue or vice, for most part at these sounds diversificate passions ...

(210)

'An explication of certaine hard Problemes about the Eares'

While the subject of hearing was important to early modern British intellectuals, it never commanded enough attention to become a topic of scientific inquiry in its own right (Gouk 1991: 95). More attention was understandably reserved for practical applications of the visual and optical sciences such as cartography and navigation, which were so necessary to an island nation commercially and militarily dependent upon the sea. Nevertheless, great advances in the physiological understanding of audition did occur during Shakespeare's lifetime. Most of this groundbreaking work took place on the Continent, and remained unavailable in English until Helkiah Crooke's *Microcosmographia* was first printed in 1616. Born in Suffolk in 1576, Crooke completed a BA at Cambridge in 1596, and then went to study medicine at Leyden, pursuing his interest in anatomy.[8] At Leyden he received an MD and returned to Cambridge to continue his studies, taking an MB in 1599 and yet another MD degree in 1604. From Cambridge he relocated to London, and was assigned personal physician to James I, to whom *Microcosmographia* is dedicated.

Microcosmographia, published with 'the Kings Maiesties especiall Direction and Warrant', is one of the earliest general treatises on human anatomy to appear in English. The work is a compilation of the major received traditions of anatomy, supplemented where possible with recent discoveries from more contemporary figures such as Avicenna, Vesalius, Fallopius, Eustachius and others. Crooke's two principal authorities are Bauhinus and Andreas Laurentius, either of whom he falls back on when other authorities present conflicting, or just plain preposterous theories. Strangely, Crooke's volume contains no mention of Harvey's discovery of the circulation of the blood, which had been publicly presented in London somewhat earlier in the same year that *Microcosmographia* was first published. The second edition of 1631 continues the omission.

The section we are interested in at present, on the ears and hearing, can be found in the volume's eighth book, which is devoted to the sense organs located in the head. Crooke's discourse on the ear begins with a reference to Aristotle, who is recorded as having called the organ of hearing '*Sensum discipline*, because it was created for the vnderstanding of Arts and Sciences: for Speach, because it is audible, becommeth the Cause of that we learne therby' (573). Crooke then proceeds to describe the parts of the outer ear. Although not entirely necessary to the act of hearing (he notes that 'if the Eares be cut off close by the heade, yet a man will heare notwithstanding'), the outer ear does assist in the preparation of sound for the inner ear:

> For in these breaches of the eare as it were in hollow bodyes, not onely the sound of the ayre that rusheth in is readyly and exactly drawne and fully receiuved: but also it is broken and boundeth or reboundeth as a ball against the sides of the inequalityes till the refraction get into the circular cauity and so the sound becomes more equall and harmonicall. It attayneth also better vnto the Tympane or drum of the eare without trouble or molestation, and is imprinted vppon or into the inward ayre more strongly and more distinctly ...
>
> (575)

The outer ear is also described as helping to regulate the temperature of the outer air with respect to the ear: 'another vse of this refraction of the aire is, least it should enter into the Eare too cold if it were not broken and beaten against the sides in the passage whereby it receiueth if not heate yet a mitigation of his coldnesse' (576). He refers to this function again later, in a specific type of instance: 'we see often times that the noyse of great Ordinance or of Bels, if a man be in the steeple, yea an intollerable cold ayer doe affect the Eare with paine and dolour; somtimes also breake the Tympane from whence deafnesse followeth' (585). This understanding of the function of the outward ear was not new, and is found expressed in poetic form over fifteen years earlier in Sir John Davies's *Nosce Teipsum*, wherein the windings of the outer ear are described as protecting the inner ear:

> Because all sounds doe lightly mount aloft;
> And that they may not pierce too violently,
> They are delaied with turnes and windings oft.
> For should the voice directly strike the braine,
> It would astonish and confuse it much;

Therefore these plaits and folds the sound restraine,
That it the organ may more gently touch.

(Davies 1975: 106)

The better to understand the sense of hearing, Crooke proposes that it is necessary to 'praemise somewhat concerning the production of a Sound in generall, for by that meanes our knowledge of this Action of the Soule, I meane the Sense of Hearing will bee better guided and perfected' (691). When it comes to the subject of hearing, Crooke yields to traditional explanations provided by philosophers: 'Considering that to intreate of the manner of Hearing belongeth rather to a Phylosopher then to Anatomists, wee will be but briefe herein, yet somthing we thinke good to say because the structure of the eare was for the most part vnknowne to the Ancients' (609). The explanations Crooke offers for the production and distribution of sound are not much different from others previously discussed in this chapter, so I will only briefly rehearse his account here. According to Crooke, three actions are required for the production of sound:

> The first action is the affront which is betwixt the two bodies which offend one aginst another. The second is the fraction or breaking of the *Medium*. The third and last is the *sounding* of the *Medium*, for so you shall giue vs leaue to call it, because wee can deuise no other name.
>
> (693)

He defines sound as 'a passiue and successiue quality produced from the interception and breaking of the Aire or Water which followeth vpon the collision or striking of two bodyes, & so fit to moue the Sense of Hearing'. Crooke gives his most concise account of sound and hearing in the later part of the book, where he deals with various questions that may be posed concerning sound and hearing:

> The manner therefore of Hearing is thus. The externall Ayre beeing strucken by two hard and solid bodyes, and affected with the qualitie of a sound doth alter that Ayre which adioyneth next vnto it, and this Ayre mooueth the next to that, vntill by this continuation and successiue motion it ariue at the Eare. For euen as if you cast a stone into a pond there will circles bubble vp one ouertaking and moouing another: so it is in the percussion of the Ayre, there are as it were certaine circles generated, vntil by succession they attaine vnto the Organ of Hearing ... The Ayre

endowed with the quality of a sound is through the auditory passage, which outwardly is alwayes open, first striken against the most drie and sounding membrane, which is therefore called Tympanum, or the Drumme. The membrane being strucken doth mooue the three littel bones, and in a moment maketh impression of the character of the sound. This sound is presently receiued of the inbred Ayre, which it carryeth through the windowes of the stony bone before described, into the winding burroughs, and so into the Labyrinth, after into the Snail-shell, and lastly into the Auditory Nerue which conueyeth it thence vnto the common Sense as vnto his Censor and Iudge. And this is the true manner of hearing.

(696)

Finally, Crooke delivers 'an explication of certaine hard Problemes about the Eares'. The section is a 'dilucidation of some difficult questions concerning the Eares, which knots we will vntye and explaine for a conclusion of these controuersies' (698). The first and most involved of the eight questions is 'How it comes to passe that wee are more recreated with Hearing then with Reading: For we are wonderfully delighted in the hearing of fables and playes acted vpon a Stage, much more then if wee learned them out of written bookes'. Crooke, citing Scaliger, provides no less than six possible answers to this question. The first is that, because it is less laborious to hear than to read, we prefer the former. The second reason is voice affects us more exactly through inflection and insinuation, 'whereas reading is onely a dumbe Actor'. Third, because things which are heard make a deeper impression in our minds. Fourth, because we prefer to share our experiences with others, and 'there is a kinde of society in narration and acting, which is very agreeable to the nature of man, but reading is more solitary'. Fifth, because we are compelled by shame to obediently pay attention to those speaking to us, which obligation is not operative when we read the words of others. Crooke argues that we naturally prefer the pleasure of 'a diligent and curious acting, then in a negligent and careless' mode of paying attention. The sixth and final reason he offers is that we prefer having the opportunity to respond to our interlocutors, and that we thereby derive more profit by asking questions. Here again Crooke refers to the contemporary stage in illustration of his point: '... because Bookes cannot digresse from their discourse for the better explication of a thing, as those may which teach by their voyce. For in changing of words or mutuall conference, many pleasant passages are brought in by accident, as the Interlocutors list to aduance themselues; as we see in

Comedies it is very ordinary' (698). Crooke, like Bacon and Wright, ends his disquisition by posing a series questions concerning sound and hearing; for each of these authors, the subject of sound seems to raise more questions than answers.

'And this is the true manner of hearing'

I have conducted this survey of early modern English discourses on sound and hearing in the hope that what these writers say about sound would tell us something more about their relationship to it. In fact, we find that the language they use to communicate their conceptualization of sound is heavily intonated with a network of specific associations. To conclude this chapter, I wish to reiterate some of these associations before we explore their various articulations in Shakespeare's works.

We find that the philosophical and anatomical discourses of the day are still heavily indebted to the traditional Classical and medieval authorities. We have heard many of these authors admit that the phenomena of sound and hearing are very difficult to understand and express. They intuit that the traditional accounts are not entirely accurate, but they don't have the intellectual tools to offer more robust theories with which to replace them. Because it is lesser understood than sight, hearing is the sense more closely aligned with tradition, whether philosophical or religious. All of the writers we encountered express a belief that hearing provides a privileged mode of access to the body's internal spirits, and from thence to the soul. Several of them also relate sound to notions of identity, whether personal or cultural – especially in the ways sounds interact with and influence personal and cultural predispositions. Sound is also related to the notion of community, because as Crooke notes, 'there is a kinde of society in narration and acting, which is very agreeable to the nature of man'.

The Protestant discourse on hearing is heavily sedimented by notions of penetration and obedience. We have seen that the government was aware of these associations as well. Taken on their own, these words can possess negative connotations for many post-Enlightenment readers; therefore it may be helpful to supplement them semantically with their more volitional counterparts, receptivity and duty. The parable of the sower serves as the central link for another network of associations having to do with the transformative and generative possibilities of sound. The parable suggests a relation between agricultural/sexual reproduction and the perceptual/aesthetic valences of hearing. In a related metaphor, hearing is conceived of as a kind of

cognitive nourishment. We have heard Robert Wilkinson describe the ear as 'where the soul feedeth', and Helkiah Crooke quote Aristotle's belief that hearing was 'created for the vnderstanding of Arts and Sciences'. In our own time, the very same relationship between understanding and transformation has been recognized by the philosopher Charles Taylor, who writes that 'in the sciences of man insofar as they are hermeneutical there can be a valid response to "I don't understand" which takes the form, not only "develop your intuitions", but more radically, "change yourself"' (Taylor 1985: 293). And this is the true manner of hearing.

3
Receptivity

When you're thin, and damp and shoddy, just
remember that you're in a body.
Ooh baby, when that human music plays I don't
know why ...
> The Soft Boys, 'Human Music'

I'll let you be in my dream if I can be in yers, an' I
said that.
> Bob Dylan, 'Talking World War III Blues'

Hearing is represented in early modern British culture as an opening up of the self, as a kind of surrender or submission, an openness. A willingness to be penetrated, and an openness to the authority of the other are related concepts that inform this disposition. It is important to note that while this receptive acoustic disposition is voiced elsewhere in early modern culture, it simply doesn't appear with equal prevalence in the work of any other poet except Shakespeare. I would argue that what we commonly refer to as the Bard's 'universality', or his wisdom, is the effect of this receptive disposition upon him, and its continuing influence on the ways in which his works invite and allow us to enter into them. This invitation to dialogue is what makes Shakespeare a great writer. The characters and plays allow us to lay our own meanings over them. They have a certain (semantic) density that is caused by their ability to *receive* meanings, in addition to their evident capacity to express them. The argument of this chapter is that Shakespeare's works continue to attract meaning because they were written by a listening self, by an author who didn't see the kind of radical receptivity early modern English subjects associated with hearing as vulnerability, but rather as strength. Our recognition of this receptivity as an important component of his aesthetic stance is evidenced by its growing

prominence in the metaphoric figurations we use to describe and analyse his genius. For example, at the end of the twentieth century, Shakespeare, the foundational culture-hero of western modernity, is no longer a star, or even a superstar, but a black hole.

Gary Taylor is to my knowledge the first to advance this metaphor, a trope he ventures at the close of his book *Reinventing Shakespeare* (1989: 410–11). During his final chapter's treatment of the traditional notion that Shakespeare possessed a singular, unique genius, he notes that the effect of Shakespeare on our literary universe is like that of a black hole:

> Light, insight, intelligence, matter – all pour ceaselessly into him, as critics are drawn into the densening vortex of his reputation; they add their own weight to his increasing mass. The light from other stars – other poets, other dramatists – is wrenched and bent as it passes by him on its way to us. He warps cultural space-time; he distorts our view of the universe around him.

This is as far as Taylor pursues this argument, which is perhaps less an argument in the service of analysing the apparent singularity of Shakespeare's genius and talent than yet another wonderfully poetic way of describing that singularity, this time by comparing it to something immensely powerful, infinitely weighty, dimly understood, difficult to locate, and above all, threatening in its indiscriminate voracity. In the long history of critical praise for the bard's singular genius (a history Taylor both bemusedly depreciates and participates in here), this is a specifically 'twentieth-century' iteration of tribute to the god. Shakespeare becomes a black hole, the post-Einsteinian volcano into which whole throngs of alienated and anxiety-ridden critics sacrifice themselves, intentionally and otherwise. I myself am compelled to follow up on Taylor's metaphor, to further literalize it, sound it out more completely, because I find it rich and suggestive for reasons of my own, reasons which relate to my impressions about the importance of sound and hearing in the anatomy of Shakespeare's genius and talent, reasons which speak to the forms of attendance and sacrifice that are generated or informed by the perceptual economy of sound. It is my own way of leaping into the volcano.

From the cultural standpoint, a black hole such as Shakespeare forms in the transition from fame into legend and myth, when a culture finds in the life or work of a figure the necessary capacity both to inscribe its ethical universe and to address therein the anxieties and challenges which confront that universe over the *longue durée*. Hercules seems to have been such a figure in the Classical world, judging from

the number and variety of narratives that spring up about him. Although there are many stars in western culture, from political leaders to artists to scientists, there are only two black holes, two figures with the requisite *capacity* to be considered such; they are William Shakespeare, and Jesus Christ. Paradoxically, the boundless capacity of these figures is a function of their radical opacity, an opacity that takes on the characteristics of a reflective surface, like a sounding board. Taylor intuitively describes this phenomenon with respect to Shakespeare when he suggests that 'we find in Shakespeare only what we bring to him or what others have left behind; he gives us back our own values' (411). Their capaciousness also derives from the lacunae that exist in, and come to characterize, their personal narratives. For both figures we lack an enormous amount of definitive psychological and biographical documentation. We know next to nothing about either's early life, and little more objective information about what follows except for the sketchy details that can be gleaned from contemporary legal records. The main sources for our knowledge of both figures are the respective texts generated in the immediate wake of their living voices.[1] It is the capaciousness, finally and most importantly, of these texts themselves, the ways in which the cultural conditions and ethical structures they describe seem already to *contain* us, that sets the gravitational momentum in motion and causes the black hole phenomenon to form around these figures. Shakespeare's genius is increasingly imaged not in terms of the ability to penetrate or dominate, but in terms of the ability to receive and to be penetrated.[2]

Hearing in Shakespearean cognition

In the film *Shakespeare in Love*, screenwriters Marc Norman and Tom Stoppard poke fun at traditional Romantic conceptions of Shakespeare's divinely-inspired poetic genius by materializing his muse, and bringing her down to earth. The film's main plot line is in fact born of this strategy. Shakespeare is portrayed as a kind of literary antenna specially attuned to the poetic potentialities in the world of raw discourse around him. Bits of flotsam and jetsam in the immediate acoustic environment end up in whatever he's writing at the time – such as the curse 'a plague a' both your houses' directed at the two competing playing companies during a public declamation by Philip Stubbes, which later finds its way into Mercutio's mouth. Norman and Stoppard's playful reconstructions of the links between Shakespeare's creative consciousness and his discursively-tuned ears resonate unmistakably with a recent spate of scholarly work that investigates various aspects of the

bodily experience of early modern consciousness, via the ways in which those experiences are voiced and recorded in the discourse of the era (Hillman and Mazzio 1997; Laqueur 1990; Paster 1993; Sawday 1995).[3] The main premise these studies share, and collectively argue for, is that discourse actually influences the experience of corporality throughout history. If this is the case, if the discursive environment does shape our experience of ourselves as embodied subjects, then certainly we need to recognize sound as an important, if not the most important, perceptual domain with respect to the creation and perpetuation of that experience, especially in considerably 'oral' cultures such as early modern England.

Furthermore, literary scholars are only just beginning to grasp the implications of the fact that one of those *bodily* experiences is consciousness itself. One critic working on the links between Shakespeare's language and what it may tell us about the deep structures of early modern consciousness is Mary Thomas Crane. Her approach to *Measure for Measure* begins with the notion that we need to historicize the very idea of cognition (Crane 1998).[4] To that end, her reading starts from 'an assumption shared with pre-Cartesian psychology of the early modern period, the assumption that the mind is inextricably part of the material body' (271). The aim of studying literary texts from the standpoint of cognitive theory is to search for

> traces of prediscursive spatial shapings of language, for example, in images and words that cluster, in radial categories, around spatial concepts, such as agency or containment. A cognitive reading might begin to suggest how discursive formations in a culture intersect with cognitive structures (at points where ideology is most powerful) but also conflict with them (at points where ideology is most likely to slip).
>
> (274)

Language provides access to the ways in which prediscursive experience is categorized, to the ways in which our brains, like our ears, are tuned to the world around us. Words are windows onto the structure of consciousness. The images they present offer 'access not just to meanings familiar from psychoanalysis but also to the underpinnings of thought itself, especially to the mechanisms that integrate disparate experiences' (274). These 'mechanisms' are metonymic connections which operate at such low latency that they often appear metaphoric or even random, since we usually aren't consciously aware of the low-level categorical principles which motivate them.[5] So far, one of the

main goals of cognitive literary studies has been to recognize these connections where they occur, which is frequently in the relationships between the different meanings that inhere in multivalent expressions, especially as these meanings come to rest and reside in diverse cultural practices and preoccupations.

I advance Crane's discussion of *Measure of Measure* because it relates closely to the discourse about sound, hearing, and receptivity that occurs in the early modern context. The very title of her article, 'Male pregnancy and cognitive permeability in *Measure for Measure*', suggests its relevance to the associations between sound, receptivity, and penetrability which we have found already heavily embedded in the discourse of the period. One is reminded, for instance, of the notion of the feminized ear that crops up in contemporary religious discourse, wherein the ear is held to be the site of spiritual fertilization. This notion is figured not only in such Biblical stories as the Annunciation, wherein Mary is impregnated through the ear, as well as the temptation of Eve, in which evil is engendered in the world through Eve's ear, but also in the idea of the true believer as bride-to-be of Christ. We have seen that the image even appears in contemporary political iconography as well.

The cornerstone of Crane's argument is her extended gloss on Shakespeare's use of the term 'pregnant', a term which she observes wouldn't take on its more familiar, exclusively physiological meaning until some years after Shakespeare's death:

> In this play Shakespeare focuses on a lexical oddity – the strange etymology of the word *pregnant* – to explore the cognitive implications of the humoral body in culture, especially as it thinks and speaks. For Shakespeare *pregnant* was a word that named the multiple ways bodies are penetrated by the external world and produce something – offspring, ideas, language – as a result of that penetration.
>
> (275–6)

For Shakespeare, the term *pregnant* was itself pregnant with meaning: it suggested 'interconnected concepts of plenitude, ability to make an impression, and vulnerability to penetration or impression' (277–8). He used the word primarily to describe things that *contain* significance or weight, and which do so typically as the result of some form of bodily or cognitive receptivity. Not infrequently, he conflates these two forms of receptivity. In *Twelfth Night*, for example, when Viola tells Olivia the discourse she brings is reserved for her 'pregnant and vouchsafed ear' alone, she flatters her by implying that Olivia alone of the

present company has the requisite moral, intellectual, and emotional capacity to receive her discourse (3.1.89). Olivia immediately asks for privacy and, though she has fallen less for the message than the messenger, prepares to take sole possession of Cesario's discourse: 'Let the garden door be shut, and leave me to my hearing' (3.1.92–3).

The receptive ear in *Coriolanus*

Among the associations ears have in the early modern period is that they are pregnable, and therefore potential targets of violent attack. This is especially apparent in Shakespeare's works. The ears are specified as sites of extreme vulnerability in almost every one of the major tragedies. No doubt the most famous instance occurs in *Hamlet*, where the king is poisoned through the "porches" of his ears with a "leprous distillment" (1.5.63–4). The ears are uncontrolled orifices, dangerously exposed at all times to possible contamination by the introduction of an infectious or poisonous agent. R.R. Simpson has suggested that the precise method of Hamlet Senior's murder is based on contemporary reports of a similar homicide in the court of the Medicis by a physician, named Gonzago.[6] Although the agent that threatens the ear can be physical, as in *Hamlet*, Shakespeare is more likely to imagine the infection or poison as verbal. When Iago confides that he'll "pour this pestilence into his [Othello's] ear," when Lady Macbeth, reading her husband's letter, conjures him to return home swiftly, 'that I may pour my spirits in thine ear', or when Pisanio reacts to the letter from Posthumous in *Cymbeline*'s third act, exclaiming 'Leonatus! / O master, what a strange infection / Is fall'n into thy ear! What false Italian / (As poisonous tongu'd as handed) hath prevail'd / On thy too ready hearing?', the pestilence, spirits, and infection are all figures for contaminating discourse (Oth. 2.3.356; Mac. 1.5.26; Cym. 3.2.2–6). A related example in which the ear is figured as the victim of violent penetration occurs in *Julius Caesar*, when Messala finds the body of Cassius and tells Titinius he will 'go to meet / The noble Brutus, thrusting this report / Into his ears; I may say "thrusting" it; / For piercing steel, and darts envenomed, / Shall be as welcome to the ears of Brutus / As tidings of this sight'; another is when Hamlet apprises his mother of the truth about her first husband's murder, and she responds, 'these words like daggers enter in my ears' (JC 5.3.73–8; Ham. 3.4.95).

Aural vulnerability is presented as more physical in the comedies, where it is common for characters to get a 'box of the ear'. Portia describes her Scottish suitor as having 'borrowed a box of the ear of the Englishman' in *The Merchant of Venice* (1.2.80). Shakespeare and his

audiences clearly enjoyed the joke of alluding to this sort of 'rough music' as if it were also a type of discourse. In *Measure for Measure* Escalus proposes to Elbow that 'if he took you a box o' the ear, you might have your action of slander too', while in *The Comedy of Errors* Dromio of Ephesus describes the beating he receives from his master in the same terms: 'he told me his mind upon mine ear: / Beshrew his hand, I scarce could understand it' (MM 2.1.175; Err. 2.1.49–50). Falstaff consoles the Lord Chief Justice after similar treatment: 'For the box of the ear that the prince gave you, he gave it like a rude prince, and you took it like a sensible lord' (2H4 1.2.193). Morris Tilley notes that the proverb 'to get a box of the ear' ironically meant 'to be the recipient of a stroke of luck' (Tilley 1950; 61).

It is striking how often violence and ears get mentioned in the same breath throughout *Coriolanus*, especially by the title character. Martius announces the great esteem in which he holds his rival Aufidius: 'Were half to half the world by th'ears and he / Upon my party, I'd revolt, to make / Only my wars with him' (1.1.233–5). In the second scene of the third act Coriolanus explodes onto the stage, responding to the threat of exile with 'Let them pull all about mine ears, present me / Death on the wheel or at wild horses' heels …' (3.2.1–2). Banished, Coriolanus appears in Antium at the house of Aufidius, where the Third Servant recounts his promise to go 'and sowl [yank] the porter of / Rome gates by th' ears' (4.5.210–11). Upon hearing news Coriolanus has joined forces with Aufidius and is headed back to Rome, the general Cominius bitterly forewarns the tribunes 'He'll shake / Your Rome about your ears' (4.6.97–8).

In addition to its association with vulnerability, aural receptivity is also recognized in the era as instrumental to the composition and maintenance of identity. Shakespeare employs sound and auditory imagery extensively in his explorations of the formation of personal and political identity in *Coriolanus*, a play in which these linked topics are foregrounded to a greater extent than anywhere else in his work. The ear is a sense organ that is also an orifice, a liminal site where bodily limits and personal identity are negotiated. Vulnerable mediators of the Other's claims on the self, the ears are constantly involved in the dialogical constitution of personal and social identity. In her cognitive reading of *Measure for Measure*, Mary Crane finds the Duke in that play 'unable to maintain his fantasy of solitary completeness and inviolability … unable at the same time to accept the inevitable vulnerability and contamination that are the conditions of human selfhood, productivity, and exchange' (292). The assessment closely resembles the central argument of more than one account of *Coriolanus*'s title character (see Adelman 1978; Weckermann 1987). Such radical vulnerability is a

fact inimical to the radical self-authentication and self-definition for which tragic heroes like Coriolanus so often strive.

Carol Sicherman has commented on the noise that accompanies Coriolanus throughout the play. She finds him 'constantly associated with noise, both of acclaim and of disgrace'. But the main thing to note about this noise, she suggests, is how befitting it is 'to the inarticulate hero' because it is, 'like him, volatile and ineffective' (Sicherman 1972: 199). Frank Kermode, in his introduction to the play for the Riverside edition, remarks on the extent to which the soundscape of the play is dominated tonally by its main character:

> He himself hums like a battery, and so does his play. Against this noise Shakespeare counterpoints the brisk character-writer's patter of Menenius, the elegant conversation of the ladies, the lively unheroic prose of the good fellows in the crowd. But the dominant noise is the exasperated shout of the beast-god Coriolanus.
>
> (Kermode 1997: 1443)

Within the world of the play itself Martius is repeatedly identified by the sounds he makes, and those associated with his presence. For example, outside the gates of Corioles Lartius prematurely eulogizes his lost comrade, praising him as a complete soldier, 'not fierce and terrible / Only in strokes, but, with thy grim looks and / The thunder-like percussion of thy sounds' (1.4.57–9). Even though he is cloaked in blood when he returns to camp, Cominius recognizes the hero the moment he opens his mouth: 'The shepherd knows not thunder from a tabor / More than I know the sound of Martius' tongue / From every meaner man' (1.6.25–7).

It was contemporarily believed that unlike sight, which mainly gives knowledge about surfaces and exteriors, sound has the special capacity to provide knowledge about interiors. It is this special faculty of sound that gives Coriolanus away with the plebeians during his attempt to be elected consul. Menenius tries unsuccessfully to placate the crowd, telling them (against their intuitions as usual) that their ears have misled them all along, that they haven't understood his man properly: 'Do not take / His rougher accents for malicious sounds, / But, as I say, such as become a soldier' (3.3.54–6). Later, Coriolanus is banished and seeks exile in Antium, where Aufidius does not at first recognize him by sight, especially in a domestic context. Coriolanus resorts to describing the effect the sound of his name will have on him. It is, he says, 'A name unmusical to the Volscians' ears, / And harsh in sound to thine' (4.5.63–4).

In the Classical world of *Coriolanus*, as in Shakespeare's England, fame is an extremely important index of social value. In both cultures,

'report' is a basic factor in the composition of identity. Jarrett Walker
has shown how closely the main character's two names are tied to
specific subjective dispositions. He writes, '"Martius" is an individual
who is constituted or "programmed" by his mother's language;
"Coriolanus" represents that same individual's retreat from language,
his desire for a transcendent, deific identity that is the result of the reifi-
cation of a single violent act ... into a stable, eternal condition' (Walker
1992: 171). In the play, Volumnia voices what appears to be the tradi-
tional Roman attitude toward the subject of fame and good report. If
Martius had died in battle at Corioles, she claims 'then his good report
should have been my son; I therein would have found issue' (1.3.19–
20). Her son shows the extent to which he has internalized this attitude
when he tries to rally the Roman troops, commanding them to fight
'... if any fear / Lesser his person than an ill report' (1.6.69–70). Valeria
is also keenly aware of her husband's good reputation, and lets slip this
awareness with one of those marvellous mild oaths that acoustically
locates her as the wife of a bourgeois citizen in Shakespeare's own day.
'In troth,' she says, 'there's wondrous things spoke of him' (2.1.136–7).

As Walker maintains, the power of aural constructions of identity
are such that they have made Caius Martius who he is. Evidence of this
appears throughout the play. Volumnia recounts to him how her
'praises made thee first a soldier', and then promises him more good
words in the future if he agrees to apologize to the plebeians: 'To have
my praise for this, perform a part / Thou hast not done before'
(3.2.109–12). She also threatens her son when he is on the verge of
destroying Rome, by referring to the effect that the act will have upon
his reputation in posterity:

> ...if thou conquer Rome, the benefit
> Which thou shalt thereby reap is such a name
> Whose repetition will be dogg'd with curses,
> Whose chronicle thus writ: 'The man was noble,
> But with his last attempt he wip'd it out,
> Destroy'd his country, and his name remains
> To th' ensuing age abhorr'd.'
>
> (5.3.142–8)

Seeking audience with Coriolanus before he destroys Rome, Menenius
attempts to cash in on his own good name as a way of gaining access to
his old friend. He tells the unimpressed guards, 'If you have heard your
general talk of Rome, / And of his friends there, it is lots to blanks / My
name hath touch'd your ears', to which the first replies, 'The virtue of

your name / Is not here passable' (5.2.9–13).[7] Fame and report, it turns out, are locally-specific currencies; Menenius finds he is not for all markets. Shakespeare's plays and the ears of their audiences open to each other in mutual receptivity, at which point cognition becomes recognition, and perception an inchoate political act. The manifest political aspects of *Coriolanus* have understandably attracted an enormous amount of attention over the years, at least since a clutch of studies in the late 1960s and early 1970s (Burke 1966; Hale 1971; Rabkin 1966; Vickers 1966), followed by a number of works in the late 1980s and early 1990s informed by ideological perspectives (Bristol 1987; Cook 1991; Dollimore 1993: 218–30; Williamson 1991; Wilson 1991). Special attention has been paid to the metaphor of the body politic in the play as well (Gurr 1975; Jagendorf 1990; Motohashi 1994; Riss 1992; Sorge 1987). None of these studies have linked the play's illustration of political life to its representation of cognitive *im*permeability, however. Coriolanus's avoidance of listening to others means there will remain no chance for the discursive construction of any sort of shared communal life, at least of one in which he will participate. The body politic is inextricably intertwined with that of the politicized body. In this play, personal and political survival are each predicated upon recognition of the Other. In *Coriolanus*, as in *Measure for Measure*, Shakespeare presents such recognition not as a choice, but as an inevitability. Caius Martius only becomes Coriolanus, after all, by listening to his mother, giving credence and attributing authority to her discourse about him.

The Elizabethan political establishment was acutely aware of the ties between hearing and the recognition of authority. We have seen the way the British government capitalized on that link by preaching political obedience in the religious setting. Attentive regulation of the playhouses is another example of that awareness. Playhouses and churches provided almost the only early modern environments in which large numbers of people could share the same acoustic experience in simultaneity. Evan Eisenberg has called attention to the political ramifications that result from this type of simultaneously shared acoustic experience, which puts listeners 'under the spell of a shared event', and effects what he calls 'ritual solidarity' (Eisenberg 1987: 31). Like their early modern counterparts, political leaders in the twentieth century have also been quick to mobilize the power of shared acoustic experience. One need look no farther than Franklin D. Roosevelt's use of radio in his fireside chats, or Adolf Hitler, who reportedly disclosed that he 'could not have conquered Germany without the loudspeaker' (Eisenberg 1987: 30). The association between control of the soundscape and authority is

made overt throughout *Coriolanus*. The juxtaposition is evident from the very beginning of the play, where the acoustic field is seized by the cacophony of an unruly mob, accompanied by first spoken words which are an individual appeal for political recognition.

Bruce Smith remarks that 'all but a handful of Shakespeare's scripts display quite obvious devices for establishing the auditory field of the play within the first few moments' (Smith 1999: 276). Working without house lights to signal the start of his plays, Shakespeare employed a wide range of techniques to take command of the auditory field: there is the storm at the beginning of *The Tempest*, thunder in *Macbeth*, a musical introduction to *Twelfth Night*, the argument that brings *The Taming of the Shrew* crashing onto the stage, Richard of Gloucester's sly charismatic confidences, and the more traditional Prologues of *Henry V*, *Troilus and Cressida*, *Henry VIII*, and *The Two Noble Kinsmen*. Each of the *Henry VI* plays employs a different technique: for the first there is a dead march, for the second ceremonial trumpet and hautboy flourishes, for the third a fight scene. Anxious calls into the imagined darkness at the outset of *Hamlet* establish not only the auditory field, but the tone of the entire play. The device is at its most crudely obvious at the beginning of *2 Henry IV*, where Rumor walks onstage and orders the audience simply to 'Open your ears; for which of you will stop / The vent of hearing when loud Rumor speaks?' French scholar J. P. Debax has observed that many plays from this period contain similar opening speeches, events he identifies as complex utterances: 'cet ordre, de faire silence est également adressé par la pièce qui commence, par les acteurs que entrent en scène, aux spectateurs, et leur signale que le jeu démarre' (Debax 1984: 63). These opening bids for attention, by virtue of their 'double énonciation théâtrale' signal to the audience that the play is starting, and concurrently function as speech acts that occur within the fictional world of the play.

Coriolanus assumes the stage with a clamorous 'company of mutinous Citizens with staves, clubs, and other weapons'. A nameless character implores the restive throng 'Before we proceed any further, hear me speak' (1.1.1–2). As complex utterances go, the play's opening words turn out to be especially rich, as multivalent as the portentous 'Who's there?' that rings in *Hamlet*. The demand for ears at the beginning of *Coriolanus* is of course a call for the audience's attention, as well as a request for the ears of the other characters onstage. It is also, however, closely related to the other demand made by the plebeians in this first scene, and another meaning of the term *ear* in the period. The reason for the plebeians' discontent is their conviction that the patricians are witholding corn from them. *Ear* in Shakespeare's day commonly meant corn or grain of any kind. The second substantive definition of the

word in the OED is 'a spike or head of corn; the part of a cereal plant which contains its flowers or seeds'.

Shakespeare uses the word *ear* in its agricultural sense in a number of plays. For instance, begging clemency from Henry Bolingbroke for her traitorous son Aumerle, the Duchess of York manages a sarcastic jibe at her husband, who has just arrived to expose him: 'in thy piteous heart plant thou thine ear' (R2 5.3.126). In Gertrude's chamber Hamlet shows his mother miniatures of her two husbands, and compares Claudius to a blighted crop: 'Here is your husband, like a mildewed ear, / Blasting his wholesome brother' (3.4.64–5). The reference to an infected ear here specifically recalls the manner in which Claudius has murdered the King. In *As You Like It*, Silvius agrees to help Phebe in her pursuit of Ganymede/Rosalind with nothing in return for his pains but the hope of love's leavings: 'I shall think it a most plenteous crop / To glean the broken ears after the man / That the main harvest reaps' (3.5.101–3). Upon Bertram's arrival at the French court, the King greets him and fondly remembers the wise conversation of the boy's father: 'his plausive words / He scatter'd not in ears, but grafted them, / to grow there and to bear' (AWW 1.2.53–5). All of these examples, especially the last, hearken back to the relations between hearing, agriculture and incorporation that motivates the principal metaphor of the parable of the sower, so central to contemporary religious discourse on the soundscape.

The initial political dispute presented in *Coriolanus*, the plebeians' calls for agricultural ears, echoes and reinforces their desire for the political ears of the patricians. Bodily, perceptual, and political senses of the word *ear* all speak to each other here in an aural palimpsest, formed from a radial category centred on what George Lakoff would call an 'idealized cognitive model' of *ear* as a liminal site of receptivity (Lakoff 1987: 68–76, 91–114). The people's need for the ears of the patricians implies that, in the world of this play, political viability is predicated not only on the availability of food, but on recognition as well. Acceptance of diverse voices into the acoustic community is represented as necessary to the survival of the polity, just as eating is necessary to physical existence.

As the struggle for recognition reaches its climax late in the play, the conflation of corn/ears/people is made explicit when Cominius informs Menenius about Coriolanus's response to his supplication on behalf of Rome:

Cominius: He said 'twas folly,
 For one poor grain or two, to leave unburnt
 And still to nose th' offence.

Menenius: For one poor grain or two!
 I am one of those! His mother, wife, his child,
 And this brave fellow too, we are the grains.
 You are the musty chaff, and you are smelt
 Above the moon. We must be burnt for you.

 (5.1.26–33)

Menenius refers to the entire population of Rome as grain, as ears. The value Coriolanus places upon these ears has become so minimal that he refuses to hear even those closest to him. He refuses to give ear to them, in any sense of the phrase. Just as political enfranchisement is conceptualized in terms of being able to produce sound (to have and to be a 'voice'), personhood is here conceptualized in terms of the ability to produce and receive sound, of the ability to be considered an ear. Bruce Smith reminds us of the acoustic etymology of the word *person*, which means 'a "through-sounding", a "per-*sona*"' (Smith 1999: 7). A similar metaphor appears earlier in the play, where Coriolanus warns of the dangers of giving ear to the plebeians' request for ears:

In soothing them, we nourish 'gainst our senate
The cockle of rebellion, insolence, sedition,
Which we ourselves have plough'd for, sow'd, and scatter'd,
By mingling them with us, the honour'd number,
Who lack not virtue, no, nor power, but that
Which they have given to beggars.

 (3.1.69–74)

Notable in this speech is the idea of contamination, so frequently a concern with respect to bodily/cognitive receptivity. Here it is used in the context of the 'body politic' rhetoric that suffuses the play. Coriolanus identifies political receptivity with social instability. He is well aware of the mutability of the plebeians, a group James Calderwood has dubbed 'phonic chameleons' (Calderwood 1995: 79).

The request for people's ears does not stop at corn, nor do these requests all come from the plebeians. Throughout the play characters constantly demand each others' ears, appealing for recognition. The sheer preponderance of these appeals throughout the play, of characters repeatedly asking to be heard, is one of its most striking aspects. There are no fewer than eighteen instances of this directing of auditory focus throughout the play, and they are uttered by characters of all classes, including the First Senator, Menenius, Sicinius, the Aedile, the First Lord, Aufidius, Volumnia, and of course Coriolanus himself.[8]

Agriculture is the practice of nourishing something that will in turn nourish us. Janet Adelman, Gail Kern Paster and Stanley Cavell have each written brilliant essays on the imagery of food and feeding in *Coriolanus* (Adelman 1978; Cavell 1987: 143–77; Paster 1981). Adelman and Cavell particularly focus on how the metaphor of starving works in the play, how Coriolanus's attempt to be entirely self-constituted and self-nourishing is what contributes to his status as god and beast. Adelman connects this theme to the idea of vulnerability, a 'psychological fact' that she finds central to the play: 'the taking in of food is the primary acknowledgement of one's dependence on the world, and as such, it is the primary token of one's vulnerability' (110). There is a circularity, a reciprocity central to the acknowledgment of mutual independence, that Coriolanus cannot abide. Rather than involve himself in a system of exchange, he wishes to remain singular, flat and linear like the sword he asks his compatriots to make of him (1.6.76).

What has yet to be discussed with reference to this play, however, is the way its central character habitually and unconsciously starves himself through the ear, which, as Robert Wilkinson declared, is 'where the soule feedeth'. Cavell comes closest to the mark – indeed, the idea is the lead melodic line of his essay – when he names Martius and Volumnia 'starvers', and then later notes the equation of words and food in the play (148; 162–3). He notes that the parable of the belly actually does seem to allay the hunger of the rebellious plebeians, when they accept Menenius's words for food. 'The first mystery of the play,' he observes, 'is that this seems to work, that the words stop the citizens, that they stop to listen, as though these citizens are themselves willing, under certain circumstances, to take words for food, or equate them' (163). He finds the play ultimately 'a tale about food, with competing interpretations requiring application, told by one man to a cluster, causing them to halt momentarily, to turn aside from their more practical or pressing concerns in order to listen' (163).

The equation of sound and food is not restricted to early modern religious discourse, or to metaphors identified and employed by literary critics. Cognitive philosopher Daniel Dennett has anchored a popular and persuasive theory of human consciousness on the assumption that the main function of the human brain is to 'assuage epistemic hunger'. According to Dennett, the purpose of the senses is to provide epistemic nutrition (information) to the brain.[9] The senses feed the brain, providing us with information about the environment, our location and status in it. Shakespeare expresses a view strikingly similar to Dennett's, especially throughout the later plays, with particular reference to the ears. In *Pericles*, Simonides thanks Pericles for his music of the night before: 'I do / Protest

my ears were never better fed / With such delightful pleasing harmony' (2.5.26–8). Later in the play, reunited with his daughter Marina, Pericles compares her to his wife Thaisa: 'in pace another Juno; / Who starves the ears she feeds, and makes them hungry, / The more she gives them speech' (5.1.111–13). Hearing the battle between the Romans and Britains from the cave, Arviragus expresses his trepidation at being discovered by the Britons: 'It is not likely / That when they hear their Roman horses neigh, / Behold their quarter'd fires, have both their eyes / And ears so cloy'd importantly as now, / That they will waste their time upon our note' (Cym. 4.4.16–20). In *The Tempest*, Alonzo breaks into the verbal badinage between Antonio, Sebastian and Gonzalo with an exasperated 'You cram these words into mine ears against / The stomach of my sense' (2.1.107–8). Perhaps most famous is how Othello describes Desdemona during his narrative of their courtship: 'She'ld come again, and with a greedy ear / Devour up my discourse' (1.3.149–50).

As notable as the number of times characters call for each others' ears in *Coriolanus* is the number of times they refuse to listen to each other. Coriolanus is of course the most conspicuous example of this in the play: his refusal to recognize the claims of others is the root cause of his inability to live in Roman society – or in Corioli or Antium, for that matter. Carol Sicherman perceptively notes how selective his hearing is: 'Again and again he hears a single word in isolation rather than the sequential speech of which it is part, and he responds so hysterically to the word that he becomes its captive' (Sicherman 1972: 199). His belief in his heroic singularity inflects his perceptions and experience of language. Cominius speaks of Coriolanus as only being able to hear war, when he remarks that 'Now all's his, / When by and by the din of war gan pierce / His ready sense' (2.2.114–16). 'Ready sense' suggests that somehow Coriolanus is specially attuned to the sounds of war, that he identifies himself with that environment. He is not the only character in the play, however, to do so. The noise of war is the sound that gets recognized and privileged in the entire culture of the play. Aufidius's First Servant expresses this sensory inclination very clearly:

> Let me have war, say I. It exceeds peace as far as day does night. It's spritely, waking, audible, and full of vent. Peace is a very apoplexy, lethargy; mull'd, deaf, sleepy, insensible, a getter of more bastard children than war's a destroyer of men.
>
> (4.5.231–5)

For his part, Coriolanus consistently refuses to 'give ear' to others, to

the point of recoiling at hearing his military 'nothings monster'd' (2.2.75–7). His preference for action over words is expressed a few lines earlier, when he recollects that 'oft, / When blows had made me stay, I fled from words' (2.2.70–1). Listening is an activity he finds more painful than battle. 'I had rather have my wounds to heal again,' he avows, 'Than hear say how I got them' (2.2.69–70). He even describes his wounds as having ears of their own: 'I have some wounds upon me, and they smart / To hear themselves remember'd' (1.9.28–9). He would, it appears, rather lose his ears than have to listen to his achievements – an attitude that Menenius finds incredulous: 'He had rather venture all his limbs for honor / Than one on's ears to hear it?' (2.2.80–1). Hans Blumenberg has suggested that 'the attitude of not wanting to hear is marked, even if only metaphorically, as more serious than not wanting to see, since the ear is, by nature, always open and cannot be shut'. For this reason, it is an attitude which 'presupposes a greater degree of contrariness and of intervention in nature than does not seeing' (Blumenberg 1993: 48).

The crucial instance in which Coriolanus starves his ears is of course when he is on the threshold of destroying Rome. Several of the people closest to him appear before him in supplication, including the father-figure Menenius. Coriolanus repeats several times how he will decline to hear suits from the land that has exiled him. 'Mine ears against your suits are stronger than / Your gates against my force,' he warns Menenius. 'I will not hear thee speak' (5.2.89–90, 93). The idea of the senses, including the ears, as gateways to the soul was commonplace in the early modern era, turning up, among other places, in Spenser's House of Alma and Bartolomeo Delbene's *Civitas Veri* (Vinge 1975; Smith 1999: 101–2; E. Wilson 1995: 10–11). Aufidius is impressed with this refusal to hear, and commends Coriolanus for having 'stopp'd your ears against / The general suit of Rome; never admitted / A private whisper, no, not with such friends / That thought them sure of you' (5.3.4–8). Coriolanus responds to this encouragement by renewing his vow of allegiance: 'Fresh embassies and suits, / Nor from the state nor private friends, hereafter / Will I lend ear to' (5.3.17–19). Immediately upon this fresh promise of deafness a shout signals the arrival of Volumnia, Virgilia, and the young Martius. In the end, of course, Volumnia's entreaty gets through to him; the disintegration of his former sense of self is brought about by an act of filial obedience and assent that is accompanied by the most famous silence in all Shakespeare.

The first chapter, 'Opening', of Bruce Smith's *The Acoustic World of Early Modern England*, introduces the sound [o:] as the most basic human mode of entry into the soundscape. At this point I would like to

invite you to read the following passage aloud. Listen to Coriolanus's first speech after relenting to his mother's pleas to save Rome:

> O mother, mother!
> What have you done? Behold, the heavens do ope,
> The gods look down, and this unnatural scene
> They laugh at. O my mother, mother! O!
> You have won a happy victory to Rome;
> But, for your son, believe it – O, believe it –
> Most dangerously you have with him prevail'd,
> If not most mortal to him.
>
> (5.3.183–9)

As you will have experienced in your own body, the sound of [oː] forms the refrain of the entire speech, from its groans of agonized resignation, to the long vowel sounds in 'behold', 'do', 'ope', 'mother', 'Rome', and 'mortal'. The repetition of [oː] marks Coriolanus's entry back into the shared world of human speech, into an acoustic community in which he is merely a player, and not the sole figure. It is the sound of him opening up, becoming receptive to the claims of the Other.

Immediately after this invisible transformation, he turns to Aufidius and pleads for the kind of recognition he has for so long denied to others: 'Were you in my stead, would you have heard / A mother less?' (5.3.191–3). His request that Aufidius put himself in his shoes – to hear, and thence understand things from Coriolanus's own perspective ('were you in my stead'), to recognize the Other – is something Coriolanus himself has been unable to do for the entire play. Of course, Coriolanus is not the only character who refuses to listen. Another character who stops up his ears is Brutus, who during the trial scene proclaims: 'We'll hear no more. / Pursue him to his house, and pluck him thence: / Lest his infection, being of catching nature, / Spread further' (3.1.308–11). We are again presented with an expression of the link between the practice of hearing and the threat of contamination, only this time the sentiment comes from the opposite side of the political spectrum.

Cavell makes the link between physical and epistemic starvation during his essay, and muses on the ramifications it might have for the audience as well. The play's

> incorporation of the parable of the belly I understand to identify us, the audience, as starvers, and to identify the words of the play as food, for our incorporation. Then we have to ask of ourselves, as we have to ask of the citizens: Why have we stopped to listen?

That is, what does it mean to be a member of this audience? Do we feel that these words have the power of redemption for us?

(Cavell 1987: 165)

The *way* a parable communicates is as important as *what* it communicates. The parable expects something from us before it divulges its true message. It expects recognition; it expects a willingness to realize that change proceeds from true understanding. Why do we subject ourselves to the discourses of others; why put ourselves in the vulnerable position of incorporating their thoughts? The first answer Shakespeare seems to offer in this play is that we don't really have a choice in the matter. The second, as anthropologists John and Jean Comaroff indicate, is that receptivity is not really a position of vulnerability at all, but rather one of immense potentiality – of a power that has typically been characterized as feminine:

> this weakness is also a source of strength. For a body that is unstable and penetrable may be the stuff of powerful transformations, or it may serve as a willing receptacle for superhuman forces. Spirit possession, in various societies, plays with tropes of physical permeability: with mounting, copulating, and, most dramatically, with the invasion of corporeal space that is frequently, if not invariably, feminized.

(Comaroff and Comaroff 1992: 74)

An audience's willingness to hear is its willingness to be receptive and set its identity at stake. Caius Martius's dream of self-authorization, of a completely self-sustaining existence, is both initiated and destroyed by his necessary obedience to the claims of the Other, claims such as those of his mother Volumnia which bring into possibility his very existence as Coriolanus. The destruction of that self is not brought about by his final obedience to these claims, but by his sustained period of deafness to them, his denial of ears, his vulnerability to the idea of invulnerability.

Coriolanus illustrates how receptivity to sound contributes to the formation of personal identity, and how that identity in turn reaches out into the world and affects cultural and political practices, including the perpetuation and formation of further personal identities and political configurations. The dialogical relation of the individual to the outside world and culture is paramount in this play – especially how that relation is (mis)understood by specific characters such as Volumnia, and through her, Coriolanus himself. The ears, liminal spaces where the outside is let in, are tuned in this dialogue to shape our perceptions not only of *physical* events such as spoken words and sounds, but of

conceptual entities such as culture, kinship, political structures, and personal identity itself.

Several critics have remarked how Shakespeare, in what is purportedly his final tragedy, represents the insufficiency of language, expressing skepticism about the power of the tool with which he had become so proficient by this point in his career (Calderwood 1995; Riss 1992; Sicherman 1972). Kenneth Burke, troubled by the play's ambivalent portrayal of its hero, felt compelled to classify *Coriolanus* a 'grotesque' tragedy (Burke 1966). Burke's gesture points to the play's insistent, unrelenting acknowledgment of what I can only feebly describe as a carnivalesque, radical provisionality, a recognition that the institutions we create and inhabit – socio-political systems, ideologies of personal and bodily subjectivity, perceptual conventions, knowledge itself – exist in time as we do. Like ears, they remain continuously open, to time if nothing else, for the duration of their existence unfinished.

Transformation and continuity

I may have a smack of Hamlet myself, if I may say so.
Samuel Coleridge

Everybody's got a little Elvis in them.
Mojo Nixon

Elvis ate America before America ate him.
Passengers

In the early modern experience of physicality, the ear is considered an unregulated bodily orifice, a site of vulnerability which, like the mouth, is a portion of the upper bodily stratum characterized by its continuity with the outside world. We have seen that sound was considered the most direct perceptual avenue to the soul in the religious, philosophical, and anatomical discourses of the period. In the contemporary notion of the feminized ear we also find sound associated with physiological and agricultural forms of reproductive transformation. In this chapter I will further trace the interrelations between sound, transformation, and grotesque continuity that were widely recognized in Shakespeare's day, and listen for these interrelations as they are articulated in some of his works. These ideas find their earliest literary expression, however, in the work of Ovid, arguably the most popular, influential, and beloved author of the Classical tradition in Shakespeare's day.

Woordes within the ground

Ovid begins the eleventh book of his *Metamorphoses* with an ending: the death of Orpheus. After losing Eurydice a second time, the legendary musician returns from the underworld to settle in Thrace, where he abjures the company of women and surrounds himself with the local

men. As Arthur Golding translates from the tenth book, it is here that he 'taught the Thracian folke a stewes of Males too make / And of the flowring pryme of boayes the pleasure for too take' (Ovid 1567: 123). While singing one day, Orpheus is attacked by a crowd of women he has doubly enraged: first by his complete lack of attention to them, and secondly by the way he has attracted the men's interest away from them. Sound turns out to be the decisive weapon in the astonishing scene of violence that follows. Orpheus apparently defends himself with his music, which functions like a science-fiction force field. The lances and stones the women hurl at the singer are strangely affected by his music, and fall harmlessly at his feet, 'vanquisht with his sweete / And most melodius harmonye' (135). Their weapons prove completely ineffective against the music he produces, which has the power to charm all animal, vegetable and mineral forms of matter, not to mention the denizens of the underworld. The tide of battle turns, however, once the women gain control over the soundscape with their own instruments and vocalizations, which mask and confuse the arresting power of his music:

> Yit had the sweetenesse of his song
> Appeasd all weapons, sauing that the noyse now growing strong
> With blowing shalmes, and beating drummes, & bedlem howling out,
> And clapping hands on euery syde by Bacchus drunken rout,
> Did drowne the sownd of Orphyes harp.
>
> (135)

With the sound of his music eclipsed by that of the women, Orpheus loses his sole mode of defence against the attackers. They descend upon him and, with plowing implements found in nearby fields, kill and dismember him.

Ovid juxtaposes the death of Orpheus with the story of the judgment of Midas, a tale with obvious parallels. Cured of his addiction to the accumulation of gold and wealth, Midas elects to pursue a life in the countryside, where he becomes a devotee of the god Pan. One day on the mountain Tmolus, Pan challenges Apollo to a musical competition, which is to be judged by the mountain itself. Each musician performs in turn; Pan plays upon his reed pipes, Apollo his lyre. As in the death of Orpheus, the narrative involves a contest or conflict between genres of musical instruments that operate as traditional acoustic indicators of high and low culture, each freighted with ideological connotations. The harp, lyre, and other polyphonic stringed instruments are aligned here with harmonic rationality and civic culture, while drums and wind instruments such as the shawm, the bagpipe, and the reed flute are associated

with simplicity, rural life, and unrestrained Bacchic festivity. After the two musicians have performed, Tmolus pronounces judgment in favour of Apollo, a verdict 'lyked well of all', and obvious to everyone present (137). Everyone, that is, except for Midas, who insists on his preference for the more rustic music of Pan. For this insult Apollo punishes Midas at the bodily site of his offence, transforming his ears into those of an ass.

When early modern writers allude to the judgment of Midas, they usually point to it as an object lesson in acute aesthetic impairment. There is no real disagreement as to whether the punishment is actually deserved, or inquiry as to why Midas might prefer Pan's flute to the lyre of Apollo. This is, after all, an instance in which the ideological valences of the two instruments might well come into play: the king has left the corrupt high-culture environment of his court for a more pastoral existence; therefore, his preference for the rustic music of Pan might well be read as a logical, understandable reaffirmation of that choice. Early modern authors typically accept the tale at face value, however, and with a commonsensical awareness of the king's track record they tend to side with Apollo in accounting Midas a fool worthy of his ass's ears. The point of the tale is that Midas has heard incorrectly, that there is a right and a wrong way to use one's ears. Geoffrey Whitney, for example, uses the story to illustrate *Perversa Judicia* (bad judgment) in his *Choice of Emblems* (Whitney 1586). John Lyly of course includes the entire story in his play, *Midas* (Lyly 1988). William Hopkins, in his commendatory verse contribution to William Davenant's *The Just Italian*, uses the myth to defend Davenant's play from its detractors, those 'giddy fooles' who hear Davenant's 'straynes, as the dull Asse the Lyre'. Hopkins directs all such incompetent audience members to simpler acoustic pleasures, such as 'the noyse they make / At Paris-garden', 'the learned layes / That make a din about the streets', or 'the Iewes-trumpe', and the bells of morris dancers. 'These,' he opines sarcastically, 'your great heads may manage' (Davenant 1630).

Contemporary English mythographer George Sandys likewise concedes in his *Ovid's Metamorphosis Englished* that the judgment of Midas is about 'an ignorant Prince, unable to distinguish betweene that which is vile and excellent; and therefore preferrs the one before the other; for which he is iustly branded by the learned with the ensignes of folly'. Sandys, however, also suggests a euhemeristic, historical explanation of the myth, in which the ass's ears refer to the dangers of wrong hearing in a political context. Here, Midas is 'a suspitious Prince; who heard whatsoeuer was done afarre off by his spies and intelligencers: who (by their false informations) becoming suspitious of his best deseruing seruants, and confident of his worst, might well be

said to heare with such eares; ignorant of the true estate of his affaires' (Sandys 1976: 390).[1]

The Orpheus and Midas myths in the *Metamorphoses* represent sound as an important instrument of cultural domination; both rehearse musical ideologies that would persist into Shakespeare's era and beyond. In these narratives contending social groups are associated with specific conventions of musical production and consumption. Orpheus enraptures the world around him with his music, until he is himself subjugated by the sounds of the Thracian women. Midas is permanently disfigured as punishment for publicly declaring his preference for the music of Pan, an act Apollo evidently considers a serious threat to his cultural hegemony, or at least the first sign of a crack in the veneer of objectivity that legitimates his apparent aesthetic superiority. In any event, Midas has heard wrong, which is a radical act of disobedience, and he is severely punished for it. There is an etymological link between the concepts of hearing and obedience that goes back to the Latin *audire*, which means both to hear and to obey. Similar punishments were directed at the ears in early modern England for political dissidence and other forms of insubordination and transgression. The offender's ears were simply cut off.

But that is not the end of the Midas myth, either. The shame that results from his disfigurement leads to the myth's most enigmatic scene. To hide his ass's ears Midas takes to wearing a head covering, a secret that is discovered by one of his servants:

> But yit his Barber who
> Was woont too notte him spyed it: and beeing eager too
> Disclose it, when he neyther durst to vtter it, nor could
> It keepe in secret still, hee went and digged vp the mowld,
> And whispring softly in the pit, declaard what eares hee spyde
> His mayster haue, and turning downe the clowre ageine, did hyde
> His blabbed woordes within the ground, and closing vp the pit
> Departed thence and neuer made mo woordes at all of it.
> Soone after, there began a tuft of quiuering reedes too growe
> Which beeing rype bewrayd theyr seede and him that did them sowe.
> For when the gentle sowtherne wynd did lyghtly on them blowe,
> The vttred foorth the woordes that had beene buried in the ground
> And so reproude the Asses eares of Midas with theyr sound.

(138)

This part of the myth was commonly interpreted by Renaissance mythographers as an allusion to the endurance and power of the written

word, of the way it allows the dead to speak, and thereby influence the judgment of future generations. Abraham Fraunce probably ventures a pun on the word *reade* in his short moralization of the myth in *The Countesse of Pembrokes Yvychurch*: 'a golden foole and a silken asse, may for the time be clad with purple, & delude the gazers on, but when the reades grow, that is, when after his death the learned begin to write, and lay him open to the world, then is his nakednes discouered' (Fraunce 1976: 11). George Sandys likewise interprets the speaking reeds as writing implements in his 'Englished' reading: 'the vices and defects of Princes are likely palliated or obscured in their lifetime: but dead; these vocall Reedes arise, the pens of historians to divulge them to posterity' (390).

It is of course only natural for early modern humanists to moralize this part of the myth as an example of the power of literacy and the written word. When the tale is transmitted in a more oral early modern context, however, it must surely communicate something very different. It speaks more of the living word, of sound as having the characteristics of a living organism.[2] The reeds that grow are also Pan's musical instruments in their raw, natural, living form, transmitting meaning through sound, when the wind is southerly. And when we speak of the living word we return to the religious context, to the most unexpectedly direct connection of all. The barber, with an irrepressible, almost sexual need to 'express' his secret, plants his words/seeds into the ground. They are then born out of the same ear they are entered into, born as the reeds which sound his secret in the wind. The myth of Midas articulates the precise sound/agriculture/reproduction matrix found in the parable of the sower. The ground receives the barber's words and yields them up again as sound/wind/spirit with a multifold increase. In these narratives we find hearing to be the perceptual domain most closely aligned with grotesque continuity through transformation and reproduction. And like the ground into which the barber speaks, Shakespeare's ear is itself an agent of such processes, where predecessor narratives, including those of Ovid (and specifically that of Midas), enter, and are transformed.

A reasonable good ear in *A Midsummer Night's Dream*

Like Midas, Bottom the weaver from *A Midsummer Night's Dream* is also known for his ass's ears. Long a favourite with audiences in the theatre, Bottom has received an increasing amount of sympathetic and serious attention from critics in recent years. He has been read as an embodiment of festivity in the play (Kott 1987; Patterson 1989), as a figure for the relationship between comedy and contemporary social unrest (McDonald

1994), even as a profound metaphor for love (Zukofsky and Zukofsky 1963). He has also been identified with Shakespeare himself since at least the nineteenth century. Twenty-three years after Emerson counted Shakespeare one of his seven *Representative Men*, Daniel Wilson echoed the phrase by praising Bottom himself as a 'representative man', and a 'natural genius' (Emerson 1850; Wilson 1873: 264). Annabel Patterson has drawn attention to the connection more recently, noting that both author and character share an artisanal class background which affords them a certain aesthetic and social mobility, particularly with respect to the range and extent of their opportunities in the contemporary theatre:

> Shakespeare's own situation as a member of the Chamberlain's company would situate him somewhere *between* the court and amateur popular theatricals, with the occasional 'command performance' bringing him closer to Bottom and his colleagues than to those, frequently themselves aristocrats, who created the royal entertainments.
>
> (Patterson 1989: 58)

When contemplating which of Shakespeare's characters is most like the author, the traditional choice is of course just such an aristocrat, Prospero, who scripts and directs almost all of the action of *The Tempest*, and whose renunciation of his art at the end of the play, breaking his staff/pen and drowning his book/paper, has for many years been figured as Shakespeare's own farewell to a professional life devoted to the creation of illusions.[3] Prospero is a fine choice, but he's a writer/director, mainly, and fails to come anywhere near representing the full spectrum of professional activities Shakespeare would have participated in as a primary shareholder in his company. Bottom, with his immense receptivity, demonstrated by his capacity for making others' narratives his own, and making his own narratives others', is easily as good a choice. His participation in the theatre is motivated by sheer enthusiasm, an ecstatic love of play, and the hope of steady patronage – not, as is at least partly the case with Prospero, by the desire to exert power and exact retribution.

Like Shakespeare, Bottom is characterized by his receptivity. Bottom's bottomless receptivity takes the form of a radical openness, an indiscriminate enthusiasm both taxing and infectious to those around him. From the mechanicals' very first rehearsal, he cannot restrain himself from eagerly swallowing up the project, artistically and procedurally. His first four speeches in the play direct Peter Quince, the play's ostensible organizer and director, as to how to proceed with their meeting.

He tells Quince 'You were best to call them generally, man by man, according to the scrip', to 'say what the play treats on, then read the names of the actors, and so grow to a point', to 'call forth your actors by the scroll', and then to 'Name what part I am for, and proceed'. Bottom is also a voracious consumer of theatrical roles. He wants to play any and every part in the play – even though he has absolutely no idea what the mains ones are: 'What is Pyramus? A lover, or a tyrant?' He wishes to play not only Pyramus, but Thisby as well, and even the lion.

Sound is the chief tool he uses for throwing himself into these different characters; it is apparently the most important parameter of his theatrical experience. He bids for each part on the strength of his vocal ability. His first choice is a role with a lot of good bombast, 'a part to tear a cat in, to make all split', though he assures the others that as a lover he promises to sound more 'condoling'. As Thisby he will speak in 'a monstrous little voice', and as the lion he plans to 'roar that I will do any man's heart good to hear me'. When his comrades become apprehensive that the roar could well frighten the female playgoers, he answers their reticence by suggesting that he could control his voice, and 'aggravate' it to 'roar you as gently as any sucking dove; I will roar you an 'twere any nightingale' (1.2.1–84).

The lion that sounds like a dove or a nightingale is an example of the fluidity that characterizes Bottom's experience of the world, an experience unregimented by the kinds of phenomenological categories those around him, like us, have become enculturated into. He seems to have an intuitive understanding that, like the character Wall he suggests they incorporate into their play, such divisions are human constructs. *Continuity* is the operative term for Bottom's perceptual assimilation of the world, a form of experience ruled by a kind of synaesthesia. I borrow the term *continuity* from Georges Bataille, who employs it in his work on eroticism to indicate the ontological category of undifferentiated Being, as opposed to the experience of individual consciousness, which he refers to as *discontinuity* (Bataille 1986).[4] Bottom is a figure for the recognition that grotesque continuity, commonly associated with the guts and what Bakhtin called the 'lower bodily stratum', can also be sublimated to the intellectual or perceptual realm, from the lower bodily stratum to the upper bodily stratum.

The continuity that characterizes Bottom's sensorium is most evident from the remarks he makes upon waking from his dream, when he declares in amazement 'The eye of man hath not heard, the ear of man hath not seen, man's hand is not able to taste, his tongue to conceive, nor his heart to report, what my dream was' (4.1.209–12). The perceptual confusion indicated in the speech is an unintentional effect of the

confusion his memory makes of a passage from Paul's first letter to the Corinthians (2:6–10), an intertextual link that has been glossed by numerous commentators.[5] Bottom's synaesthetic experience of the world is also registered during the performance of the Pyramus and Thisby play, in which Bottom-as-Pyramus says 'I see a voice. Now will I to the chink, / To spy an I can hear my Thisby's face' (5.1.191–2).

Bottom's phenomenological experience of continuity extends from base levels of perception into higher-order conceptual categories with more readily identifiable ideological ramifications. An example of this is his inability to recognize the boundaries that describe proprietary rights. His exuberant appropriation of the mechanicals' play is one side of that coin; his willingness to share the narrative of his own experience with the faeries, to have Quince commit it to paper for him, is the other: 'I will get Peter Quince to write a ballad of this dream. It shall be call'd "Bottom's Dream", because it hath no bottom; and I will sing it in the latter end of a play, before the Duke' (4.1.212–5). He calls the proposed epilogue 'Bottom's Dream' not because he wants to stake an authorial claim to it, but because it is, like him, more than a little confused; it is his dream not because he *created* it, but because it *contains* him. The idea of 'confusion' (con-fusion) is extremely important in *A Midsummer Night's Dream*: almost every character in the play spends at least some time being confused in one sense of the word or another. Confusion is the precise word for articulating, from the perspective of the grotesque aesthetic, what Patricia Parker has identified as the pervasive discourse about 'joinery' in the play.[6]

Bottom's continuity is also apparent in the range of social interaction of which he is capable, from his mechanical peers to performance at court, and most importantly his 'translation' into the world of the faeries. He is the only mortal in the *Dream* who actually perceives the faeries and interacts with them, in a metaphysical region where he moves with the same easy familiarity and sense of entitlement as Prospero. This sense of entitlement extends to erotic relations as well. Like a certain aristocrat from one of Shakespeare's other festive comedies, Bottom is pleasantly surprised to find himself the object of the erotic attentions of a beautiful, powerful woman he has never seen before in his life. Both men accept the situation with little or no hesitation. Titania's liaison with Bottom is presented and recognized as the more grotesque, however, and I would argue that this is not *wholly* due to their phylogenetic incommensurability (the man/ass embodies that grotesque condition well enough on his own), but also because the relationship is not sanctioned by equal social rank, as is the love of Olivia and Sebastian. As David Wiles puts it, 'It is in the figure of Bottom the clown, the lower-class male locked in the arms of a queen, that we must seek the elusive Bakhtinian grotesque' (Wiles

1998: 78). The kind of radical continuity Bottom represents is a potential threat to social order, to the distinctions that define and maintain hierarchy. Untune that string …

With Bottom, we again come across the ears associated with transformation, or what Peter Quince calls 'translation'. While the flower juice is administered through the eyes, which links the eyes with the many transformations that occur in the play, all of these transformations are preceded and triggered by aural stimuli which awaken the characters out of their sleep. It should be remembered that the play is literally a *dark* comedy: most of it takes place in the woods at night, where, as Hermia notes, the sense of hearing is all the more relied upon:

> Dark night, that from the eye his function takes,
> The ear more quick of apprehension makes;
> Wherein it doth impair the seeing sense,
> It pays the hearing double recompense.
> Thou art not by mine eye, Lysander, found;
> Mine ear, I thank it, brought me to thy sound.
>
> (3.2.177–82)

As Oberon and Puck go about correcting the latter's pardonable mistake in applying the love potion to the wrong young good-looking Athenian, Oberon remarks that Lysander and Helena will finish the job for them, occasioning the desired result with their sound: 'Stand aside. The noise they make / Will cause Demetrius to awake' (3.2.116–7). His instructions to Puck as to how to deal with Lysander and Demetrius also focus on the creation of acoustic decoys in the dark night: 'Like to Lysander sometime frame thy tongue, / Then stir Demetrius up with bitter wrong; / and sometime rail thou like Demetrius' (3.2.360–2). Such ventriloquism is a skill Puck is evidently practiced in: he has boasted before of how he can beguile 'a fat and bean-fed horse' by 'neighing in likeness of a filly foal' (2.1.45–6).

While the flower juice compels Titania to fall in love with whatever she first sees upon awakening, it is evident that she is first alerted to Bottom by the noise he makes. After his companions have abandoned him in fright, Bottom begins to sing, so that 'they shall hear I am not afraid' (3.1.119). It is this 'angelic' noise which wakes Titania from her 'flow'ry bed', and which first introduces her to her new love (124). Entranced, she requests he keep singing: 'Mine ear,' she says, 'is much enamored of thy note' (133). The incongruity of Titania falling in love with such a monstrous creature is linked with her inclination toward the

song he sings, which is surely punctuated with a kind of braying noise that she takes for the sweetest music. Like Midas, Titania is punished for her disobedience, for her failure to 'hear' Oberon correctly. In her last words of the scene, she orders the attendant faeries to transport Bottom, and in the process to 'Tie up my lover's tongue, bring him silently' (3.1.196). The remark suggests she is not entirely under the spell of the flower juice, that she has momentarily relapsed into a degree of normal consciousness, and is in some sense enamoured of this creature in spite of herself. There is a rent, an opening, a continuity in her affection for him, through which her altered and unaltered states of consciousness intermingle and uneasily coexist as an emotional monstrosity.

References to sound are used throughout the *Dream* to chart physical and emotional proximity. Hermia's growing emotional distance from Lysander is figured in her speech as she sounds out into the darkness: 'Lysander! What, remov'd? Lysander! Lord! / What, out of hearing? Gone? No sound, no word? / Alack, where are you? Speak, an if you hear' (2.2.151–3). The play in fact begins with reference to love in acoustic terms, when Theseus assures Hippolyta that although he won her in battle, he will wed her 'in another key' (1.1.18). Lysander's wooing of Hermia is described as having been conducted in a similarly musical manner, when Egeus accuses him of having 'by moonlight at her window sung / With feigning voice verses of feigning love' (1.1.30–1). Lysander in turns describes the fragile 'course of true love' in acoustic terms when he calls it 'momentany as a sound' (1.1.143). In the same scene, Helena refers to Hermia's voice as an important component of her beauty: her 'tongue's sweet air' is 'More tuneable than lark to shepherd's ear' (1.1.183–4). Later in the play, when Helena reminisces over the affection she and Hermia once shared, she recalls them knitting together, 'Both warbling of one song, both in one key, / As if our hands, our sides, voices, and minds / Had been incorporate' (3.2.206–8).

The one aspect of Bottom's changed physiognomy that is remarked upon repeatedly in the play is the set of ass's ears on his head. His ears are the most recognizable visual image of the play, identifiable even in silhouette. After a skinny youth in black tights conversing with a skull, or a young girl leaning out over a balcony, the image of a man with ass's ears is probably the most iconic in all of Shakespeare. The ears are the signature of his translation. For years costume designers have called special attention to the ears by creating ways for actors to move them independently. The First Folio stage direction, *'Enter Piramus with the Asse head'*, seems to indicate that a special prop head was used for Bottom's translation in Shakespeare's day (Shakespeare 1995: TLN 927). Actors

playing Bottom in the nineteenth century often found themselves swimming around in huge realistic ass heads which made them unable to communicate to the audience with facial expressions, and cut down a great deal on the clarity of their voices. Directors and costume designers in our own century have often done away with the realistic ass head, and substituted more evocative suggestions of his translation. Trevor Griffiths, in his stage history of the play, notes that director Harcourt Williams was among the first to take this route in 1931:

> The traditional fully built-up head, even if it had moving ears and jaws, tended to muffle the actor's voice, and encouraged broad playing in the translation scenes. Williams 'substituted a light mask of my own devising' which left [Ralph] Richardson's eyes visible and 'added greatly to his powers of expression as the donkey'.
>
> (Griffiths 1996: 53)

As designers continue to distil the costume down to its most essential elements, what remains are the ears. No matter how far these designs are pared down, a Bottom *always* has some sort of ass's ears. In Robert Lepage's 'mudsummer' production, for example, Bottom's translation was accomplished by the actor playing Puck using her feet to represent the ass's ears (Griffiths 1996: 146).

The ass's ears are an erotic focal point for Titania, who makes a point of kissing Bottom's 'fair large ears' in the scene in which they are lovers (4.1.4). Bottom himself refers to them a few lines later. When asked, 'wilt thou hear some music, my sweet love?', he replies 'I have a reasonable good ear in music. Let's have the tongs and the bones' (4.1.27–9). Allusion to the judgment of Midas is easily recognizable here, with Bottom presented as the bigger fool – his musical preferences do not even extend to instruments capable of melody. When Bottom awakes from his dream, the actor playing him usually feels the air above his head for the ass's ears that have vanished as inexplicably as they arrived: 'Methought I was – and methought I had – but man is but a patch'd fool, if he will offer to say what methought I had' (4.1.206–9).

Bottom, himself a 'patch'd' fusion of man and ass, is likewise a grotesque admixture of legends and myths. In his book on the character, Jan Kott notes that the ass 'appears both in ancient tradition, in Apuleius, and in the Old and New Testaments as Balaam's she-ass, and as the ass on which Jesus rode into Jerusalem for the last time'. He also points to graffiti from third-century Rome which depict an ass's head on the crucified Christ as an example of how 'the bodily meets with the spiritual in the

figura and the masque of the ass' (Kott 1987: 43–4). Kott also remarks on the prevalence of the ass in festive practice: 'From Saturnalia to medieval *ludi* the ass is one of the main actors in processions, comic rituals, and holiday revels' (43). Bakhtin specifically describes the Feast of the Ass, which celebrated the ass that carried Mary and the infant Jesus to Egypt. Sound was an important part of this ritual, in which the priest and congregation would engage in call-and-response braying. 'The ass,' Bakhtin observes, 'is one of the most ancient and lasting symbols of the lower bodily stratum, which at the same time degrades and regenerates' (Bakhtin 1984: 78). Annabel Patterson has noticed the connections to festive inversion in *Dream*, in which 'the ass's head distinguishes itself from comic props and masks in general, and becomes part of a complex structural pun' in which Bottom is 'not only the bottom of the social hierarchy as the play represents it, but also the "bottom" of the body when seated, literally the social ass or arse' (Patterson 1989: 66). François Laroque also sees the scenes with Titania and Bottom as examples of festive inversion, inversion which has, however, overstepped even the boundaries of festive decorum and entered into the grotesque (Laroque 1991: 246).

The grotesque ear

In this section I want to lean on Annabel Patterson's claim that Bottom's ass head is a 'complex structural pun', and investigate the way that pun works self-referentially, theorizing the very grotesque aesthetic out of which it is generated. The pun co-locates the ass, the most durable symbol of the lower bodily stratum, with the ear, which is the primary site of upper bodily grotesque continuity. In current criticism, the grotesque is referred to almost exclusively in connection with the lower bodily stratum. Shakespeare's image of the ass with ears is an emblem for the idea that grotesque continuity must be understood to obtain at the level of the *upper* bodily stratum, as well. While this point is implicit in several critical accounts of the early modern grotesque, it has never explicitly been stated, let alone adequately explored or analysed.

The continuity of bodily strata is recognized persistently in theories of the grotesque in early modern England. Neil Rhodes makes this idea the central thesis of his work on the Elizabethan grotesque, which he sees primarily as a linguistic and literary phenomenon. Elizabethan writers were preoccupied with what he calls 'the physicality of language', an aesthetic which 'could almost be called a non-verbal experience of language', in which the implications of language as 'incarnadine' are played out (Rhodes 1980: 104–5).[7] Willard Farnham, in his book on the Shakespearean grotesque, speaks of the pun itself as a grotesque

form of language, as a 'monstrous union of incompatible things' (Farnham 1971: 61).

The most important theorist of the early modern grotesque is undoubtedly Mikhail Bakhtin, whose work on the carnivalesque in *Rabelais and His World* is a classic of literary and cultural criticism. At different points in that work he provides short catalogues of important sites of the grotesque body, places where it opens up to the world outside. Ears are notable by their absence from these catalogues. During an initial discussion about the openness of the grotesque body, for example, he says: 'the emphasis is on the apertures or the convexities, or on various ramifications and offshoots: the open mouth, the genital organs, the breasts, the phallus, the potbelly, the nose' (Bakhtin 1984: 26). There is no mention of the ear. He likewise seems to suggest that the ear is absent from slang in the period, though this language is full of reference to other parts of the grotesque body: 'In all languages there is a great number of expressions related to the genital organs, the anus and buttocks, the belly, the mouth and nose. But there are few expressions for the other parts of the body: arms and legs, face, and eyes' (319). In this list the ears are not even included as alternate possibilities. As far as early modern England is concerned, however, Bakhtin is only partially correct. While it is true that early modern English does not include many slang *synonyms* for them, the ears are extremely prevalent in other types of slang expressions. In his dictionary of proverbs for the period, Tilley collects no fewer than six proverbial sayings that include references to the ear (Tilley 1950). Shakespeare himself seems to have been particularly fond of the ear, employing it in numerous expressions, such as the 'ear of grief', the 'married ear', the 'shepherd's ear', the 'open ear of youth', the 'treacherous ear', 'the public ear', the 'dull ear of a drowsy man', the 'welkin's ear', the 'knowing ear', the 'credent ear', 'Night's dull ear' – the list literally goes on and on.[8]

I would argue that the reason Bakhtin appears to overlook the ear in his theory of the grotesque body is not that he considers it peripheral, but that he takes its centrality so completely for granted that he neglects to even mention it. In fact, the hermeneutic approach of his most important work is premised on the act of *listening* to the texts of early modern culture. The text for Bakhtin is an acoustic event. Accordingly, he often describes reading as 'listening'. In his critique of the work of Lucien Febvre, he applauds Febvre's insistence on understanding the past in its fullest contemporary context, which includes checking one's own ears at the door, and listening imaginatively with ears conditioned by contemporary cultural experience: 'the historian's main task is to discover how the men of 1532 ...

listened to Pantagruel speaking, how these men (not we) could under-
stand him' (131). He takes Febvre to task, however, for not being
attuned enough to the laughter in Rabelais, for not hearing that essen-
tial element of the book's soundscape. Since 'Febvre considers anach-
ronism, modernization, as the historian's most grievous sin', he
maintains, it is unfortunate that 'he himself commits this sin in rela-
tion to laughter. He hears Rabelais' laughter with the ears of the twen-
tieth century, rather than with those of the sixteenth' (133). When he
applauds Johann Fischart's German translation of *Gargantua*, he
describes it as one in which 'the triumphal tones of birth and renewal
can still be heard' (64). During his discussion of Janotus's oration at
the Sorbonne, he invites his reader to imagine hearing that oration in
its performative fullness: 'A tape recording of this speech would show
how full it is of sounds imitating all forms and degrees of coughing,
spitting, short breath, and wheezing' (217).

Bakhtin is particularly sensitive to different tonalities of discourse.
He hears an especially wide spectrum of linguistic tonalities in the
language of 'praise-abuse' in *Gargantua and Pantagruel*, 'either polite,
laudatory, flattering, cordial words, or contemptuous, debasing, abusive
ones' (420). This is especially apparent when he writes about the diffi-
culties of our attempts to understand early modern irony, a trope that
hinges on inflections caught by the ear: 'In the world culture of the past
there is much more irony, a form of reduced laughter, than our ear can
catch …. We often lose the sense of parody and would doubtless have
to reread many a text of world literature to hear its tone in another key'
(135–6). Listening to texts imaginatively is so important to his critical
method that he returns to the idea in the final paragraphs of *Rabelais and
His World*, arguing that the approach has not only aesthetic, but impor-
tant political implications as well:

> While analyzing past ages we are too often obliged to 'take each
> epoch at its word', that is, to believe its official ideologists. We do
> not hear the voice of the people and cannot find and decipher its
> pure unmixed expression …. All the acts of the drama of world
> history were performed before a chorus of laughing people. Without
> hearing this chorus we cannot understand the drama as a whole.
>
> (474)

Bakhtin was surely encouraged to begin listening to texts by Rabelais
himself. In the third book of *Gargantua and Pantagruel*, Panurge becomes
anxious over whether to take a wife. He and his friends decide that he
should consult a well-known sibyl about the dilemma. During this

section of the book, Pantagruel makes a comment about the ears that is well worth noting in the context of our entire discussion. He says,

> I don't believe nature didn't know what she was up to when she provided us with wide open ears, ears that can't be closed or shut in any way, though our eyes, and our tongues, and all the other openings in our body can be. And I think the reason was so that we'd always – day and night – be able to hear, and by hearing always be able to learn, for of all our senses that is the most appropriate for learning.
>
> (Rabelais 1990: 286)

The ear, permanently open to receive sound, is a constant agent of perceptual continuity. The grotesque body, Bakhtin observes, 'is looking for that which protrudes from the body, all that seeks to go out beyond the body's confines' (316). This notion of the 'body's confines' is closely related to Bataille's ideas on discontinuity and continuity – so close, in fact, that Bataille is probably the premier postmodern theorist of the carnivalesque. Bataille notes the grotesque character of the body as well in his *Erotism*: 'Bodies open out to a state of continuity through secret channels that give us a feeling of obscenity. Obscenity is our name for the uneasiness which upsets the physical states associated with self-possession, with the possession of a recognised and stable individuality' (1986: 17–8). It is just such a fluid, unstable sense of individuality that Michael Bristol identifies with Bottom, in his reading of the *Dream* in his book on carnival and plebeian culture in the period.[9]

Gargantua, the archetypal grotesque body, is born through his mother's left ear.[10] During the birth, his mother's entire colon and intestine prolapse (she gives birth to herself, to her own gut). To counteract this, she is given a powerful astringent by an attending midwife, which causes her whole body to close up in a complete inversion of the grotesque openness one would expect from a Gargantuan birth. The astringent is described as so strong that 'every sphincter in her body was locked up tight, snapped so fiercely shut that you couldn't have pulled them open with your teeth, which is pretty awful to think about' (21). As a result, the baby Gargantua has no choice but to take the only open route of egress available to him. The astringent inverts the normal physiological characteristics of the mother's body, so that

> it made her womb stretch loose at the top, instead of the bottom, which squeezed out the child, right into a hollow vein, by means of

which he ascended through the diaphragm up to her shoulders,
where that vein is divided in two. Taking the left-hand route, he
finally came out the ear on that same side.

(21)

Another story that has its birth at the ear is *Hamlet*, of course. The very
event that brings the play into being is Claudius poisoning his brother
through the ear. The two episodes, Gargantua's birth and the Danish
king's death, each portray the ear as an important conduit of continuity
between being and non-being. The ear operates at the limits of life itself,
letting birth out in Rabelais's narrative, and death in, in Shakespeare's.

Sound economics: excess, surfeit, stealing, giving

When Gary Taylor suggests that Shakespeare 'warps cultural space
time; he distorts our view of the universe around him', what he means
by the phrase 'the universe around him' is the literary universe – the
other poets, dramatists, and critics he refers to in the immediate context
of that passage. I think more can be made from this statement, however,
and I want to bring this chapter to a close by asserting that, just as black
holes exist at the limits of the physical universe, where the laws of
physics as we understand them break down, so Shakespeare articu-
lates, and has thereby come himself to designate, the limits of our
ethical and aesthetic universes, where the laws of perceptual, represen-
tational and moral economy begin to break down and become radically
unstable. The grotesque, which recognizes the fundamental provisionality
of all boundaries, whether corporeal, epistemic, or ethical, is the
primary aesthetic Shakespeare employs in the representation of these
ambivalent economies.[11]

Scott Wilson is attracted to the idea of Shakespeare as a kind of sun
because, like Bataille, he finds the sun to be '*the* example of pure expen-
diture without profit or return' (Wilson 1995: 127). Nick Bottom's
boundless, energetic enthusiasm is one instance of an economy that
verges on potlatch; Shakespeare's linguistic exuberance, in its sublime
excess, is another. As Stephen Orgel has persuasively argued in an
essay titled 'The poetics of incomprehensibility', the very *sound* of
Shakespeare's verbal plethora would have been a large part of the
attraction his plays held for contemporary audiences (Orgel 1991).

When Shakespeare describes love and other related forms of interper-
sonal experience, he frequently describes them as open, ambivalent
economies, characterized by excess, fluidity and free-flow. In *All's Well
that Ends Well*, Helena describes her love for Bertram in just these terms:

I know I love in vain, strive against hope,
Yet in this captious and intenible sieve
I still pour in the waters of my love
And lack not to lose still.

(1.3.201–4)

She believes her love is like the sun of which Scott Wilson speaks, 'pure expenditure without profit or return'. It is the continuous outpouring of an unending supply that she will 'lack not to lose still'. Bertram is presented as a 'captious and intenible sieve', a gigantic receptacle in which nothing is saved and everything is wasted. Shakespeare repeatedly uses the metaphor of the sieve, or strainer, in relation to this kind of total expenditure. When Portia proclaims to Shylock that 'The quality of mercy is not strain'd', she is speaking of a similar kind of expenditure, in which nothing is held back. Mercy is not run through a sieve; it is free-flowing, like 'the gentle rain from heaven / Upon the place beneath'.[12] As an ethical act it is grotesque, transforming the boundaries of reciprocity that describe a particular negative act as deserving response in kind.

Each of these examples ultimately points to the fundamentally ambivalent nature of such total expenditure, however. The sun may be pure expenditure (outflow), but in so being it is also pure consumption (influx). Scott Wilson's Shakespeare-as-sun is the other side of Gary Taylor's Shakespeare-as-black hole. Helena may believe she gives her love to Bertram without any hope of return, but she ends up with him anyway. Mercy opens up the closed economy of revenge with pure expenditure, and in the process it generates a multifold increase: it is 'twice blest: / It blesseth him that gives and him that takes' (Mer. 4.1.184–7).

I introduce the idea of the grotesque economy because sound is the main perceptual domain Shakespeare imagines in conjunction with it. When Antonio tries to help his brother get over his grief over the plight of Hero in *Much Ado about Nothing*, Leonato answers by comparing his own ears to a sieve: 'I pray thee cease thy counsel, / Which falls into mine ears as profitless / As water in a sieve' (5.1.3–5). The sieve is employed here as a metaphor for aural perception, for the ear catching or straining what is valuable out of the soup of raw data in the acoustic environment. Undoubtedly, the most famous expression of this sound economy is the opening speech of *Twelfth Night*:

If music be the food of love play on,
Give me excess of it; that surfeiting,
The appetite may sicken and so die.

That strain again, it had a dying fall;
O, it came o'er my ear like the sweet sound
That breathes upon a bank of violets,
Stealing and giving odor. Enough, no more,
'Tis not so sweet now as it was before.
O spirit of love, how quick and fresh art thou,
That notwithstanding thy capacity
Receiveth as the sea, nought enters there,
Of what validity and pitch soe'er,
But falls into abatement and low price
Even in a minute.

(1.1.1–14)

Orsino begins by quickly associating sound, nourishment, and love (an emotion characterized by transformation, as in Ovid). The emotional economy he describes is radically ambivalent: he wishes to 'surfeit' on this musical food, to have 'excess' of it so that his appetite will eat itself to death. The 'sweet sound / That breathes upon the bank of violets' is also notably ambivalent, in that it both steals *and* gives. In a synaesthetic image worthy of Bottom himself, it steals and gives not waves of sound, but odours. The 'spirit of love', which feeds on sound, is represented as having a capacity as great as the sea, a capacity which transforms the value of all that enters, levelling all to 'abatement and low price'.

It is at this point that the speech develops a grotesque circularity, one in which sound, transformation, and continuity all appear as interrelated components. Orsino's reference to 'pitch', linked to the concept of 'validity', is of course a musical term he uses to indicate his advanced position in the hierarchy of Illyrian society. In using this term he translates himself metaphorically *into* sound; he makes himself a pitch, one which will 'fall' because it loves. Orsino hears the sound, and then becomes transformed into the sound he hears, turning into that strain, again, the one that had the dying fall.

Shakespearean acoustemologies

Aphrodite, beautiful goddess, invisible, standing
up, is born of this chaotic sea, this nautical chaos,
the *noise*.

Michel Serres, *Genesis*

Perdition catch my soul
But I do love thee! And when I love thee not,
Chaos is come again.

Othello (3.3.90–2)

While working with the Songhay in West Africa, anthropologist Paul
Stoller developed an appreciation for the distinctively immersive, expe-
riential character of acoustic epistemology. Stoller records his reflec-
tions on the role of sound in Songhay culture during his influential
meditation on ethnographic writing, *The Taste of Ethnographic Things*:

> When a musician or an apprentice Songhay sorcerer learns to hear,
> he or she begins to learn that sound allows for the interpenetration
> of the inner and outer worlds, of the visible and the invisible, or the
> tangible and intangible. A person's spatialized 'gaze' creates distance.
> Sound, by contrast, penetrates the individual and creates a sense of
> communication and participation. From the musical perspective,
> the 'out-there' is replaced by what Zuckercandl calls the 'from-out-
> there-toward-me-and-through-me'. In this way outer and inner
> words interpenetrate in a flowing and dynamic universe, a universe
> in which sound is a foundation.
>
> (Stoller 1989: 120).

During his studies of the important role played by sound symbolism in
the everyday experience of the Kaluli people of Papua New Guinea,
another anthropologist, Steven Feld, became increasingly aware of the
extent to which 'the sensual, bodily experiencing of sound is a special

kind of knowing' (Feld 1994). Returning from his fieldwork with the need for a term to express the particular ways cultures experience their knowledge of the world through sound, he combined the words *acoustics* and *epistemology* to form the portmanteau word *acoustemology*.

Shakespeare seems to have understood something very like Steven Feld's concept of acoustemology. As we have discovered, the characters in his plays routinely engage sound in an epistemological capacity, as a way of orienting themselves in physical space, in society at large, and with respect to other individuals. Naturally, Shakespeare doesn't use Feld's term; instead, he tends to describe these ways of knowing through sound much as Christ does in the parable of the sower, in terms of different types of ears – from the 'quick ear' in *The Two Gentlemen of Verona*, to the 'credent' and 'knowing' ears in *Hamlet*, to the 'dull' ears of night and of drowsy men in *Henry V* and *King John*.[1] This chapter explores two further examples of Shakespearean acoustemology: the greedy ear, and finally, the willing ear.

The greedy ear in *Othello*

In an article which unpacks the sound of a single phoneme, the sound of 'O' in *Othello*, Joel Fineman identifies the play as 'the real tragedy of desire'. Noting Ben Jonson's famous reference to at least some Greek in the playwright's education, Fineman hears in the name 'Othello' an echo of the Greek word *ethelo*, which translates as 'I desire', 'I wish', 'I want', or 'I will' (Fineman 1994b: 106). In the brief reading that follows I focus on the ear as an acoustemological agent in this tragedy of desire. For *Othello* is, among other things, a play about the greedy ear, the desiring ear, the ear become a vortex of desire in which characters lose their bearings and are swept away, disappearing into the space between what they hear, and what they more strongly desire to hear.

The greedy ear is first named when Othello tells the story of how he inadvertently courted his young wife. He relates with what keenness she would listen to his stories of hardship, privation, and sorrow. 'These things to hear / Would Desdemona seriously incline', he recounts, adding that whenever the opportunity presented itself, 'She'ld come again, and with a greedy ear / Devour up my discourse' (1.3.145–6; 149–50). Parrying Brabantio's accusations of witchcraft, he insists his overtures to her were initiated by the intensity of her desire to hear his stories. Their marriage has its origin in her ear, in her desire. Othello's association of sound and hearing with feminine desire returns us to the early modern notion of the feminized ear. While the critical discourse surrounding this play has been traditionally dominated by visual

indicators (most notably Othello's colour, of course), Karen Newman tunes into Desdemona's aural voracity, or at least others' awareness of it, as the expression of a feminine sexuality not primarily visual, but rather acoustic in orientation. 'Desdemona is presented in the play as a sexual subject who hears and desires,' she maintains, 'and that desire is punished because the non-specular, or non-phallic sexuality it displays is frightening and dangerous' (Newman 1994: 133). As the modifier 'greedy' suggests, Othello does associate his wife's ear with a desire which is not only strong, but even inordinate. In front of the assembled audience of Venetian dignitaries he downplays the sexual implications of that thought even as he expresses it, referring to her ear as as ravenous for food, as devouring his discourse. Elsewhere in Shake-speare's plays, female characters are more overt in imagining their ears as sexually voracious, as when Cleopatra implores a messenger to thrust his words into her ears, suggestively instructing him, 'Ram thou thy fruitful tidings in mine ears, / That long time have been barren' (Ant. 2.5.23–4).[2]

Othello imparts the story of their courtship both to the 'grave ears' of the surrounding senators, and to the ears of the audience in the theatre as well, who in this scene hear one of the earliest and most compelling instances of what G. Wilson Knight famously called the 'Othello music', recognizable in the 'exquisitely moulded language, the noble cadence and chiselled phrase' of his poetry (Knight 1949: 106). The story Othello tells of his wife's desire is a story about a story, a narrative about the power of narrative, about the sorts of transforma-tions certain narratives can trigger in those who listen to them. Listening with his own 'prosperous ear', the Duke can only respond to what he hears by acknowledging that such a tale 'would win my daughter too' (1.3.244; 171). By contrast, Desdemona's passionate response to Othello's life story gives her own father the impression that she has been drugged or otherwise charmed. He is incapable of any other explanation for the sea-change she has undergone, from one 'So opposite to marriage' to an elopement (1.2.67). Like his daughter, Brabantio too listens with a greedy ear, though he longs to hear some-thing very different from that which he does hear in this scene. He calls upon Desdemona to speak, to verify his understanding of this absurd situation, to authenticate his knowledge of who she really is. What he hears instead, her simple, unwavering contradiction of those beliefs, eventually kills him.

Like Karen Newman, John Wall has noted the sexual valences of hearing in this play, though in his reading he instead focuses on the relationship between Othello and Iago, which he identifies as a parody

of the Annunciation (Wall 1979: 366). Wall also recognizes the feminized ear as operative in their relationship, noting that this is the avenue through which Othello gives birth to his own jealousy (361). Othello begins to devour Iago's discourse whole, without rumination, in the play's third act, when the ancient starts to throw out suggestive half-sentences and incomplete thoughts that draw Othello in, impelling him to try to piece them together. Intrigued, he develops a deeper desire for the contents of Iago's inmost thoughts. Hungry to find out what Iago knows, or suspects, he sounds him out with a confused mixture of reproof, threat and fear: 'Thou dost conspire against thy friend, Iago, / If thou but think'st him wronged and mak'st his ear / A stranger to thy thoughts' (3.3.142–4). But as Kenneth Gross notes, Iago's words are really just 'a kind of disguised babble; their main effect is to make his listeners lend their ears to a meaning they do not comprehend but think of as urgent' (Gross 2001: 109). At this point in the play it is Othello himself who listens with a greedy ear, who devours up the discourses others utter about him. Iago speaks directly to a self-revulsion that Othello is perversely hungry to hear more of, perhaps simply because the very sorrows of his life, and the poignant narrative they supply him with, have provided him with his greatest happiness.

The dangers of sea travel are apparent in many of Shakespeare's plays, perhaps most notably in *The Tempest*, *Twelfth Night*, and *Pericles*, but also in *The Comedy of Errors*, *The Merchant of Venice*, and even *Measure for Measure*. In *Othello*, the Turkish fleet is destroyed by a tempest which likewise threatens the Venetian ships that transport the main characters to Cyprus. Upon their arrival, however, further perilous navigations still await them – for the nautical pertains not only to the sea, but to noise and the acoustic environment as well. As Michel Serres notes in *Genesis*, his philosophical inquiry into the relations of multiplicity, chaos, and form, 'There, precisely, is the origin. *Noise* and nausea, *noise* and the nautical, *noise* and navy belong to the same family. We mustn't be surprised' (Serres 1995: 13). We live in a sea of sound which we navigate ceaselessly, asleep as well as awake, registering the various acoustic events through which we coordinate our spatial orientation, social position, emotional proximity. Such acoustemological coordinates arise out of noise and chaos, buoyed up to phenomenological recognition by conscious attention and intention:

> Noise cannot be a phenomenon; every phenomenon is separated from it, a silhouette on a backdrop, like a beacon against the fog, as every message, every cry, every call, every signal must be separated

from the hubbub that occupies silence, in order to be, to be perceived, to be known, to be exchanged. As soon as a phenomenon appears, it leaves the noise; as soon as a form looms up or pokes through, it reveals itself by veiling noise.

(Serres 1995: 13)

From this noise, nausea – a word which has its origin in the effect of the nautical upon the body's sense of equilibrium. The inner ear is the bodily organ which monitors our orientation in the world. Our ears balance us; they tell us where we are, and what our attitude is. In *Othello* this function of the ear becomes compromised by the strong gravitational pull of desire. Accordingly, a sense of destabilization and uncertainty marks the play, which is crowded with acoustic disturbances, tempestuous noises and decentring words which catch characters off guard and throw them off balance. Joel Fineman observes, for instance, that Othello's and Desdemona's marriage is apparently never consummated because all of the potential opportunities the couple have to do so are in fact interrupted by noise (Fineman 1994b: 115). Such acoustic disturbances in the play typically compound the distance between characters, who have difficulty recognizing one another in the context of this noise: Roderigo and Iago wake Brabantio in the small hours of the night to alert him to the fact that he no longer knows his own daughter; a night-time disturbance in Cyprus results in Othello becoming estranged from his trusted lieutenant. Kenneth Gross remarks that the 'Othello music' is accompanied by what he calls the 'Othello noise', by which he means the play's unsettling linguistic indeterminacy and instability. He identifies 'a kind of furious blankness of meaning that gathers around certain words and utterances in the play', especially in the way words such as 'honest' and 'thought' are repeated until they are leached of any stable significance or reference (Gross 2001: 120).

The openings of many scenes in the play evoke a sense of epistemological instability, as when from the outset Roderigo suspects Iago of wronging him (1.1), or when the Duke, Senators and Officers attempt to piece together the movements of the Turkish fleet, sifting through the evidence as it arrives via messenger, adjudicating the evidentiary value of conflicting reports, working toward a clearer knowledge of events transpiring on the waters of the Mediterranean (1.3). At the beginning of the second act, Montano and others gaze searchingly, uncertainly out to sea, attempting to discern if anyone from their side has survived the transit through the storm. Further on in the play, this tone of uncertainty is maintained by three scenes in succession which begin with questions (3.4, 4.1, 4.2). Such representations of uncertainty and destabilization,

representations which are of course writ large in the jealousy that fuels the main storyline, also work in concert with the play's take on the dark side of festive inversion.

An interval of festivity is declared on Cyprus in act two, scene two, a combined celebration of the disappearance of the Turkish fleet and Othello's recent marriage. The radical self-alienation which can accompany festive inversion is noted by Othello in the following scene, when he finds himself torn from his marriage bed to investigate the noise of the brawl: 'Are we turned Turks, and to ourselves do that / Which heaven hath forbid the Ottomites?' (2.3.170–1). As he speaks these lines, the alarm bells continue to clang noisily, furthering the theatrical effect of destabilization by competing with Othello's words for control of the acoustic field. Clearly irritated by the noise, Othello turns and commands that the ringing be ceased, for 'it frights the isle / From her propriety', making the island itself other than what it should be (2.3.175–6). Before this nocturnal commotion, shortly after the announcement of the festive period, Iago comments in an aside that Roderigo is a fool 'Whom love hath turned almost the wrong side out' (2.3.52). Iago recognizes that Roderigo's desire makes him vulnerable; it turns his deeper sense of subjectivity outward, where it can be seen and manipulated more easily by someone such as he. Later Iago is himself shown to be susceptible to the same vertiginous desire, when Emilia recollects his own jealousy of Othello: 'Some such squire he was / That turned your wit the seamy side without / And made you to suspect me with the Moor' (4.2.145–7). Each of these inversions speaks to the destabilizing effect of desire on the sense of orientation that the ear normally enables.

The play's most direct expression of confused disorientation is of course expressed by Othello himself, to Iago: 'By the world, / I think my wife be honest and think she is not; / I think that thou art just and think thou art not' (3.3.383–5). Not even Othello knows if these words are a warning, a threat, or a plea for help. From this noise, nausea. He finally succumbs to the noise entirely in the fourth act, when words, ideas, insinuations all fall into his greedy ears, tumbling undigested headlong, spinning into his ears, whirling, worlding, stifling his ability to locate himself with respect to them. The noise overwhelms him totally, causing him to turn over evidence and innuendo until he himself starts turning, then reeling, completely disoriented. 'It is not words that shakes me thus. Pish! Noses, ears, and lips – Is 't possible? – Confess – handkerchief! – O devil!' (4.1.41–3). He loses his balance, his ear fails him, he completely loses his bearings in the world and falls into a heap upon the ground. The loss of control represented in this moment is total: emotional, physical, epistemological. And it is heroic,

too. We hear the domesticated sounds of language, a doomed understanding fighting to break through, to repel the chaos that would suffocate it. Nausea, noise, chaos.

Othello's total loss of orientation stems from the failure of the ear as an agent of balance, of ears which have become confused, sifting through information, listening, trying to winnow what is important from what is not, comparing acoustic information with evidence received from the other senses, particularly the eyes (he must have ocular proof to confirm his belief, which is a function of his ear – it's not as if Othello has seen something, and needs for his ear to corroborate it, rather, it is the other way around). The unspoken importance of the aural evidence he encounters is such that he never has to refer to it directly. This evidence is always taken as a given, it seems, and forms the basic understanding which the eye either corroborates or discredits. Othello's unconsidered reliance on the auditory is what makes it easy for Iago to 'abuse Othello's ear', and to pour 'this pestilence into his ear' (1.3.395; 2.3.356). His sense of vertigo is expressed again after he strikes his wife in front of Lodovico. He says, 'Ay, you did wish that I would make her turn. / Sir, she can turn, and turn, and yet go on / And turn again' (4.1.252–4). There is a dizziness to his perspective which causes him to believe that it is she who turns and not himself. Before he kills her he demands to hear his wife confess her sins, to elicit from her mouth that which his greedy ear already knows.

Othello is a tragedy in which desire is the predominant acoustemological disposition, in which this disposition throws wide open the floodgates of the ears, causing them to be engulfed by a sea of noises and narrative fragments which rush in before the faculties of reason and discernment can begin to channel them, to prioritize their claims to attention and judgment. Instead, it is desire that shapes these noises into the contours of recognizable phenomena. In their desire to hear the unhearable in Venice and Cyprus – 'Of course you have been promoted from ancient to lieutenant', 'Desdemona has decided to leave her husband for you', 'I would never marry without your consent', 'Your wife has been unfaithful with Cassio' – the characters become shipwrecked, slipping into the sea of noise, into its chaos of infinitude and ungrounded possibility.[3]

Our own hunger for stories to help us orient ourselves in the world is evident in the greedy ear of Shakespeare scholarship as well, in our obsessive need to gauge his contribution to the way we have come to orient and define ourselves – from Joel Fineman's reference to the 'Shakespearean' as an entire mode of subjectivity, to Harold Bloom attributing to him the very 'invention of the human' (Fineman 1987;

Bloom 1998). *Othello* ends with an echo, with Lodovico sounding out his intent to repeat this tragic narrative 'to the state, / this heavy act with heavy heart relate' (5.2.370–1), much as Horatio does in *Hamlet*. The tragic play we have just heard is a present echo of events past, acoustic food for future greedy ears such as our own, which listen for hints of ways we might better orient ourselves in relation to our own volatile desires and epistemological uncertainties.

The willing ear in *Measure for Measure*

Measure for Measure was probably written at about the same time as *Othello*, and like that play it summarizes its ethical concerns in the image of a particular type of ear. Before it finally names this ear, the 'willing ear', in its concluding moments, however, the play stages various other acoustemological dispositions which are worth attention. Listening, for instance, appears to be the Duke Vincentio's preferred method of intelligence-gathering. He eavesdrops on a conversation between Isabella and Claudio in the third act, and then fruitlessly attempts to shrive Barnardine in preparation for execution in the next (the comic absurdity of the episode with Barnardine is refracted through a tragic lens in Othello's pathetic attempt to shrive Desdemona before he suffocates her). Apart from his experience with Barnardine, shriving or hearing confession is a clerical prerogative which the 'duke of dark corners' indulges in elsewhere with apparent success. In the second act he elicits from Juliet her story while disguised as Friar Lodowick, and in the fifth he declares having heard Mariana confess, at the same time publicly disclosing confidential knowledge about her confession in order to rebut Angelo's objections to marrying her.

Despite a long tradition of folk narratives which portray rulers going in disguise among their people, these episodes of hearing under false pretences by and large reflect badly on Vincentio, and detract from our estimation of him. Jonathan Dollimore, in his discussion of surveillance practices in the play, finds the Duke to be mindful of his own integrity primarily to the extent that it functions as an ideological representation which legitimates his political authority: 'the play can be read to disclose integrity as a strategy of authority rather than the disinterested virtue of the leader' (Dollimore 1999: 51). The point is well taken, though I do think that, as Isabella and Angelo do in the play itself, Dollimore sets the bar of virtue a little high here. After all, if you think about it, when is virtue ever necessarily 'disinterested'? Might it not also be considered a strategy in its own right, as the phrase 'honesty is the best *policy*' implies? While the Duke undeniably mobilizes his ears in

the service of maintaining power and stabilizing his regime, I would suggest that not all of his acts of hearing ask to be construed in this way. In fact, some of what he hears while in disguise appears to have a profoundly destabilizing effect on him. As Margaret Webster has observed, 'the Duke does quite a lot of listening and quite a lot of learning as he listens ...' (Webster 1957: 249). He occasionally finds himself confronted with information he would rather not hear about himself, as when Lucio so surprisingly and effortlessly exposes the real motivations which underlie his current official absence, motivations which he has been at some pains to conceal (3.2.92–5).[4] His repeated attempts to silence Lucio in the final act may not be flattering, but they are psychologically realistic and thereby contribute to our sense of his mimetic authority, if not his ethical authority.

Even more prevalent than these depictions of listening-as-surveillance are scenes which associate the ear with justice, relating the practice of hearing directly to one of the play's central concerns. In *Measure for Measure*, hearing is represented as the principal obligation of those in power, and correspondingly the primary occupation of those invested with the authority to administer justice. It is notable that Angelo, Escalus and Vincentio are each shown not once, but repeatedly and routinely conducting hearings of cases, causes and other disputes. Angelo and Escalus both hear Elbow's accusation against Pompey, though Escalus is eventually left alone to hear the tedious remainder of Pompey's response after his colleague departs in frustration (2.1). Yet the very following scene begins with Angelo again 'hearing of a cause' offstage, and then entering to hear successive appeals, first by the Provost and then by Isabella, on behalf of Claudio (2.2.1). In the play's final scene, Isabella urgently petitions the Duke to hear her complaint in the hope that he might be able to grant her 'justice, justice, justice, justice!' (5.1.25). When he instead directs her to the hearing of Angelo, she entreats him to 'Hear me yourself; for that which I must speak / Must either punish me, not being believ'd, / Or wring redress from you. Hear me, O, hear me, here' (5.130–2). Isabella's repetition of the words *justice* and *hear* at the end of these consecutive speeches further emphasizes the close connection and correlation between the two.

As these instances of judicial hearing collectively suggest, the ear of justice belongs not to a single person, but is rather a social organ, part of the body politic. This idea is underscored when Isabella returns in the fifth act after Vincentio has momentarily disappeared. She immediately asks 'Where is the Duke? 'Tis he should hear me speak', to which Escalus responds that his presence is unnecessary, since 'The Duke's in us, and we will hear you speak' (5.1.294–5). Until Vincentio returns,

Escalus considers his own ear to be the Duke's ear. That is, during Vincentio's absence he hears with the Duke's ear. When Vincentio reappears moments later as Friar Lodowick and proceeds to malign his real self, Escalus continues on in this vein, decrying the villainy of one who would speak so of the Duke 'in the witness of his proper ear' (308). The Duke's 'proper ear' is actually a function of his office. It is ostensibly for this reason that Vincentio has taken to listening to others while disguised in the habit of a friar; in his own person and office he is exposed to having his 'royal ear abus'd' with lies (5.1.139).

Michael Friedman has noted that ever since John Barton's Royal Shakespeare Company production of 1970, in which Isabella declined the Duke's proposal at the play's end, her 'response (or lack thereof) … has become a recurrent topic of Shakespearean performance criticism' (Friedman 1995: 454). Since Shakespeare doesn't provide anything for Isabella to say after either of the Duke's two tentative proposals, and since there are no extant stage directions, recorded audience responses, or other contemporary paratextual indicators, we can hardly know exactly what he intended her response to be. Philip McGuire has named such moments of indeterminacy 'open silences', and he finds the final act of *Measure for Measure* full of them, where, in the absence of linguistic cues provided by the text, the meanings of particular theatrical moments depend on an actor's interpretation (McGuire 1985). While acknowledging the textual indeterminacy that produces these open silences, I wish to draw attention back to what Shakespeare *did* write in this scene, specifically to the way he makes the whole issue of whether Isabella accepts or declines the Duke hinge upon whether or not she will incline a 'willing ear' to his offer, since upon her response to this question rests the generic identity and ethical complexion of the entire play.

The Duke first proposes to Isabella immediately after he miraculously returns her brother to her. His strategy here is so transparent that it is comic, and yet so bold that it is actually impressive in a disturbing sort of way. Keeping Isabella in the dark about her brother's condition until just this moment is something he has obviously done for maximum effect. He pardons Claudio at the same time, and even suggests that Isabella try on the idea that her brother would undergo a significant transformation in social class, becoming the brother of a Duke, were she to accept his proposal:

> If he be like your brother, for his sake
> Is he pardoned, and for your lovely sake,

Give me your hand and say you will be mine;
He is my brother too. But fitter time for that.
 (5.1.489–93)

Isabella says nothing in reply to this overture; even without taking the
Duke's offer into account one can hardly imagine the dizzying combi-
nation of emotions which must swarm in her chest at this moment. In
the absence of any verbal response from her Vincentio presses onward,
continuing to display his beneficence, dispensing justice with mercy,
first pardoning Angelo, which Isabella has just begged him to do, then
sentencing Lucio to a life of familial responsibility, extending his grati-
tude to Escalus and the Provost, pardoning the Provost for deceiving
Angelo – all of this until the 'fitter time' for further talk of marriage
finally arrives, some forty lines after his first proposal:

 Dear Isabel,
I have a motion much imports your good,
Whereto if you'll a willing ear incline,
What's mine is yours, and what is yours is mine.
 (5.1.534–7)

By the time of the Duke's second proposal we see mercy itself as a gift
economy bordering on potlatch, where something of tremendous value
is given primarily in order to confer an obligation to reciprocate on the
part of the recipient. The Duke seems to count on the logic of the occa-
sion to influence Isabella's response to his offer. In asking her to incline
a 'willing ear' he asks her to have mercy on him, one who has lied to
her, who has led her to believe falsely that her own brother had been
killed, who even caused her to lie publicly, to confess to the same crime
for which her brother had been sentenced to death. Whether she
assents to this marriage or no, it is remarkable that the Duke frames
the second proposal so that her response hinges upon her having a
willing ear, which can be read as an acoustemological disposition
linked to assent, specifically to the role of assent in the practice of
judging or 'hearing' others. It relates back to the notion of the ear of
justice as a social organ which becomes engaged once we listen with the
ears of others.

 The play's title of course resonates with numerous Biblical passages,
especially with phrases from the Sermon on the Mount which comment
on the relation between justice and reciprocity. When she is about to
plead for Angelo's life the Duke reminds Isabella of her own loss and
argues unconvincingly that the law enacts its own mercy:

The very mercy of the law cries out
Most audible, even from his proper tongue,
'An Angelo for Claudio, death for death!'
Haste still pays haste, and leisure answers leisure;
Like doth quit like, and measure still for measure

(5.1.407–11)

In the version of the Sermon on the Mount from Matthew, Christ exhorts his followers to 'Judge not, that ye be not judged. For with what judgment ye judge, ye shall be judged: and with what measure ye mete, it shall be measured to you again' (Matt 7:1–2). The agricultural metaphor in this passage is repeated at Luke 6:38, and calls to mind yet again the relation between ears and the planting of seed in the parable of the sower, as well as Robert Wilkinson's injunction in *A Iewell for the Eare* that the best way to hear is to 'sift with your ears'. All of this returns us to the Duke mentioning he has 'strew'd it in the common ear' that he would be away in Poland, suggesting he has scattered this notion like a sower into the ears of his subjects. We should not therefore be surprised to find hearing incorporated into this nexus of ideas more overtly, in acoustemological form, when we return to the conclusion of the parable of the sower in Mark: 'If any man have ears to hear, let him hear. And he said unto them, Take heed what ye hear: with what measure ye mete, it shall be measured to you: and unto you that hear shall more be given' (Mark 4:23–4).

In *The Wheel of Fire*, G. Wilson Knight situates *Measure for Measure* within the Gospel tradition, maintaining that the play itself is 'a parable, like the parables of Jesus', one which ultimately reflects 'the sublime strangeness and unreason of Jesus's teaching' (Knight 1949: 96). While providential readings along the lines of the one Knight delivers have long since gone out of style, I am impressed by the extent to which the ethical core of such readings endures, the extent to which the play so successfully seems to encourage critical empathy in its readers, who try to listen to it with willing ears, with the ears of others. Lars Engle begins his recent essay on the play, which considers the Duke as a radical sceptic so advanced in this posture that he is even sceptical of his own scepticism, with an engaging fable (or is it a parable?) that asks his readers to imagine what it would be like to be in the Duke's position (Engle 2000: 86–7). Even more remarkable in this respect is Harry Berger, Jr, who during his *tour de force* essay asks us no less than six times to hear with the Duke's ears (see Berger 1997: 378; 394; 403–4; 417; and 419).[5] Those that have ears, let them hear.

In the previous chapter I referred to mercy as a grotesque ethical act which redescribes and even renders unrecognizable the contours by which reciprocity is ordinarily defined. The willing ear, like the suitor who chooses Portia's leaden casket, like Orsino when he listens to that dying fall again, ventures all it has, and has all to gain. For Isabella to accept the Duke's proposal is to make a mockery of everything she has stood for so strictly and absolutely up to this moment in the play; it explodes our understanding of her, as it surely must her own understanding of herself. It is for this reason, and no other, that I like to imagine she accepts.

To draw this discussion of the willing ear to a close, let us shift from the Duke of Vienna to the Duke of Hollywood. Four months to the day before John Wayne's death, noted culture critic and popular historian Greil Marcus published a piece on the actor in the *Los Angeles Times*, in which he tried to get past the 'legend ... encrusted with the myths he has acted out', past the 'statue-in-waiting', and onward to an appreciation of the real actor (Marcus 1995: 210). 'Very few actors enter such desperate, psychologically catastrophic crises,' Marcus notes, 'and when they do they protect themselves', either by overacting, underacting, or by completely losing themselves in their roles (214). What makes John Wayne such a significant and special actor is that he does none of the above. In films like *The Searchers* and *Red River*, Marcus finds, 'you understand that Wayne is judging the motives and actions of his characters and finding them correct, necessary – satisfying'. He assents to the characters he plays, in their fullness. Furthermore, the main argument of the essay is that Wayne's particular ability to achieve this results from the way he *listens* to the characters as he acts them out: 'When Ethan Edwards speaks in *The Searchers*, or Tom Dunson in *Red River* – when their vows are made, and then they are taken back – John Wayne is listening to what they say' (215).

I introduce Greil Marcus's assessment of John Wayne's acting style and method because it describes the very representational mode that Harold Bloom credits William Shakespeare (another actor, whom Bloom calls 'keenest of ears') with inventing (Bloom 1998: 634). Shakespeare's most important and enduring contribution to the Western literary tradition, according to Bloom, is his representation of subjectivity as a process of continual transition.[6] Moreover, what makes Shakespeare's characters so real, he finds, is not only that they are represented changing over time, but also the way in which they are represented changing over time. This is accomplished through instances in which characters are represented overhearing themselves, in which

they exteriorize their thoughts and emotions, and subsequently change as a result of listening to themselves.[7]

One of the places Bloom broaches the subject more overtly is in *The Western Canon* (1995), when he explains why Shakespeare occupies the centre of the canon. The earliest representation of overhearing in literature occurs in Chaucer's portrayals of the Pardoner and the Wife of Bath. Shakespeare, says Bloom, tunes into this 'burgeoning secret of representation', and soon

> surpasses all others in evidencing a psychology of mutability. That is only part of the Shakespearean splendor; he not only betters all rivals but originates the depiction of self-change on the basis of self-overhearing, with nothing but the hint from Chaucer to provoke him to this most remarkable of all literary innovations.
>
> (Bloom 1995: 48)

Working with a phrase from Hegel, Bloom suggests that in Shakespeare's plays, characters such as Hamlet, Iago, and Edmund become 'free artists of themselves'. Through overhearing themselves, these characters are able to 'change and go on to contemplate an otherness in the self, or the possibility of such otherness' (70). The idea of overhearing is given further treatment in Bloom's book *Shakespeare: The Invention of the Human*, where it makes its initial appearance in the context of his discussion of *Richard II* (Bloom 1998: 268).

Greil Marcus would argue that the sense in which John Wayne *listens* to the characters he plays, in which he assents to their reality in a thorough and fundamental way, is exactly how history should be confronted. The alternative might be safe, but you really don't get to go anywhere:

> Perhaps the most pernicious strain of contemporary criticism says one thing before it says anything else, says it to whatever historical event or cultural happenstance is supposedly at issue: *You can't fool me*. I think criticism, or a critical engagement with history, has a good deal to do with a willingness to be fooled: to take an idea too far, to bet too much on too small an object or occasion, to be caught up and even swept away.
>
> (Marcus 1995: 6–7)

This is obviously how Bloom thinks we should read Shakespeare too – and he ought to know. After having been swept away for over 700 pages he washes ashore, sputtering, clearing his ears, and clutching a pearl of a sentence: 'Shakespeare's plays are the wheel of all our lives,

and teach us whether we are fools of time, or of love, or of fortune, or of our parents, or of ourselves' (Bloom 1998: 735).

More than one reviewer of *Shakespeare: The Invention of the Human* found the repetition in the book annoying.[8] Perhaps these readers failed to appreciate that Bloom, as a Shakespeare critic, operates in the same way as a jazz musician. These repetitions are actually melodic lines, or refrains. In the book, he improvises on a small core of ideas – Hegel on Shakespeare's characters as free artists of themselves, Nietzsche on language as the graveyard of meaning – and returns to them, listening to how they play in different contexts, with different subtleties of phrasing. They are part of his repertoire, and like every jazz musician he always keeps a few of them close to hand in case he wants, or needs, to revisit them during his explorations. He finds that these ideas, like melodies, have a fascinating dimensionality to them. Because he is convinced of their resonance, listens to them, assents to them, they bear repetition, and pearls.

Then play on

The rest is silence. As Hamlet dies, he provides us not with a visual *glimpse* of that undiscovered country, but with a brief description of what it *sounds* like there. His last words clearly cannot pertain to the play itself, wherein people continue, discoursing and making sounds after his death. There are governments to form, state funerals to plan, death marches to play, stories to relate. Every time he dies, the world fills up again with sound. Hamlet leaves sound, and leaves us in sound. To hear, Hamlet tells us with his final breath, is what it is to be alive. The rest is silence.

In the theatre at Epidaurus it is morning. A philosopher, Michel Serres, sits alone in the calm, and finds to his regret that no matter how he tries he cannot escape sound, the constant vibration of being. As he sits he even becomes aware of the noises made by his own body through the proprioceptive faculty of hearing. A group of tourists enters the ruin, disturbing the tranquillity even further with their incessant jabbering, their addiction to language. They leave. The theatre itself transforms into a giant ear pointed towards the gods: 'I listen. My ear grows to the dimensions of the amphitheatre, porch of marble. Hearing laid out on the earth, along a vertical axis, which listens for the harmony of the world.'[9]

For Serres, hearing is all about involvements, and transformations. His is a difficult relationship to sound, because he so closely associates it with the prison of language, straitjacket of experience. He wants to be

able to listen and hear nothing except the stillness at the limits of being. But sound will not allow him his desire to think apart, to be apart; it keeps calling him back, involving him in the world. He prefers the theatre at Pinara, with its silent audience of the dead. The chapter of *Les Cinq Sens* in which this scene occurs is titled 'Boîtes', a word that refers to Serres's conception of hearing. Of all senses it most perfectly demonstrates the mysterious transformations whereby raw data becomes metamorphosed into meaning, through means of processes he can only locate in 'black boxes', the contents of which are inaccessible to us. Ears take the hard data of the environment, which includes ourselves, and transform it into the soft data of consciousness. The precise mechanisms through which they achieve this we really don't understand much better now than we did in Shakespeare's day.

I can't help thinking of Shakespeare as a listening self, a *will*-ing ear, one who had developed an acute awareness of the way in which sounds create worlds. The prologue to *Henry V* famously exhorts the audience to 'Think, when we talk of horses, that you see them / Printing their proud hoofs i' th' receiving earth' (26–7). The surrounding speech is often produced as proof of the power of Shakespeare's imagination, of his ability to conjure up images through language. But that isn't what the speech is about at all: it is, rather, an expression of the extreme vulnerability that is always associated with the project of trying to get people to really *listen*, which is the necessary precondition for the creation of situations people will believe in. An actor stands alone, on an empty stage, in front of two thousand people who have paid money to be entertained. The speech is an admission that the contract is not finished, that if this thing, this presentation, is going to work, we are going to have to participate.[10] Something more is being asked of us in this speech: we must listen, to it, with a careful and imaginative ear. It is the best we can do.

Listening is essential not only in the theatre; it is also an important element in the imaginative engagement with texts. Thousands of people now hear the work of François Rabelais in a new way, through the ears of Mikhail Bakhtin, who was the first in many years to tune into and reclaim the laughter in Rabelais's book as an expression of the durable wisdom of the common people. Another extremely influential critic, Stephen Greenblatt, has more dramatically described his own impulse to read early modern literature as the result of a shamanistic 'desire to speak with the dead', to listen to the stories they have to tell:

Even when I came to understand that in my most intense moments of straining to listen all I could hear was my own voice, even then I

did not abandon my desire. It was true that I could hear only my own voice, but my own voice was the voice of the dead, for the dead had contrived to leave textual traces of themselves, and those traces make themselves heard in the voices of the living.

(Greenblatt 1988: 1)

The early modern text is represented here as a storehouse of sound, though Greenblatt seems to mean not so much literal sound, as sound's insistence on the fullness of experience, the sense of immersion and involvement that we associate with it most closely of all the modes of perception. Just as when Henry Irving first listened to himself on the phonograph, hearing the voices in these texts radically destabilizes Greenblatt's own sense of identity, which begins to oscillate back and forth between himself and the other, vibrating like a plucked string. At first he hears only his own voice, but that voice soon transforms into the voice of the dead, which then becomes the sound of the dead in the texts pronounced by his voice. It is a dialogue that is a dialectic. Like the Duke of Orsino, he hears a sound, and then turns into the sound he hears.

In this book I have tried to make listening my own critical practice, by attending to the ways Shakespeare is attuned to, and rebroadcasts throughout his work, the many interrelated associations sound and hearing have for early modern ears. Among them are notions of grotesque transformation and continuity, generativity and nourishment, community, vulnerability, and unbounded expenditure, as well as related ethical dispositions such as obedience, receptivity, assent, and belief. These apprehensions of what it means to have ears, to be alive, play on in Shakespeare's works, and in us as well. Pick up a play, lend a willing ear, and listen for your self.

Notes

Introduction

1 British actor Richard Bebb has compiled a magnificently detailed history of the recording. My own discussion draws on the factual material collected in his account. See Bebb 1977.

2 Vocal distinctiveness is an attribute of immense value and importance to successful male actors, especially those who would assume leading roles. In our own popular culture, one need only think of James Stewart, Humphrey Bogart, James Cagney, Orson Welles, Cary Grant, James Earl Jones, Marlon Brando, Mel Gibson, Jack Nicholson, Al Pacino, or even Arnold Schwarzenegger, each of whom is immediately identifiable by sound alone.

3 As of this writing, the recording is available on the worldwide web at The Irving Society site: http://www.theirvingsociety.org.uk/richard_iii.htm, and I would strongly encourage the reader to listen to it there. If this link becomes inoperative in the future for any reason, please visit http://www.shakespeare.mcgill.ca/sound for further information on how to listen. The recording can also be found on *Great Historical Shakespeare Recordings* (Naxos Audiobooks CD NA220012, 2000). For those who still love their vinyl, an attenuated version was also previously included on two LPs released in the 1970s: *Great Actors of the Past* (Argo Records LP SW 510, 1977), and *Authors and Actors* (Rococo Records LP 4002, 1970).

4 This and all succeeding references to the plays are from *The Riverside Shakespeare*, ed. G. Blakemore Evans, 2nd ed. (Boston: Houghton Mifflin, 1997).

1 Shakespearience

1 The performance dates and location are suggested by the venerable Frederick Gard Fleay in his *A Chronicle History of the Life and Work of William Shakespeare: Player, Poet, and Playmaker* (Fleay 1886: 154).

2 All references are from Thomas Dekker, *The Shoemaker's Holiday* (Berkeley: University of California Press, 1968).

3 In a related note, Marta Straznicky observes that 'the festival in *The Shoemaker's Holiday* ... enacts an imaginary appropriation of civic authority and commercial wealth by a group of industrial laborers for whom both privileges were largely

a matter of fantasy'. See her article 'The End(s) of Discord in The Shoemaker's Holiday' (Straznicky 1996: 368).

4 See Taylor 1630: 115. The reference to the date of the passage's composition also occurs on that page.

5 John Taylor remarks upon this violence in *Iacke-A-Lent*: 'Then these youths arm'd with cudgels, stones, hammers, rules, trowels, and hand-sawes, put Play-houses to the sacke, and Bawdy-houses to the spoyle, in the quarrell breaking a thousand quarrels (of glasse I meane) making ambitious brickbats breake their neckes, tumbling from the tops of lofty chimnies, terribly vntyling houses, ripping vp the bowels of feather-beds, to the inriching of vpholsters, the profit of Plaisterers, and Dirtdawbers, the gaine of Glaisiers, Ioyners, Carpenters, Tylers and Bricklayers' (Taylor 1630: 115).

6 Bells of course have a host of other associations for the early modern English; in Shakespeare's plays, for example, when referred to in the singular, a bell commonly refers to the death knell. When referred to in the plural, bells usually allude to the time.

7 The larger group is called the World Soundscape Project. See Schafer 1977, Truax 1978, and Truax 1984.

8 For a wonderfully comprehensive account of the many disparate speech communities of early modern Britain, see Fox 2000: 51–111.

9 Schutz is best known for his work on intersubjective phenomenology, particularly for his deft syncretic fusions of the work of phenomenologist Edmund Husserl and sociologist Max Weber. Born in Austria, he fled to the USA in 1939, where he eventually came to teach at the New School for Social Research. For an informative biography, see Wagner 1983. Because recent research into human consciousness in cognitive studies corroborates some of the fundamental intuitions of phenomenology, it is plausible that Schutz's work could find a larger audience in literary and performance studies in coming years.

10 When Schutz refers to 'language' in this context, he undoubtedly means *langue* as opposed to *parole*. For Ferdinand de Saussure's famous distinction between the two, see Saussure 1983: 13–4, and 18.

11 For more wide-ranging discussions of the cultural effects of print technology, see McLuhan 1962, Eisenstein 1979, and Ong 1977 and 1982.

12 The threat of competition posed by the appearance of new technologies of communication and representation has become a familiar story in the early twenty-first century. When radio first appeared, musicians' unions expressed concern that audience attendance at live performances would decline, since people could hear performances for free over the bandwaves. The movie theatre posed a similar threat to the live theatre, and when the videocassette recorder was initially introduced, it in turn was seen as a threat to the existence of movie theatres. Nowadays communications conglomerates devote significant resources to monitoring and investing in future communications technologies, so that they will have a stake in them when they are introduced. What should also be noted is that live music and theatre are more popular now than they ever have been.

13 The one editor responsible for more auditory stage directions than any other was eighteenth-century editor Edward Capell, who read the plays with an exceptionally attentive ear. In his edition of the plays he also introduced new types of punctuation marks to indicate irony, mid-speech changes in address, etc. The punctuation marks never stuck, but the better part of his stage directions and other notes have. See Capell 1767.

14 For further discussion of surveillance in *The Rape of Lucrece*, see Dubrow 1987: 90–91.

15 It is this last quote, 'for by our ears our hearts oft tainted be', which provides the refrain for Joel Fineman's reading of the poem (Fineman 1987). In his essay, titled 'Shakespeare's Will', he nevertheless surprisingly relegates the line I cite earlier in this paragraph, which characterizes the will in terms of a specific sensorial configuration, to a footnote. For more on the workings of mimetic desire in the poem, see Girard 1991: 21–8.

16 There are numerous examples of this throughout Shakespeare. In *1 Henry VI*, Charles directs the Reignier to impersonate the Dauphin during his interview with Joan, for 'By this means shall we sound what skill she hath'. In the following instalment of that tetralogy, Suffolk describes Richard of Gloucester as 'a man / Unsounded yet and full of deep deceit'. The opening scene of *Richard II* has the king, anxious about Mowbray's potential response to Bolingbroke's accusations, nervously probing Gaunt as to whether or not he has 'sounded him'. Cassius asks his fellow conspirators, 'But what of Cicero? Shall we sound him?' *Lear's* Gloucester too credulously asks Edmund if Edgar has 'never before sounded you in this business?' in reference to the supposed plot on his life. In *Merry Wives*, Ford announces that he has 'a disguise to sound Falstaff'. In Padua, Baptista promises, upon learning of Bianca's marriage to Lucentio, to 'sound the depth of this knavery'. See 1H6 (1.2.63); 2H6 (2.4.56–7); R2 (1.1.8); JC (2.1.141); Lear (1.2.70); MWW (2.1.238); and Shrew (5.2.137).

17 Marshall McLuhan begins *The Gutenberg Galaxy* by suggesting that Shakespeare 'seems to have missed due recognition for having in *King Lear* made the first, and so far as I know, the only piece of verbal three-dimensional perspective in any literature' in the scene with Edgar and Gloucester on the 'cliff' (McLuhan 1962: 15).

2 The public ear

1 Although the Folio text is almost certainly corrupt in parts of this passage, with resort to Plutarch one can ascertain that Antony is not concerned about Caesar ordering a public reading of Caesar's own will, but of Antony's. At least one commentator from the turn of the previous century ingeniously, if a little too conveniently, attributed the passage's syntactic irregularities to Antony's agitated state. For references concerning this passage, see Marvin Spevack's enormously helpful New Variorum edition of the play, Spevack 1990: 165–6.

2 One of the many beneficial offshoots of the Records of Early English Drama project has been an increased awareness of and interest in the activities of town waits. See, for example Coldewey 1982, and White 1987. For further information about town waits in England, the best introduction remains Woodfill 1953: 33–53, and 74–108.

3 This is perhaps one reason why Will Kemp lavishes such praise on the waits of Norwich, who greet him at the end of his long morris dance from London; one can imagine his gratification at receiving the kind of official welcome usually reserved for respectable authority figures far above his station in life. See Kemp 1600.

4 This and all succeeding references to the *Sylva* are to paragraph number, as these remain consistent from edition to edition.

5 The selections on sound in *Sylva Sylvarum* were evidently incorporated from an earlier work. James Spedding, editor of the 1963 edition of the *Works*, has

found much of this material in an earlier, and somewhat better-organized Latin fragment entitled *Historia Soni et Auditus.*

6 For wider discussion of the sensorium as a whole in the early modern period, see Vinge 1975 and Summers 1987.

7 My main source for bibliographical information on Wright is the invaluable work of William Webster Newbold, who provides a detailed account in the general introduction to his critical edition of *The Passions of the Mind in General.* See Wright 1986: 3–16. The DNB's entry on Thomas Wright posits at least three individuals of that not uncommon name during the era, and divvies up the publications accordingly. Newbold's account, more recent and far more thoroughly investigated, is the more compelling.

8 A short biographical sketch of Crooke's life can be found in the DNB.

3 Receptivity

1 See also Bristol 1990: 91–119. Although Bristol locates the scriptural component of his argument specifically in the Old Testament book of Deuteronomy and its relation to the rest of the Pentateuch, the institutional practices outlined in that argument translate seamlessly into the sorts of practices that must have been involved in the textual arrangement and editing of Christ's life and work in the various gospel accounts that found their way into the New Testament.

2 While I obviously focus on the ear in the present context of receptivity, Scott Wilson is led to an extended contemplation of another of our holes as part of his remarkable discussion of *The Merchant of Venice,* in which he poses the unforgettable question, 'What lover could be as destined to be engulfed in the abyss of an impossible desire than the Shakespeare scholar faced with the blinding image of Shakespeare's intact yet devouring solar anus, the scholar's own narcissistic mirror-image?' (1996: 131). A slightly elaborated version of this discussion appears in Wilson's *Cultural Materialism: Theory and Practice* (S. Wilson 1995): 85–91. Wilson is here playing off of a short article by Georges Bataille from 1927 titled 'The Solar Anus', which ends, 'The solar annulus is the intact anus of her body at eighteen years to which nothing sufficiently blinding can be compared except the sun, even though the anus is the night' (Bataille 1985: 9). This, the final sentence of Bataille's mercurial meditation on the prevalence and tremendous generativity of parody as a form of associative thinking and world-making, enacts its own argument with an obvious parody of the opening line of Shakespeare's 130th sonnet: 'My mistress' eyes are nothing like the sun'. Well, maybe her eyes are nothing like the sun, but her anus is another story! – Bataille seems to retort with an ardency of his own, as real as it is outrageous.

Wilson also relates his own question to Michael Bristol's remarks on humanism's erotic, submissive empathy with the 'intact body' of the Shakespearean text, and the practice of 'doing an edition' in *Shakespeare's America, America's Shakespeare* (Bristol 1990: 17; 91). Wilson reads Bristol as suggesting that such editorial work constitutes an 'anally erotic or anally retentive activity' (130). While I'm fairly certain that Michael Bristol would not object to such a characterization of editorial work on Shakespeare, I'm more interested in the physical mechanics of Wilson's metaphor, because they serve to further illuminate Gary Taylor's. As Wilson coyly reminds us during his reading of Bristol on the erotics of editorial work, Taylor has 'not merely done an edition of a particular play, but

covered them all'. He here suggests that editors do the penetrating and Shakespeare the receiving in this erotic relationship. My cue for this inference is his choice of the verb 'cover', a word still used in equestrian settings for the stallion's role in copulation. I find Wilson's image significant for the way it relates Shakespeare's genius to the notions of penetrability and capaciousness that were so directly associated with sound and hearing during the early modern period. That is, the image of Shakespeare being covered by generation after generation of textual editors is funny, but it works because it also so vividly suggests his phenomenal capaciousness.

3 One of the earliest researchers to take this approach was Caroline Spurgeon, who conducted a careful analysis of image clusters in her book *Shakespeare's Imagery, and What it Tells Us* (Spurgeon 1935). She found, among other things, that Shakespeare disliked dogs, greasy food, and noisy argument, and had extraordinary eyesight. While these types of biographical claims are typically dismissed by scholars, Spurgeon's book has enjoyed a longevity that most current critical work on Shakespeare will simply never achieve. During a panel on academic book publishing at the 1999 Shakespeare Association of America meeting in San Francisco, Sarah Stanton of the Cambridge University Press informed a surprised audience that Spurgeon's book remains, over sixty years after its initial publication, one of the press's two perennially best-selling Shakespeare monographs, the other being John Dover Wilson's *What Happens in Hamlet*, which was first published in the same year. The continuing commercial viability of these two studies is even more impressive when one takes into consideration the fact that Cambridge publishes more Shakespeare monographs than any other press.

4 The 1998 article also appears in a later version as the fifth chapter of her recent book *Shakespeare's Brain: Reading with Cognitive Theory* (Crane 2001).

5 See, for example, George Lakoff's account of the classificatory system of the Dyirbal aboriginal people of Australia in *Women, Fire, and Dangerous Things: What Categories Reveal About the Mind* (Lakoff 1987: 91–114). Lakoff maintains in this book that 'metonymy is one of the basic characteristics of cognition' (77).

6 It appears this technique of homicide was typically associated with Italy in the popular imagination, as were most enormative forms of intrigue. The character Lightborn in Marlowe's *Edward II* speaks of his grisly apprenticeship in Naples, where he learned how to murder a man secretly in numerous ways, including 'whilst one is asleep, to take a quill, / And blow a little powder in his ears' (5.4.33–4).

7 For additional references to the place of fame and report in the culture of the play, see 1.3.9–13, and 1.9.21–6.

8 See, for example, the following passages: 1.5.8; 2.2.52–4; 2.2.61–2; 3.1.89–90; 3.1.190–1; 3.1.213–14; 3.1.277–9; 3.1.282–5; 3.3.41–2; 3.3.110–13; 4.2.12–14; 4.2.37–42; 5.3.91; 5.3.92–3; 5.6.102; 5.6.114; 5.6.71; and 5.6.137.

9 See Dennett 1991: 16ff.

4 Transformation and continuity

1 Eighteenth-century French mythographer Antoine Banier is similarly open to various interpretations of the myth. 'Midas's Stupidity,' he writes, 'or possibly his exquisite Sense of Hearing, made him be complimented with the Ears of an Ass.' He is endowed by Apollo with ass's ears either because 'he was very dull

and stupid', or because the act 'was designed to intimate that he had a very fine Ear like that Animal; or because he kept Spies thro' all his Dominions; or, in fine, because he commonly dwelt in a Place named ... *the Asses Ears*' (Banier 1976: vol. 1, 77; and vol. 2, 403).

2 The only reference to this part of the myth I have found in contemporary popular literature occurs in Thomas Tomkis's *Lingua*, when the title character shares her plans for revenge on the other senses with her partner Mendacio: 'I dare not trust these secrets to the Earth, ere since she brought forth Reedes, whose babling noise tolde all the world of Midas Asses eares' (Tomkis 1874).

3 The earliest mention of this popular nineteenth-century interpretation I have found is by Thomas Campbell, who noted in 1838 that Shakespeare wrote *The Tempest* 'as if conscious that it would be his last, and as if inspired to typify himself'. 'Here Shakespeare himself is Prospero, or rather the superior genius who commands both Prospero and Ariel. But the time was approaching when the potent sorcerer was to break his staff, and to bury it fathoms in the ocean – "deeper than did ever plummet sound". That staff has never been, and never will be, recovered' (quoted in Furness 1892: 356).

4 Bataille's theory of eroticism is a striking, elegant synthesis of Plato and Freud: 'We are discontinuous beings, individuals who perish in isolation in the midst of an incomprehensible adventure, but we yearn for our lost continuity. We find the state of affairs that binds us to our random and ephemeral individuality hard to bear. Along with our tormenting desire that this evanescent thing should last, there stands our obsession with a primal continuity linking us with everything that is' (Bataille 1986: 15).

5 See, for example, Miller 1975; Hassel, Jr 1971; Stroup 1978; and Peters 1988.

6 See Parker 1996: 83–115.

7 The most complete and comprehensive account of this literary trope remains Maggie Kilgour's pun-filled *From Communion to Cannibalism: An Anatomy of Metaphors of Incorporation* (Kilgour 1990), which tracks the idea as it occurs throughout the Western tradition, providing much food for thought along the way.

8 See LLL 5.2.738, 5.2.890; MND 1.1.184; R2 2.1.20, 4.1.54; Ant. 3.4.5; John 3.4.109, 5.2.172; Ham. 4.7.3, 1.3.30; and H5 4.Chorus.10.

9 Bristol suggests that 'Bottom is not an individual subject or character at all, but a temporary name assumed by a public figure whose willingness to play all parts is a comic uncrowning of limited identity and social discrimination' (Bristol 1985: 174). That Bataille and Bakhtin are in fundamental consonance is also indicated by their similar choice of illustrative examples: startlingly, each employs the example of the division of the single-cell organism to problematize the notion of identity as a stable condition (Bakhtin 1984: 52–3; Bataille 1986: 13–5).

10 This is of course another contemporary reference to the feminized ear. For a consideration of the grotesque from a feminist standpoint see Russo 1997.

11 Bakhtin argues for the fundamental ambivalence of the grotesque throughout *Rabelais and His World*. For example, he refers to the ambivalence of the performance/real life distinction (Bakhtin 1984: 7–8); to the ambivalence which characterizes the scene of Gargantua's birth (407); and to the duality of tone in language as ambivalent (432).

12 All three of the most popular teaching editions of the complete works (Riverside, Norton, and Bevington) gloss the word 'strain'd' in this speech as either 'forced',

'compelled', or 'constrained' – obviously taking their cue from Shylock's question, 'On what compulsion must I?' which the speech purportedly answers. I'm not arguing *against* this reading, but am merely supplementing it with further semantic shadings.

5 Shakespearean acoustemologies

1 See TGV 4.2.61; Ham. 1.3.30 and 4.7.3; H5 4.Pro.10; and Jn. 3.4.109.

2 Desdemona's greedy ear reappears upon her safe arrival in Cyprus, where she makes repeated requests to hear Iago praise first herself, and then other feminine types, such as she who is 'black and witty', or she who is 'fair and foolish' (2.1.117ff). Her teasing provocations recall a brief moment in *The Winter's Tale*, when the pregnant Hermione encourages her own jealous husband Leontes to 'cram 's with praise, and make 's / As fat as tame things' – to fill not only her own ears, but those of other women as well (WT 1.2.91–2).

3 In *That Shakespeherian Rag: Essays on a Critical Process*, Terence Hawkes likens the Shakespearean playtext to a sea-shell which, 'held to the ear … apparently emits the sounds of the sea. But of course the sea-shell does no such thing: it produces no sound. In fact the sound we hear may simply be the sound of the circulation of our own blood' (Hawkes 1986: 43). I agree that as we read the plays we do sound out ourselves, but would add that such a sea-shell allows us to listen to ourselves in ways that we are normally less likely to in the course of the everyday. The sea-shell enables us to hear our own otherness, as it were.

4 At one point in his magnificent essay on the play, Harry Berger, Jr refers to Lucio as a 'noisy resonator' of the Duke's conscience (Berger 1997: 417).

5 For an important discussion of empathy and its relation to substitution in *Measure for Measure*, see Maus 1999, especially pages 208–9.

6 Peter Cummings notes that it is not only Shakespeare's characters that change, but we as well, and that all of those changes are reflected and registered in sound: 'We hear other things in texts as we grow older with them, as their lines and voices speak to us, just as we hear more subtle nuances in the human voices we know over time' (Cummings 1990: 83).

7 The idea appears in *Ruin the Sacred Truths*, in which he notes that Shakespeare introduces 'the representation of change by showing people pondering their own speeches and being altered through that consideration' (Bloom 1989: 54).

8 See Kerrigan 1998: 37, and Lane 1998: 86.

9 'J'écoute. L'oreille s'agrandit aux dimensions de l'amphithéâtre, pavillon de marbre. Ouïe couchée sur la terre, dans une axe vertical, qui tente d'entendre l'harmonie du monde' (Serres 1985: 109). The English translation is my own.

10 Peter Brook's universally lauded production of *A Midsummer Night's Dream*, arguably the most important production of Shakespeare of the twentieth century, was based on this admission. As a result, it presented audiences not only with the power of Shakespeare's imagination, but astonished them with that of their own.

References

Adelman, J. (1973) *The Common Liar: An Essay on Antony and Cleopatra*, New Haven: Yale University Press.

—— (1978) '"Anger's my meat": feeding, dependency, and aggression in *Coriolanus*', in D. Bevington and J. Halio (eds) *Shakespeare, Pattern of Excelling Nature*, Newark: University of Delaware Press.

Armin, R. (1609) *The history of the two maids of More-clacke, vvith the life and simple Maner of Iohn in the Hospitall. Played by the Children of the Kings Maiesties Reuels. VVritten by Robert Armin, seruant to the Kings most excellent Maiestie*, London: Printed by Nicholas Okes for Thomas Archer.

Attali, J. (1985) *Noise: the Political Economy of Music*, Minneapolis: University of Minnesota Press.

Authors and Actors (1970) LP record, Rococo LP 4002. Toronto: Rococo Records.

Bacon, F. (1824) *The Works of Francis Bacon, Baron of Verulam, Viscount St. Albans, and Lord High Chancellor of England*, London: W. Baynes and Son.

Baines, A. (1957) *Woodwind Instruments and Their History*, New York: W.W. Norton.

Bakhtin, M.M. (1984) *Rabelais and His World*, trans. H. Iswolsky, Bloomington: Indiana University Press.

Banier, A. (1976) *The Mythology and Fables of the Ancients Explain'd from History: London, 1739–40*, trans. Anon., S. Orgel (ed.) New York: Garland.

Barker, F. (1984) *The Tremulous Private Body: Essays on Subjection*, London: Methuen.

Bataille, G. (1985) *Visions of Excess: Selected Writings, 1927–1939*, trans. A. Stoekl, with C.R. Lovitt and D.M. Leslie, Jr, A. Stoekl (ed.) Minneapolis: University of Minnesota Press.

—— (1986) *Erotism: Death and Sensuality*, trans. M. Dalwood, San Francisco: City Lights Books.

Beaumont, F. (1969) *The Knight of the Burning Pestle*, London: Benn.

Bebb, R. (1977) 'The Voice of Henry Irving: An Investigation,' *Recorded Sound: the Journal of the British Institute of Recorded Sound* 68: 727–32.

Bellamy, J.G. (1973) *Crime and Public Order in England in the Later Middle Ages*, London: Routledge and Kegan Paul.

Berger, Jr, H. (1989) *Imaginary Audition: Shakespeare on Stage and Page*, Berkeley: University of California Press.

—— (1997) *Making Trifles of Terrors: Redistributing Complicities in Shakespeare*, Stanford: Stanford University Press.

Bingham, M. (1978) *Henry Irving, the Greatest Victorian Actor*, New York: Stein and Day.

Bloom, H. (1989) *Ruin the Sacred Truths*, Cambridge: Harvard University Press.

—— (1995) *The Western Canon: the Books and School of the Ages*, New York: Riverhead Books.

—— (1998) *Shakespeare: The Invention of the Human*, New York: Riverhead Books.

Blumenberg, H (1993) 'Light as a metaphor for truth: at the preliminary stage of philosophical concept formation', in D.M. Levin (ed.) *Modernity and the Hegemony of Vision*, Berkeley: University of California Press.

Brathwaite, R. (1620) *Essaies vpon the fiue senses, with a pithie one vpon detraction. Continued vvith sundry Christian resolues, full of passion and deuotion, purposely composed for the zealously-disposed. By Rich: Brathwayt Esquire*, London: Printed by E: G[riffin]: for Richard Whittaker, and are to be sold at his shop at the Kings head in Paules Church-yard.

Bristol, M.D. (1985) *Carnival and Theater: Plebeian Culture and the Structure of Authority in Rennaisance England*, New York: Methuen.

—— (1987) 'Lenten butchery: legitimation crisis in *Coriolanus*,' in J.M. Howard and M.F. O'Connor (eds) *Shakespeare Reproduced: The Text in History and Ideology*, New York: Methuen.

—— (1990) *Shakespeare's America, America's Shakespeare*, New York: Routledge.

—— (1996) *Big-Time Shakespeare*, New York: Routledge.

Burke, K. (1966) '*Coriolanus* – and the Delights of Faction,' *Hudson Review* 19: 185–202.

Burnett, C. and Fend, M. *et al.* (eds) (1991) *The Second Sense: Studies in Hearing and Musical Judgment from Antiquity to the Seventeenth Century*, Warburg Institute surveys and texts; 22, London: The Warburg Institute, University of London.

Calderwood, J.L. (1995) '*Coriolanus:* wordless meanings and meaningless words', in D. Wheeler (ed.) *Coriolanus: Critical Essays*, New York: Garland.

Capell, E. (ed.) (1767) *Mr. William Shakespeare, His Comedies, Histories, and Tragedies*, London: Printed by Dryden Leach for J. and R. Tonson in the Strand.

Cavell, S. (1987) *Disowning Knowledge: in Six Plays of Shakespeare*. Cambridge: Cambridge University Press.

Chambers, E.K. (1923) *The Elizabethan Stage*, Oxford: Clarendon.

Charney, M. (1969) *Style in Hamlet*, Princeton: Princeton University Press.

Chaucer, G. (1987) *The Riverside Chaucer*, J.M. Fyler (ed.) Boston: Houghton Mifflin.

Church of England (1844) *The Book of Common Prayer, Commonly Called the First Book of Queen Elizabeth: Printed by Grafton 1559*, London: W. Pickering.

Classen, C. (1993) *Worlds of Sense: Exploring the Senses in History and Across Cultures*, New York: Routledge.

Coldewey, J. (1982) 'Some Nottinghamshire Waits: their history and habits', *Records of Early English Drama Newsletter* 1: 40–49.

Comaroff, J.L. and Comaroff, J. (1992) *Ethnography and the Historical Imagination*, Boulder: Westview Press.

Cook, A. (1991) 'Some observations on Shakespeare and the incommensurability of interpretive strategies', *New Literary History* 22(3): 773–93.

Craig, E.G. (1930) *Henry Irving*, London: Dent.

Crane, M.T. (1998) 'Male pregnancy and cognitive permeability in *Measure for Measure*', *Shakespeare Quarterly* 49(3): 269–92.

—— (2001) *Shakespeare's Brain: Reading with Cognitive Theory*, Princeton: Princeton University Press.

Cressy, D. (1989) *Bonfires and Bells: National Memory and the Protestant Calendar in Elizabethan and Stuart England*, London: Weidenfeld and Nicolson.

Crockett, B. (1993) '"Holy Cozenage" and the Renaissance cult of the ear', *The Sixteenth Century Journal: The Journal of Early Modern Studies* 24(1): 47–66.

Crombie, A.C. (1962) 'The study of the senses in Renaissance science', in *Proceedings of the Tenth International Congress of the History of Science*, Paris: Hermann.

Crooke, H. (1616) *Microcosmographia: a Description of the Body of Man*, London: William Jaggard.

Cummings, P. (1990) 'Hearing in *Hamlet:* poisoned ears and the psychopathology of flawed audition', *Shakespeare Yearbook* 1, Spring: 81–92.

Davenant, W. (1630) *The Ivst Italian. Lately Presented in the Priuate House at Blacke Friers, By His Maiesties Seruants*, London: Thomas Harper.

Davies, Sir J. (1975) 'Nosce Teipsum', in R. Kreuger (ed.) *The Poems of Sir John Davies*, Oxford: Clarendon.

Dawson, T. (1596) *The good husvvifes iewell. VVherein is to he [sic] found most excellent [sic] and rare deuises for conceites in cookery, found out by the practise of Thomas Dawson...*, Imprinted at London: [By E. Allde] for Edward White, dwelling at the litle north doore of Paules at the signe of the Gun.

Debax, J.P. (1984) '*Coriolan* ou la parole en question', *Caliban* 21: 63–79.

Dekker, T. (1963) 'Lanthorne and Candle-Light; or, The Bel-Man's Second Nights-Walke', in A.B. Grosart (ed.) *The Non-Dramatic Works of Thomas Dekker*, 3: 171–303 New York: Russell and Russell.

—— (1968) *The Shoemaker's Holiday*, Berkeley: University of California Press.

Deloney, T. (1912) 'The Gentle Craft (The First Part)', in F.O. Mann (ed.) *Works of Thomas Deloney*, Oxford: Clarendon.

Dennett, D.C. (1991) *Consciousness Explained*, Boston: Little Brown.

Dollimore, J. (1993) *Radical Tragedy: Religion, Ideology, and Power in the Drama of Shakespeare and his Contemporaries*, Durham: Duke University Press.

—— (1999) 'Transgression and surveillance in *Measure for Measure*', in R.P. Wheeler (ed.) *Critical Essays on Shakespeare's Measure for Measure*, New York: G.K. Hall.

Dover Wilson, J. (1935) What Happens in Hamlet, Cambridge: Cambridge University Press.

Dubrow, H. (1987) *Captive Victors: Shakespeare's Narrative Poems and Sonnets*, Ithaca: Cornell University Press.

Dylan, B. (1963) 'Talking World War III Blues', on *The Freewheelin' Bob Dylan*, LP record, Columbia Records.

Egerton, S. (1623) *The boring of the eare contayning a plaine and profitable discourse by way of dialogue: concerning 1. Our preparation before hearing, 2. Our demeanour in hearing, 3. Our exercise after we haue heard the Word of God / written by that faithfull and diligent minister of Gods Word, Master Stephen Egerton*, London: Printed by William Stansby.

134 References

Eisenberg, E. (1987) *The Recording Angel: Explorations in Phonography*, New York: McGraw-Hill.

Eisenstein, E.L. (1979) *The Printing Press as an Agent of Change: Communications and Cultural Transformation in Early-Modern Europe*, Cambridge: Cambridge University Press.

Emerson, R.W. (1850) *Representative Men: Seven Lectures*, Boston: Phillips Sampson.

Engle, L. (2000) '*Measure for Measure* and modernity: the problem of the sceptic's authority', in H. Grady (ed.) *Shakespeare and Modernity: Early Modern to Millennium*, New York: Routledge.

Farnham, W. (1971) *The Shakespearian Grotesque*, Oxford: Clarendon.

Feld, S (1994) 'From ethnomusicology to echo-muse-ecology: reading R. Murray Schafer in the Papua New Guinea rainforest', *The Soundscape Newsletter* June, 8. Available HTTP: http://interact.uoregon.edu/MediaLit/WFAE/news_letter/08.html#Ethnomusicology (11 October 2001).

—— (1996) 'Waterfalls of song: an acoustemology of place resounding in Bosavi, Papua New Guinea', in S. Feld and K.H. Basso (eds) *Senses of Place*, Santa Fe: School of American Research Press.

Fenton, R. (1603) *A perfume against the noysome pestilence, prescribed by Moses vnto Aaron. Num. 16. 46. Written by Roger Fenton, preacher of Grayes Inne*, Imprinted at London: By R. R[ead] for William Aspley.

Fineman, J. (1987) 'Shakespeare's will: the temporality of rape', *Representations* 20: 25–76.

—— (1994a) 'Shakespeare's ear', in H.A. Veeser (ed.) *The New Historicism Reader*, New York: Routledge.

—— (1994b) 'The sound of *O* in *Othello*: the real tragedy of desire', in A.G. Barthelemy (ed.) *Critical Essays on Shakespeare's Othello*, New York: G.K. Hall.

Fioravanti, L. and Hester, J. *et al.* (1579) *A ioyfull iewell. Contayning aswell such excellent orders, preseruatiues and precious practises for the plague, as also such meruelous medcins for diuers maladies, as hitherto haue not beene published in the English tung…,* Imprinted at London: [By J. Allde] for William Wright, and are to be solde at the long shop in the pultrie adioyning to S. Mildreds Church.

Fleay, F.G. (1886) *A Chronicle History of the Life and Work of William Shakespeare: Player, Poet, and Playmaker*, London: J.C. Nimmo.

Fox, A. (2000) *Oral and Literate Culture in England, 1500–1700*, Oxford: Oxford University Press.

Fraunce, A. (1976) *The Third Part of the Countesse of Pembrokes Yuychurch: London 1592*, trans. R. Lynche, S. Orgel (ed.), New York: Garland.

Friedman, M.D. (1995) '"O, let him marry her!": matrimony and recompense in *Measure for Measure*', *Shakespeare Quarterly* 46(4): 454–64.

Furness, H.H. (ed.) (1892) *The Tempest; vol. 9 of A New Variorum Edition of Shakespeare*, 10th edn, Philadelphia: J.B. Lippincott.

Garner, S.B. (1989) *The Absent Voice: Narrative Comprehension in the Theater*, Urbana: University of Illinois Press.

—— (1994) *Bodied Spaces: Phenomenology and Performance in Contemporary Drama*, Ithaca: Cornell University Press.

Gesner, K. and Hill, T. *et al.* (1576) *The newe iewell of health, wherein is contayned the most*

excellent secretes of phisicke and philosophie, deuided into fower bookes..., Printed at London: By Henrie Denham.

Girard, R. (1991) *A Theater of Envy: William Shakespeare*, Oxford: Oxford University Press.

Gosson, S. (1587) *The schoole of abuse, contayning a pleasaunt inuectiue against poets, pipers, players, iesters, and such like caterpillers of a common wealth; setting vp the flagge of defiance to their mischiuous exercise, and ouerthrowing their bulwarkes, by prophane writers, naturall reason and common experience....By Stephan Gosson stud. Oxon,* Imprinted at London: [By Thomas Dawson] for Thomas Woodcocke.

Gouk, P. (1991) 'Some english theories of hearing in the seventeenth century: before and after Descartes', in C. Burnett, M. Fend and P. Gouk (eds) *The Second Sense: Studies in Hearing and Musical Judgment from Antiquity to the Seventeenth Century*, London: The Warburg Institute University of London.

—— (1999) *Music, Science and Natural Magic in Seventeenth-Century England*, New Haven: Yale University Press.

Great Actors of the Past (1977) LP record, Argo SW LP 510, Argo Records.

Great Historical Shakespeare Recordings (2000) Compact disc, Naxos CD NA220012, London: Naxos Audiobooks.

Greenblatt, S.J. (1988) *Shakespearean Negotiations: the Circulation of Social Energy in Renaissance England*, Berkeley: University of California Press.

Greene, R. (1972) 'The Second Part of Cony-Catching', in G. Salgado (ed.) *Cony-Catchers and Bawdy Baskets: an Anthology of Elizabethan Low Life*, Harmondsworth: Penguin.

Griffiths, T.R. (ed.) (1996) *A Midsummer Night's Dream*, Shakespeare in Production, New York: Cambridge University Press.

Gross, K. (2001) *Shakespeare's Noise*, Chicago: University of Chicago Press.

Gurr, A. (1975) '*Coriolanus* and the body politic', *Shakespeare Survey* 28: 63–69.

—— (1984) 'Hearers and beholders in Shakespearean drama', *Essays in Theatre* 3(1): 30–45.

Hale, D.G. (1971) 'Coriolanus: the death of a political metaphor', *Shakespeare Quarterly* 22: 197–202.

Handel, S. (1989) *Listening: an Introduction to the Perception of Auditory Events*, Cambridge: MIT Press.

Hankey, J. (ed.) (1981) *Richard III*, Plays in Performance, London: Junction Books.

Hapgood, R. (1971) 'Hearing Shakespeare: sound and meaning in *Antony and Cleopatra*', *Shakespeare Survey* 24: 1–12.

Harrison, W. (1614) *The difference of hearers. Or An exposition of the parable of the sower. Deliuered in certaine sermons at Hyton in Lancashire By William Harrison, his Maiesties preacher there. Together with a post-script to the Papists in Lancashire, containing an apologie for the points of controuersie touched in the sermons*, London: Printed by T. C[reede] for Arthur Iohnson dwelling at the signe of the white Horse, neere the great North Doore of Pauls.

Hassel Jr, R.C. (1971) 'Saint Paul and Shakespeare's early comedies', *Thought* 46: 371–88.

Hawkes, T. (1986) *That Shakespeherian Rag: Essays on a Critical Process*, London: Methuen.

Hillman, D. and Mazzio, C. (eds) (1997) *The Body in Parts: Fantasies of Corporeality in Early Modern Europe*, New York: Routledge.

Historical Manuscripts Commission (1905) *Report on the Manuscripts of the Earl of Egmont*, London: Printed for His Majesty's Stationery Office by Mackie.

Hollander, J. (1993) *The Untuning of the Sky: Ideas of Music in English Poetry, 1500–1700*, Hamden: Archon Books.

Howes, D. (ed.) (1991) *The Varieties of Sensory Experience: a Sourcebook in the Anthropology of the Senses*, Toronto: University of Toronto Press.

Hughes, A. (1981) *Henry Irving, Shakespearean*, Cambridge: Cambridge University Press.

Hunt, F.V. (1978) *Origins in Acoustics: the Science of Sound from Antiquity to the Age of Newton*, New Haven: Yale University Press.

Ihde, D. (1976) *Listening and Voice: a Phenomenology of Sound*, Athens: Ohio University Press.

Ingram, R.W. (1984) *'Their noise be our instruction': Listening to* Titus Andronicus *and* Coriolanus, Toronto: University of Toronto Press.

Irving, H. (1888) 'Now is the winter of our discontent ...', Wax cylinder sound recording. Streaming media version, The Irving Society, Available HTTP: http://www.theirvingsociety.org.uk/richard_iii.htm (11 October 2001).

Jagendorf, Z. (1990) 'Coriolanus: body politic and private parts', *Shakespeare Quarterly* 41(4): 455–69.

Jay, M. (1988) 'Scopic regimes of modernity', in H. Foster (ed.) *Vision and Visuality*, Seattle: Bay Press.

Johnson, C.O. (1979) '"Hoboyes" and *Macbeth*: a note on *Macbeth* I.vi.', in G.A. Stringer (ed.) *Explorations in Renaissance Culture*, vol. 5, Hattiesburg: South-Central Renaissance Conference.

Kemp, W. (1600) *Kemps nine daies vvonder. Performed in a daunce from London to Norwich. Containing the pleasure, paines and kinde entertainment of William Kemp betweene London and the Citty in his late Morrice*, London: Printed by E.A. for Nicholas Ling, and are to be solde at his shop at the west doore of Saint Paules Church.

Kermode, F. (1997) 'Introduction to *Coriolanus*,' in G. Blakemore Evans (ed.) *The Riverside Shakespeare*, Boston: Houghton Mifflin.

Kerrigan, W.W. (1998) 'The case for bardolatry: Harold Bloom rescues Shakespeare from the critics', *Lingua Franca*, November: 28–37.

Kilgour, M. (1990) *From Communion to Cannibalism: An Anatomy of Metaphors of Incorporation*, Princeton: Princeton University Press.

Knight, G.W. (1949) *The Wheel of Fire: Interpretations of Shakespearian Tragedy, with Three New Essays*, London: Methuen.

Kott, J. (1987) *The Bottom Translation: Marlowe and Shakespeare and the Carnival Tradition*, Evanston: Northwestern University Press.

Lakoff, G. (1987) *Women, Fire, and Dangerous Things: What Categories Reveal About the Mind*, Chicago: University of Chicago Press.

Lane, A. (1998) 'Infinite exercise: Harold Bloom takes on all of Shakespeare, and humanity, too', *New Yorker*, 19 October: 82–6.

Langwill, L.G. (1952) 'The Waits: a short historical study', *Hinrichsen's Musical Year Book* 7: 170–83.

Laqueur, T.W. (1990) *Making Sex: Body and Gender from the Greeks to Freud*, Cambridge: Harvard University Press.

Laroque, F. (1991) *Shakespeare's Festive World: Elizabethan Seasonal Entertainment and the Professional Stage*, Cambridge: Cambridge University Press.

Lawrence, W. (1927) 'Illusion of sounds in the Elizabethan theatre', in *Pre-Restoration Stage Studies*, Cambridge: Harvard University Press.

—— (1935) 'Bells in the Elizabethan drama', in *Those Nut-Cracking Elizabethans: Studies of the Early Theatre and Drama*, London: The Argonaut Press.

Lecouras, P. (1996) 'A note on egomania and sound in *Richard III*', *Shakespeare Bulletin: a Journal of Performance Criticism and Scholarship* 14(1): 44.

Lodge, T. and Greene, R. (1594) *A looking glasse for London and England. Made by Thomas Lodge Gentleman, and Robert Greene. In Artibus Magister*, London: Printed by Thomas Creede, and are to be sold by William Barley, at his shop in Gratious streete.

Luther, M. (1955) 'Lectures on Hebrews', in J. Pelikan and W.A. Hansen (eds) *Luther's Works*, vol 29, Saint Louis: Concordia Publishing House.

Lyly, J. (1988) 'Midas', in C.A. Daniel (ed.) *The Plays of John Lyly*, Lewisburg: Bucknell University Press.

McDonald, M. (1994) 'Bottom's space: historicizing comic theory and practice in *A Midsummer Night's Dream*', in F. Teague (ed.) *Acting Funny: Comic Theory and Practice in Shakespeare's Plays*, Rutherford: Fairleigh Dickinson University Press.

McGuire, P.C. (1985) *Speechless Dialect: Shakespeare's Open Silences*, Berkeley: University of California Press.

McLuhan, M. (1960) 'The effect of the printed book on language in the 16th century', in E. Carpenter and M. McLuhan (eds) *Explorations in Communications*, Boston: Beacon.

—— (1962) *The Gutenberg Galaxy; the Making of Typographic Man*, Toronto: University of Toronto Press.

Madelaine, R. (ed.) (1998) *Antony and Cleopatra*, Cambridge: Cambridge University Press.

Marcus, G. (1995) *The Dustbin of History*, Cambridge: Harvard University Press.

Marlowe, C. (1969) *The Complete Plays*, J.B. Steane (ed.) Harmondsworth: Penguin.

Marston, J. (1965) *The Fawn*, Lincoln: University of Nebraska Press.

—— (1967) *The Malcontent*, New York: W.W. Norton.

Maus, K.E. (1995) *Inwardness and Theater in the English Renaissance*, Chicago: University of Chicago Press.

—— (1999) 'Sexual secrecy in *Measure for Measure*', in R.P. Wheeler (ed.) *Critical Essays on Shakespeare's Measure for Measure*, New York: G. K. Hall.

Mayer, D. (ed.) (1980) *Henry Irving and The Bells*, Manchester: Manchester University Press.

Miller, R.F. (1975) '*A Midsummer Night's Dream*: the faeries, Bottom, and the mystery of things', *Shakespeare Quarterly* 26: 254–68.

Moston, D. (1995) 'Introduction', in D. Moston (ed.) *The First Folio of Shakespeare, 1623*, New York: Applause.

Motohashi, T. (1994) 'Body politic and political body in *Coriolanus*', *Forum for Modern Language Studies* 30(2): 97–112.

Munday, A. (1579) *The mirrour of mutabilitie, or Principall part of the Mirrour for magistrates. Describing the fall of diuers famous princes, and other memorable personages. Selected out of the sacred Scriptures by Antony Munday, and dedicated to the Right Honorable the Earle of Oxenford*, Imprinted at London: By Iohn Allde and are to be solde by Richard Ballard, at Saint Magnus Corner.

——, and Salvian of Marseilles (1580) *A second and third blast of retrait from plaies and theaters: the one whereof was sounded by a reuerend byshop dead long since; the other by a worshipful and zealous gentleman now aliue...*, Imprinted at London: by Henrie Denham, dwelling in Pater noster Row, at the signe of the Starre, being the assigne of William Seres. Allowed by aucthoritie.

Newman, K. (1994) '"And wash the Ethiop white": femininity and the monstrous in *Othello*', in A.G. Barthelemy (ed.) *Critical Essays on Shakespeare's Othello*, New York: G.K. Hall.

Olivier, L. (1986) *On Acting*, New York: Simon and Schuster.

Ong, W.J. (1977) *Interfaces of the Word: Studies in the Evolution of Consciousness and Culture*, Ithaca: Cornell University Press.

—— (1982) *Orality and Literacy: The Technologizing of the Word*, New York: Routledge.

Orgel, S. (1991) 'The poetics of incomprehensibility', *Shakespeare Quarterly* 42(4): 431–7.

Ovid (1567) *The .xv. Bookes of P. Ouidius Naso, entytuled Metamorphosis, translated oute of Latin into English meeter, by Arthur Golding Gentleman, A worke very pleasaunt and delectable*, London: Willyam Seres.

Parker, P. (1996) *Shakespeare from the Margins: Language, Culture, Context*, Chicago: University of Chicago Press.

Passengers (1995) 'Elvis Ate America', on *Original Soundtracks 1*, Compact disc, Island Records.

Paster, G.K. (1981) 'To starve with feeding: the city in *Coriolanus*', *Shakespeare Studies* 11: 123–44.

—— (1993) *The Body Embarrassed: Drama and the Disciplines of Shame in Early Modern England*, Ithaca: Cornell University Press.

Patterson, A. (1989) *Shakespeare and the Popular Voice*, Cambridge: Blackwell.

Peters, H. (1988) 'Bottom: making sense of sense and scripture', *Notes and Queries* 35(1): 45–7.

Prall, S.E. (1993) *Church and State in Tudor and Stuart England*, Arlington Heights: H. Davidson.

Rabelais, F. (1990) *Gargantua and Pantagruel*, trans. B. Raffel, New York: W.W. Norton.

Rabkin, N. (1966) '*Coriolanus*: the tragedy of politics', *Shakespeare Quarterly* 17: 195–212.

Rankins, W. (1587) *A mirrour of monsters: wherein is plainely described the manifold vices, &c spotted enormities, that are caused by the infectious sight of playes, with the description of the subtile slights of Sathan, making them his instruments. Compiled by Wil. Rankins*, London: Printed by I[ohn] C[harlewood] for T[homas] H[acket].

Rhodes, N. (1980) *Elizabethan Grotesque*, London: Routledge and Kegan Paul.

Riss, A. (1992) 'The belly politic: *Coriolanus* and the revolt of language', *English Literary History* 59(1): 53–75.

Russo, M. (1997) 'Female grotesques: carnival and theory', in N. Medina, K.

Conboy and S. Stanbury (eds) *Writing on the Body: Female Embodiment and Feminist Theory*, New York: Columbia University Press.

Sadie, S. and Tyrrell, J. (eds) (2001) *The New Grove Dictionary of Music and Musicians*, New York: Grove's Dictionaries.

Sandys, G. (1976) *Ovid's Metamorphosis Englished: Oxford 1632*, S. Orgel (ed.) New York: Garland. Reprint of the 1632 ed. imprinted at Oxford by J. Lichfield.

Saussure, F. de (1983) *Course in General Linguistics*, C. Bally and A. Sechehaye (eds), trans. R. Harris, London: Duckworth.

Sawday, J. (1995) *The Body Emblazoned: Dissection and the Human Body in Renaissance Culture*, New York: Routledge.

Schafer, R.M. (1977) *The Tuning of the World*, New York: Knopf.

Schoenfeldt, M.C. (1999) *Bodies and Selves in Early Modern England: Physiology and Inwardness in Spenser, Shakespeare, Herbert, and Milton*, Cambridge: Cambridge University Press.

Schutz, A. (1962) 'Making music together: a study in social relationship', in M. Natason (ed.) *Collected Papers*, vol. 2, The Hague: M. Nijhoff.

Seitz, C.G. (1987) 'Sounds and sweet airs: city Waits of medieval and renaissance England', *Essays in Medieval Studies* 4: 119–42.

Serres, M. (1985) *Les Cinq Sens*, Paris: Éditions Grasset et Fasquelle.

—— (1995) *Genesis*, trans. Geneviève James and James Nielson, Ann Arbor: University of Michigan Press.

Shakespeare, W. (1997) *The Riverside Shakespeare*, G. Blakemore Evans (ed.) Boston: Houghton Mifflin.

Shakespeare in Love (1998) Dir. John Madden, Miramax.

Shaw, J. (1974) '"In every corner of the stage": *Antony and Cleopatra*, IV.iii.', *Shakespeare Studies* 7: 227–32.

Shirley, F.A. (1963) *Shakespeare's Use of Off-Stage Sounds*, Lincoln: University of Nebraska Press.

Sicherman, C.M. (1972) '*Coriolanus*: the failure of words', *English Literary History* 39: 189–207.

Simonds, P.M. (1982) '"No more ... offend our hearing": aural imagery in *Cymbeline*', *Texas Studies in Literature and Language* 24(2): 137–54.

Simpson, R.R. (1959) *Shakespeare and Medicine*, Edinburgh: E. and S. Livingstone.

Smith, B.R. (1999) *The Acoustic World of Early Modern England: Attending to the O-Factor*, Chicago: University of Chicago Press.

Soft Boys, The (1979) 'Human music', on *A Can of Bees*, LP record, CLA.

Sorge, T. (1987) 'The failure of orthodoxy in *Coriolanus*', in J.E. Howard and M.F. O'Connor (eds) *Shakespeare Reproduced: The Text in History and Ideology*, New York: Methuen.

Spevack, M. (ed.) (1990) *Antony and Cleopatra*, New York: Modern Language Association.

Spurgeon, C.F.E. (1935) *Shakespeare's Imagery, and What it Tells Us*, Cambridge: Cambridge University Press.

States, B.O. (1985) *Great Reckonings in Little Rooms: On the Phenomenology of Theater*, Berkeley: University of California Press.

Stoller, P. (1989) *The Taste of Ethnographic Things: the Senses in Anthropology*, Philadelphia: University of Pennsylvania Press.

Straznicky, M. (1996) 'The end(s) of discord in *The Shoemaker's Holiday*', *Studies in English Literature 1500–1900* 36(2): 357–68.

Stroup, T.B. (1978) 'Bottom's name and his epiphany', *Shakespeare Quarterly* 29: 79–81.

Summers, D. (1987) *The Judgment of Sense: Renaissance Naturalism and the Rise of Aesthetics*, Cambridge: Cambridge University Press.

Swift, J. (1612) *The diuine eccho, or resounding voice from heauen, moralized betwixt a Christian and his soule, with short and effectuall directions how to liue and die well…*, London: Printed [by W. Stansby] for R. Bonion, and are to be sold at the shop in Paules Church-yard, at the Flower de Luce.

Taylor, C. (1985) *Philosophy and the Human Sciences*, Cambridge: Cambridge University Press.

Taylor, G. (1989) *Reinventing Shakespeare: a Cultural History, from the Restoration to the Present*, New York: Weidenfeld and Nicolson.

Taylor, J. (1630) *All the vvorkes of Iohn Taylor the water-poet. Beeing sixty and three in number. Collected into one volume by the author: vvith sundry new additions corrected, reuised, and newly imprinted, 1630*, At London: Printed by I[ohn] B[eale, Elizabeth Allde, Bernard Alsop, and Thomas Fawcet] for Iames Boler; at the signe of the Marigold in Pauls Churchyard.

Thomson, P. (1992) *Shakespeare's Theatre*, New York: Routledge.

—— (1994) *Shakespeare's Professional Career*, Cambridge: Cambridge University Press.

Tilley, M.P. (1950) *A Dictionary of Proverbs in England in the Sixteenth and Seventeenth Centuries: A Collection of Proverbs Found in English Literature and Dictionaries of the Period*, Ann Arbor: University of Michigan Press.

Tomkis, T. (1874) 'Lingua: or, The Combat of the Tongue, and the Five Senses, for Superiority. A Pleasant Comedy', in W.C. Hazlitt (ed.) *A Select Collection of Old English Plays*, vol. 9, London: Reeves and Turner.

Trip Shakespeare (1988) *Are You Shakespearienced?*, Compact disc, Gark Records.

Truax, B. (ed.) (1978) *The World Soundscape Project's Handbook for Acoustic Ecology*, Burnaby: Sonic Research Studio, Department of Communication, Simon Fraser University.

—— (1984) *Acoustic Communication*, Norwood: Ablex.

Vickers, B. (1966) *Shakespeare: Coriolanus*, London: Arnold.

—— (1978) *Francis Bacon*, Burnt Mill: Published for the British Council by Longman.

Vinge, L. (1975) *The Five Senses: Studies in a Literary Tradition*, Lund, Sweden: Publications of the Royal Society of Letters at Lund.

Wagner, H.R. (1983) *Alfred Schutz: An Intellectual Biography*, Chicago: University of Chicago Press.

Walker, J. (1992) 'Voiceless bodies and bodiless voices: the drama of human perception in *Coriolanus*', *Shakespeare Quarterly* 43(2): 170–85.

Wall, J.N. (1979) 'Shakespeare's aural art: the metaphor of the ear in *Othello*', *Shakespeare Quarterly* 30(3): 358–66.

Webster, M. (1957) *Shakespeare Today*, London: Dent.

Weckermann, H.-J. (1987) 'Coriolanus: The failure of the autonomous individual',

in B. Fabian and K.T. von Rosador (eds) *Shakespeare: Text, Language, Criticism: Essays in Honour of Marvin Spevack*, New York: Olms-Weidmann.

White, E. (1987) 'Hewet, the Wait of York', *Records of Early English Drama Newsletter* 12(2): 17–23.

Whitney, G. (1586) *A Choice of Emblemes, and other Devises*, Leyden: Christopher Plantyn.

Wiles, D. (1998) 'The carnivalesque in *A Midsummer Night's Dream*', in R. Knowles (ed.) *Shakespeare and Carnival: After Bakhtin*, New York: St Martin's Press.

Wilkinson, R. (1610) *A ievvell for the eare*, At London: Printed [by R. Blower] for Thomas Pauyer, and are to be sold at his shop at the entrance into the Exchange.

Williamson, M.L. (1991) 'Violence and gender ideology in *Coriolanus* and *Macbeth*', in I. Kamps, L. Danson and L. Woodbridge (eds) *Shakespeare Left and Right*, New York: Routledge.

Wilson, D. (1873) *Caliban, the Missing Link*, London: Macmillan.

Wilson, E. (1995) 'Plagues, fairs, and street cries: sounding out society and space in early modern London', *Modern Language Studies* 25(3): 1–42.

Wilson, R. (1991) 'Against the grain: representing the market in *Coriolanus*', *Seventeenth Century* 6(2): 111–48.

Wilson, S. (1995) *Cultural Materialism: Theory and Practice*, Cambridge: Blackwell.

—— (1996) 'Heterology', in N. Wood (ed.) *The Merchant of Venice*, Buckingham: Open University Press.

Woodfill, W.L. (1953) *Musicians in Society from Elizabeth to Charles I*, Princeton: Princeton University Press.

Wright, T. (1986) *The Passions of the Mind in General*, New York: Garland.

Zukofsky, L. and Zukofsky, C.T. (1963) *Bottom: On Shakespeare*, Austin: Ark Press.

Index